LIFE IN HOLLYWOOD

1936 – 1952

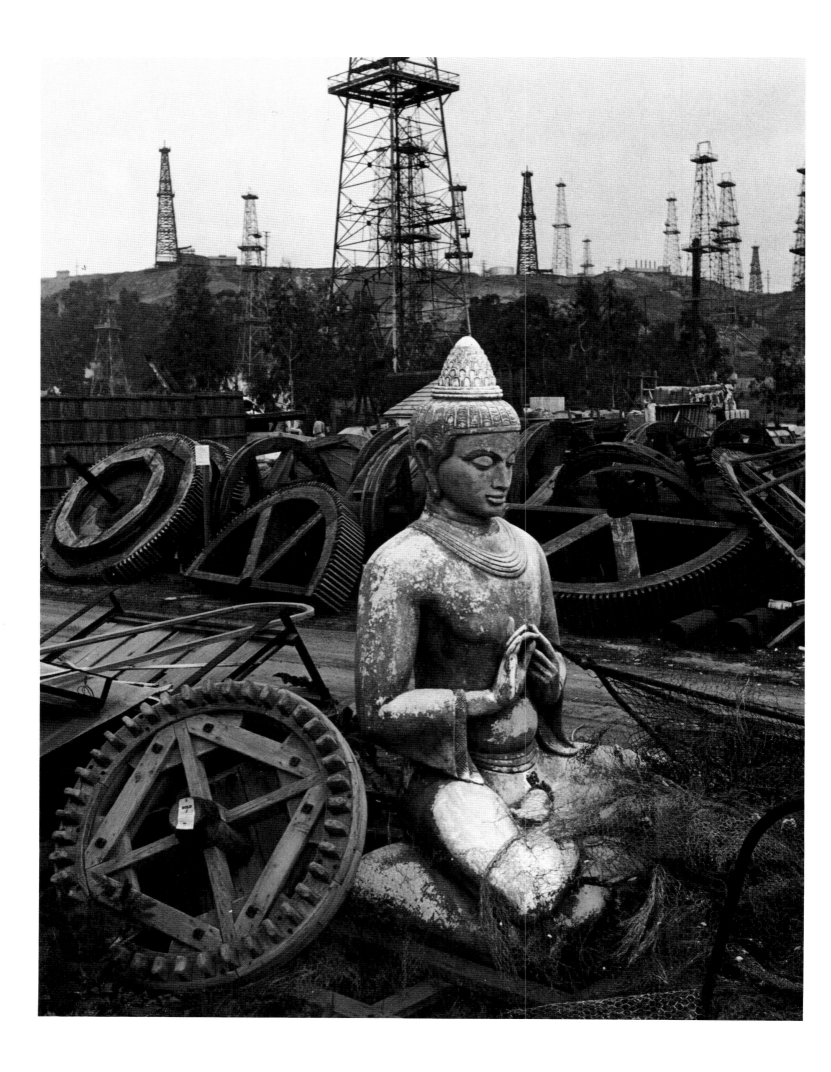

PETER STACKPOLE

LIFE IN HOLLYWOOD, 1936–1952

CLARK CITY PRESS

LIVINGSTON, MONTANA

Copyright © 1992 by Clark City Press.
Photos © 1992 by Peter Stackpole/Life Magazine/Time Warner.
All rights reserved. Printed in the United States of America.
First printing.

ISBN: 0-944439-18-7

Library of Congress Cataloging-in-Publication Data

Stackpole, Peter, 1913–
 Peter Stackpole : Life in Hollywood, 1936–1952.
 p. cm.
 Includes index.
 ISBN 0-944439-18-7 : $50.00
 1. Motion picture actors and actresses—California—Hollywood (Los
Angeles)—Portraits. 2. Hollywood (Los Angeles, Calif.)—Social
life and customs—Pictorial works. I. Title.
PN2285.S59 1992
791.43'028'092279494—dc20 89-82475
 CIP

Unless otherwise noted, all photographs in this volume were taken
by Peter Stackpole.

Clark City Press wishes to thank the following individuals for
their assistance and patience: Anne Garner, Cindy Murphy,
Singeli Agnew, Jan Kimmel, Therese Heyman, Marcia Eymann,
Nancy Nadel, George Gibson, the staff of Wilsted & Taylor,
Rick Harrison, William Donati, and Mary Jane McGonegal
of LIFE Magazine.

Title spread photo: The MGM back lot, 1939.

Clark City Press
Post Office Box 1358
Livingston, Montana 59047

This book is dedicated to
all of the photographers
whose inspiration
found its way into LIFE,
the greatest picture magazine
the world has ever known.

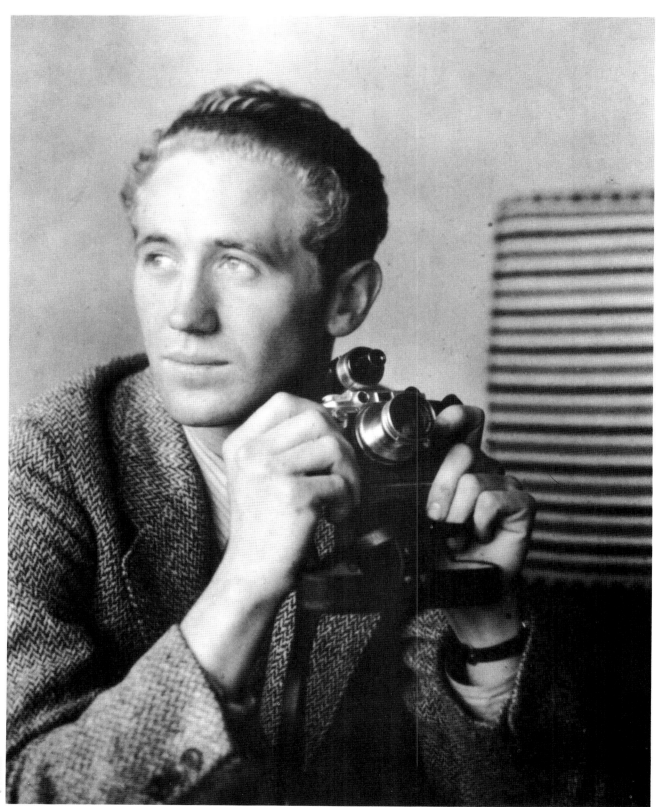

PETER STACKPOLE

FROM LEICA TO *LIFE*

A candid photograph of former president Herbert Hoover dozing off during a speech by the secretary of labor first gave Peter Stackpole an identity with Time Inc. Stackpole, born in San Francisco in 1913, took the picture for the *Oakland Tribune* at Charter Day exercises on the campus of the University of California at Berkeley. Because the photo had political connotations—the *Tribune* was owned by the Republican family of the soon-to-be-senator William Knowland— the paper refused to run it. But an editor sent it on to *Time*, and not only did they print the picture, the magazine sent Stackpole a check for a hundred dollars, a small fortune to pay for a photograph during the Depression. And they would remember the young photographer when they began to assemble the staff of a revolutionary new picture magazine called, simply, *Life*.

Both of Peter Stackpole's parents were artists, and their strong visual sense helped him develop his photographic style. His father, Ralph Stackpole, was a sculptor who entertained the local arts scene in the Bay Area in the twenties and thirties. Ralph Stackpole was instrumental in bringing the Mexican muralist Diego Rivera to San Francisco in 1929, giving him a place to stay while he painted his famous mural at the San Francisco Stock Exchange, where the elder Stackpole had created the large stone sculptures at the entrance. When Peter went to see his father one day to show him a new model airplane, Rivera asked him to pose for sketches for the mural; Stackpole became the central figure in the mural—a young boy holding up a small plane.

During his high-school years, Stackpole picked up a camera—a model A Leica—and began taking candid photos of his classmates. He delighted in taking pictures of his teacher through an inkwell hole in his desk. It was the beginning of an unobtrusive style that would make Stackpole's candid photography so lively.

During this time, Stackpole met the publisher of the *Oakland Post-Enquirer*, one of the smaller daily papers of the Hearst chain, and began shooting after- school and weekend assignments. Most of the photographers used the 4×5 Speedgraphics and Graphlexes, but Stackpole liked the ease with which he could

*Portrait of Peter Stackpole
at nineteen, 1932.*

Below: Stackpole set his Model A Leica on an ASA of 20 to capture Max Baer and an unidentified opponent in 1933.

Right: The ingot pourer was photographed at Columbia Steel in 1933, while Ralph Stackpole made sketches for his Coit Tower mural.

capture more spontaneous moments with the Leica. In 1933, he decided to try out this approach when he was sent to cover a Max Baer boxing match. "I thought the way to shoot this assignment was to get the action by the side of the ring," says Stackpole. However, with the 35mm camera, the film turned out very grainy. "The photoengravers didn't like what they saw, but they had to use it anyway— it was all they had," he says. He found little support at the paper for the 35mm, or for his candid images. The paper preferred posed pictures of people shaking hands and looking at the camera. "I was really ahead of my time," says Stackpole. "I ended up being fired." This was Prohibition, and the reporters and editors at the *Enquirer* liked to use the darkroom to sample the liquor they picked up during police raids. They clearly didn't want a kid hanging around. Stackpole says today

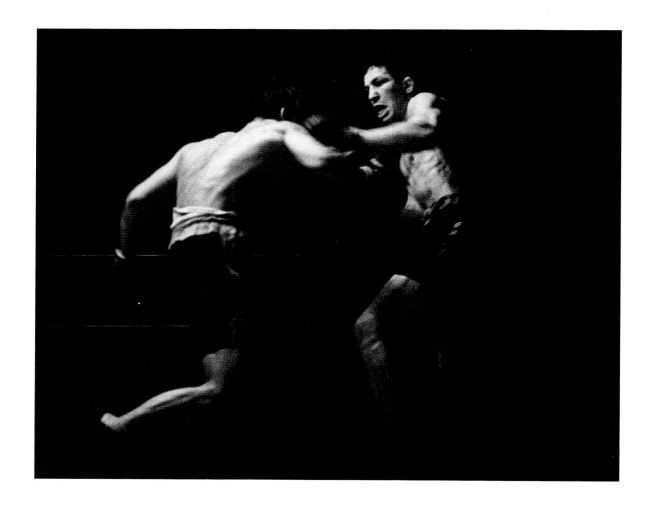

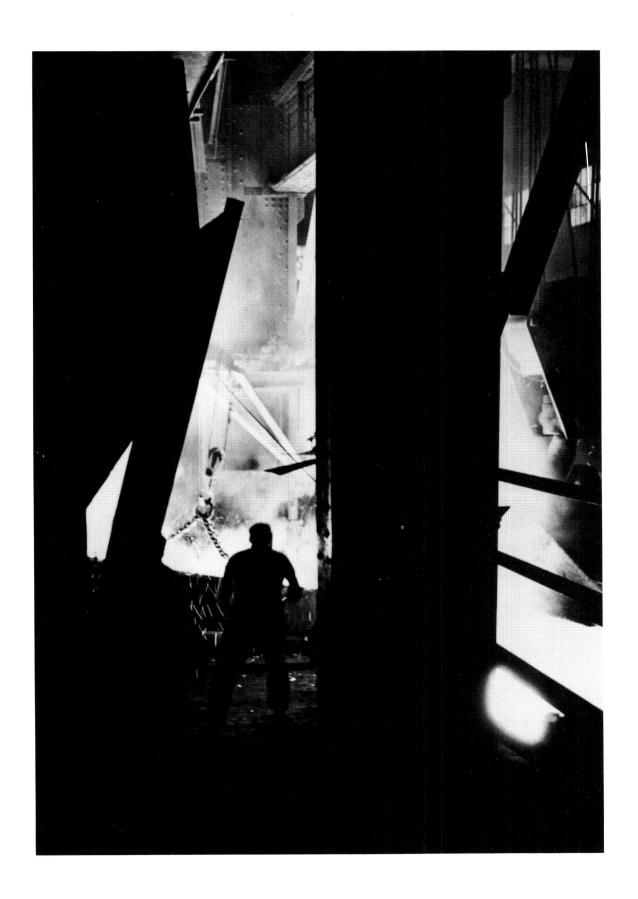

Near right: The San Francisco Bay Bridge under construction, 1935.

Far right: Stackpole photographed William Randolph Hearst at Wyntoon in 1935 for "Fortune."

New Yorkers do the Big Apple in one of Stackpole's "'LIFE' Goes to a Party" assignments, 1938.

Stackpole's work in the Bay Area encompassed a range of men, including this 1936 portrait of Lawrence Giannini (upper right), the son of the founder of the Bank of America; his father Ralph Stackpole, at work in his San Francisco stoneyard in 1939 (lower right); and Diego Rivera (facing page), shown working on a mural in Ralph Stackpole's studio in 1939.

"My father wanted me to be an artist, too," says Stackpole. "He once put a hammer and chisel in my hands and turned me to face a block of raw stone. I lasted about half an hour. When he saw me with my first Leica he said, 'You don't need that thing. All you need is this,' and he pulled a pad and pencil from his pocket and did a sketch of me on the spot. But shortly after I began to show him my published pictures he decided my being a photographer was okay."

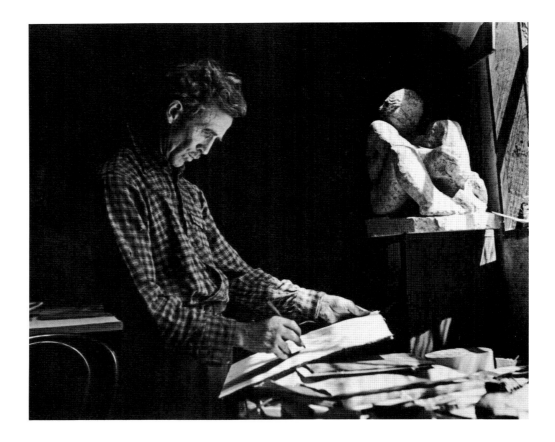

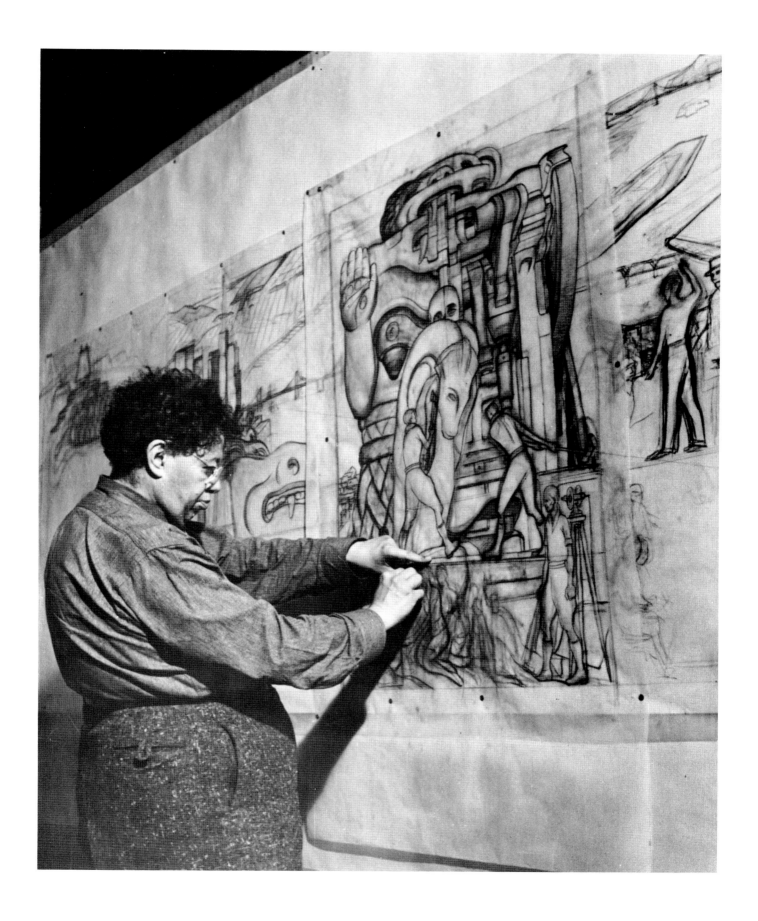

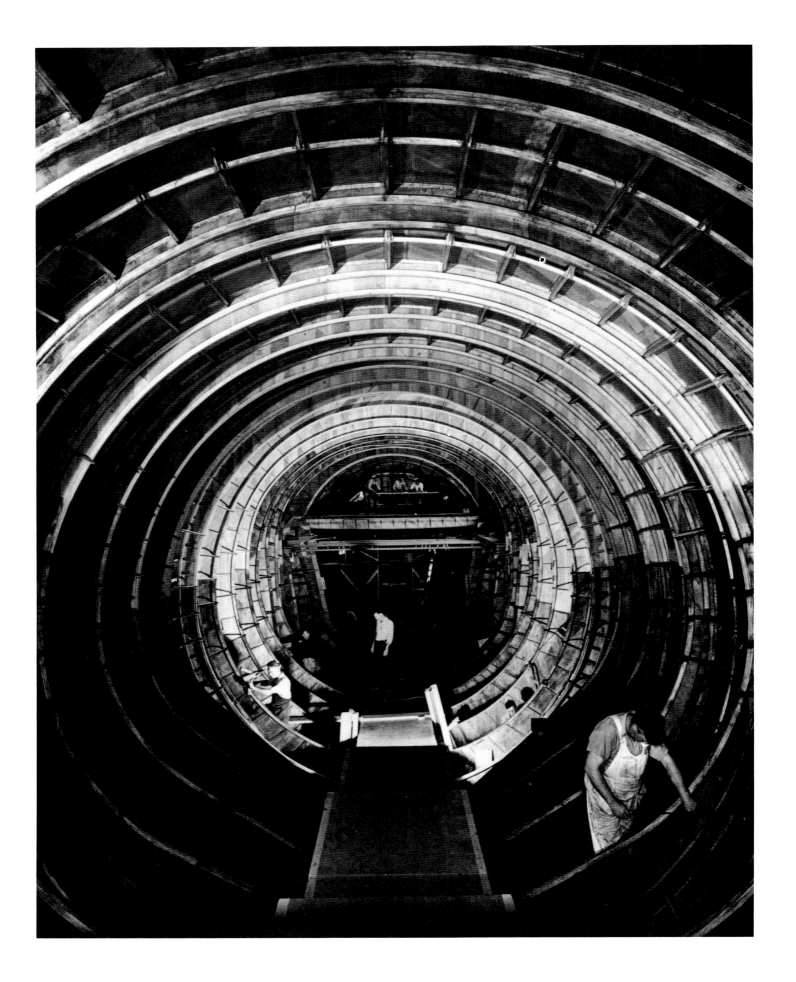

that it was hard being fired from a job that didn't even pay him, but it forced him to move on.

Stackpole attributes much of his photographic influence at this time to Thomas D. McAvoy, who was working out of Washington, D.C. McAvoy was known for his candid pictures of senators and presidents. He was later to become another of the original four *Life* shooters. "When my picture of Hoover came out in *Time*, a subscriber wrote that I was the Tom McAvoy of the West," says Stackpole, "and this pleased me to no end."

While stringing for Time Inc., Stackpole was becoming fascinated with the building of the Oakland Bay Bridge and began photographing its construction. "I realized I was on to something," he remembers. After sneaking out on the beams a few times, he was finally given a pass by Columbia Steel, and they eventually bought numerous pictures from him of their project. They also bought him a 16mm camera, so that he could do a cable-spinning film. Photographer Imogen Cunningham sent some of the pictures to Frank Crowninshield, the editor of *Vanity Fair*, and they were published in the July 1935 issue.

After the photos appeared, Stackpole, at twenty-two, was asked by Willard Van Dyke to join California's Group F/64, the thirties' body of Bay Area photographers that included Ansel Adams, Edward Weston, Dorothea Lange and Cunningham. At this time also, Stackpole was asked by the San Francisco Museum of Modern Art to exhibit his bridge photos, a collection of images that document an important part of the newly industrial California of the thirties.

Stackpole gained more and more recognition for his work, and *Fortune* magazine, part of Time Inc., asked him to do a picture story in 1936 about William Randolph Hearst. Time Inc. was in touch with the photographer again that year: Henry Luce was dreaming of adding a new magazine to his stable. They weren't sure whether to call it *Dime*, *Pic*, *Look* or *See*, but finally they settled on *Life*. Stackpole recalls the first meeting in New York, on the top floor of the Chrysler Building, then the home of Time Inc. His pictures were passed around and examined by all of the editors. Luce, Stackpole says, spoke in a sort of staccato voice, his words nearly gibberish. "The man had such an active mind that his words didn't flow in sync with what he was thinking," Stackpole remembers. "But he was a man of vision and innovation."

Stackpole was accepted into the fold. He was disappointed, however, when

Facing page: A shy Howard Hughes (center) finally agreed to be photographed deep in the hull of the "Spruce Goose" in 1943.

Below: Henry Luce (right) and "Fortune" editor Russell Davenport (left).

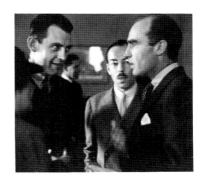

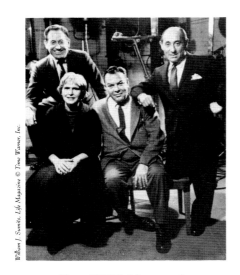

*Above: "LIFE's" four original
photographers were Stackpole,
Margaret Bourke-White,
Thomas McAvoy, and
Alfred Eisenstaedt
(from left, in 1960).*

Right: Hedy Lamarr, 1941.

*Following pages: This picture of
Gary Cooper (left) as "The
Westerner" was a cover image in
1940; Rita Hayworth, still a
starlet, posed on a bicycle picnic
in the same year.*

his bridge pictures were not used on the cover of the first issue. Instead, a Margaret Bourke-White photo of the dam at Fort Peck was on the cover, and because her lab technician was out sick, Stackpole himself had to print her pictures.

An atmosphere of competition permeated the offices, as well as the work out in the field, Stackpole says. He describes photo editor Wilson Hicks as being particularly fond of pitting photographer against photographer. "Hicks did that to me during the war in Saipan," he says. "Another photographer showed up whom I didn't even know. It turned out to be Eugene Smith." Stackpole believes Smith took the greatest war photos. "After Saipan, I knew he was a daredevil—almost suicidal," Stackpole recalls. Once, over lunch, he told Smith that no war correspondent had to take the kinds of risks he was taking. "What good is a dead photographer to his wife and kids—or to his magazine?" Stackpole asked him, and soon after, Smith got part of his jaw shot away in Okinawa.

Although there was a photo editor at *Life* from the beginning, a lot of the editorial decisions were left up to the photographer. "The first few issues were really hit and miss," says Stackpole. "They would say, 'Why don't you go over to Madison Square Garden and see what you can get on the eight-day bicycle race?'" Finally, to handle more assignments, William Vandivert and Carl Mydans were added to the staff.

They and the original four photographers—Stackpole, Bourke-White, McAvoy and Alfred Eisenstaedt—were pioneering photojournalism in those days, and *Life* was their showcase. Eisenstaedt, or Eisie, as he was called, had begun using the Leica in Germany, and *Life* gave him choice assignments, like shooting Winston Churchill, financier Bernard Baruch and Albert Einstein. "While none of us begrudged him his ability, we wished we had his assignments," Stackpole remembers. "He would go down to his locker hours before the assignment and figure out what lenses to use. His locker was a showcase of memorabilia."

Margaret Bourke-White was also given special treatment: she had her own secretary and office. Stackpole describes Bourke-White as one of the hardest-working women he has ever met, but he avoided her. The photograph was all-important, and if she had to, she would ask even the luminaries she was photographing to help with her equipment (Bourke-White used mostly the large 4×5 cameras and not 35mm). She didn't trust meters and would shoot dozens

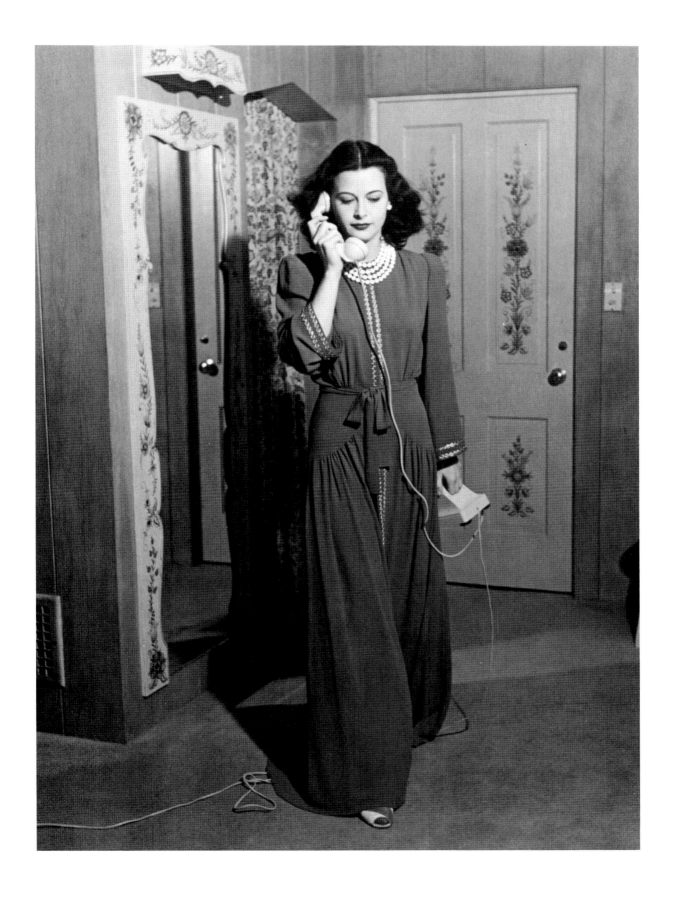

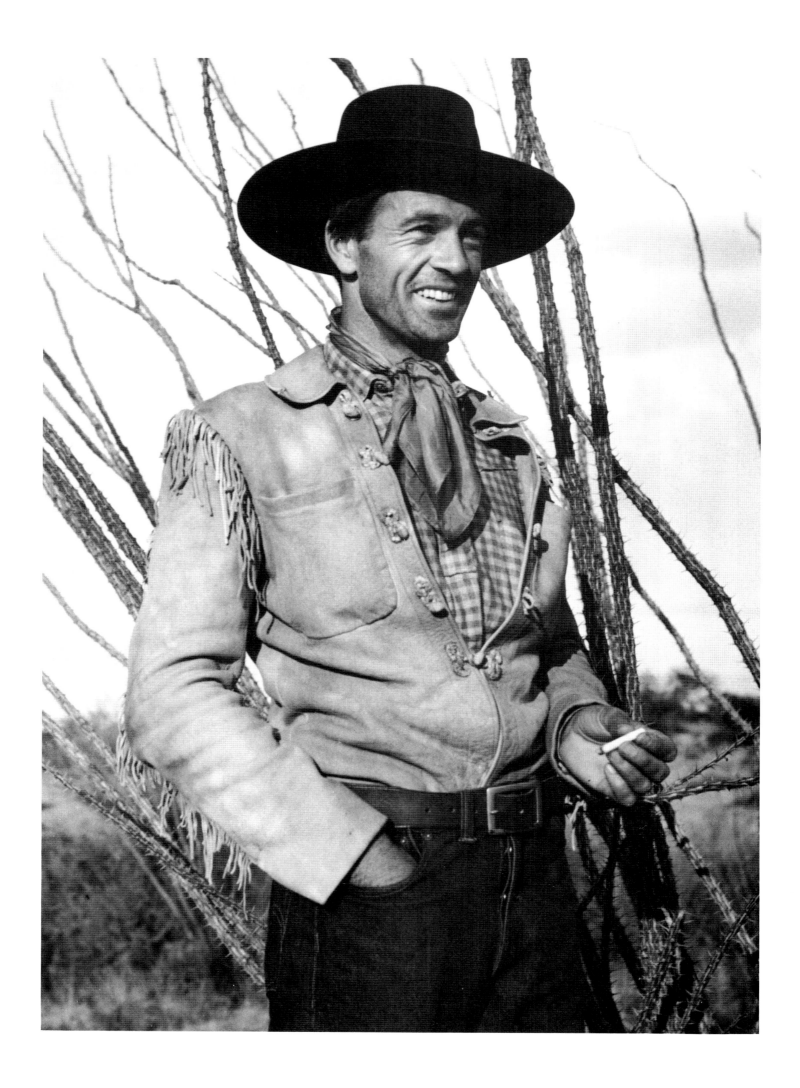

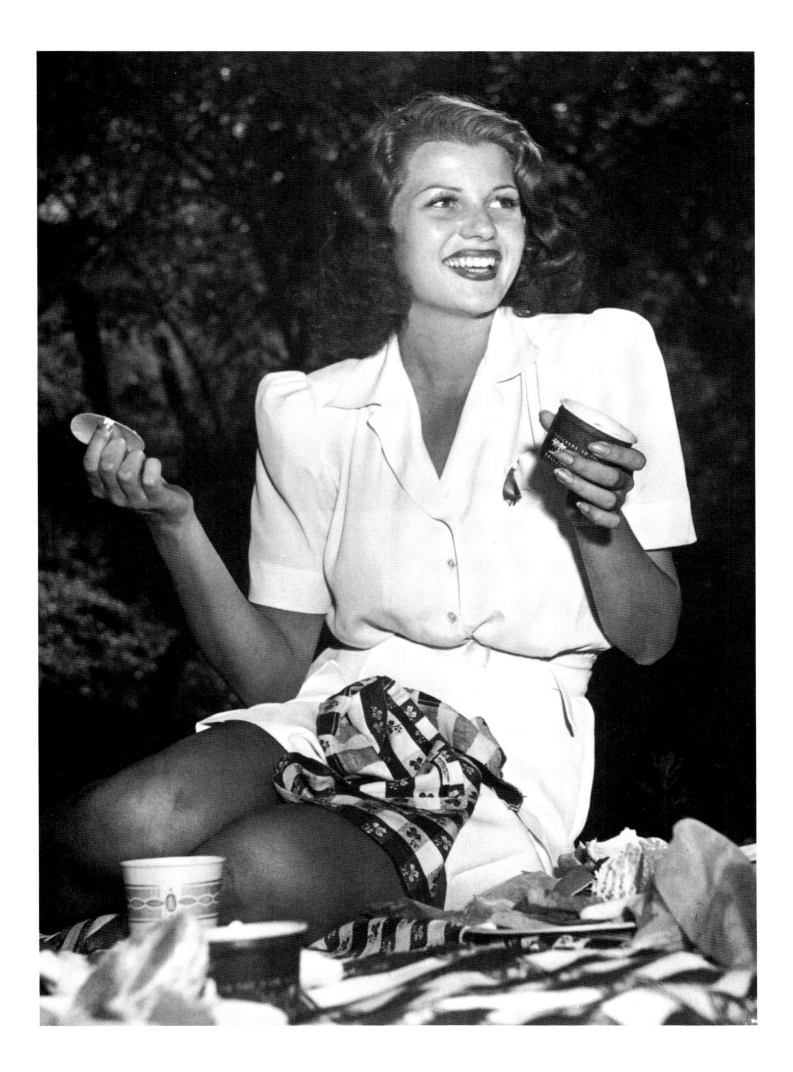

of film packs to make sure she got the right exposure, Stackpole recalls. "She drove the lab crazy with all the processing."

While assignments were being dished out in New York, Stackpole drew a long one: he was sent to Hollywood to capture the Golden Age of the movies. He became known as "*Life*-goes-to-a-party Stackpole," but despised the studio stills and the fan magazines where stars "were all gagged up and posed." Instead, Stackpole brought to the glamour scene of Hollywood his own style of candid photography. "I wanted to photograph the stars as real people," Stackpole explains.

In the forties, the glitz of Hollywood was juxtaposed with the war, and the public began to depend on *Life* to find out what was going on in the world. It sold

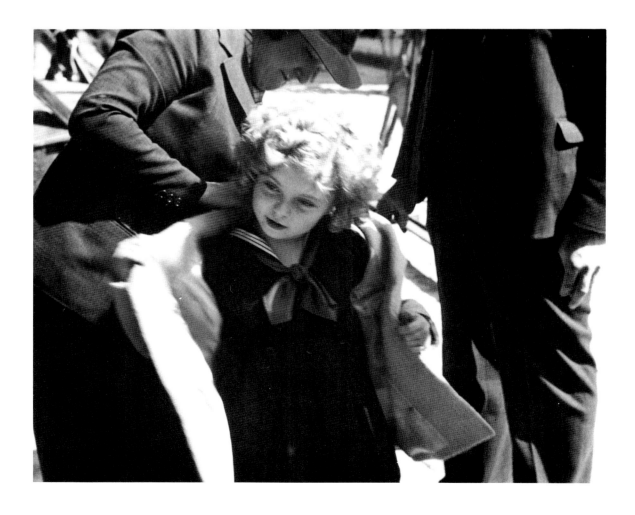

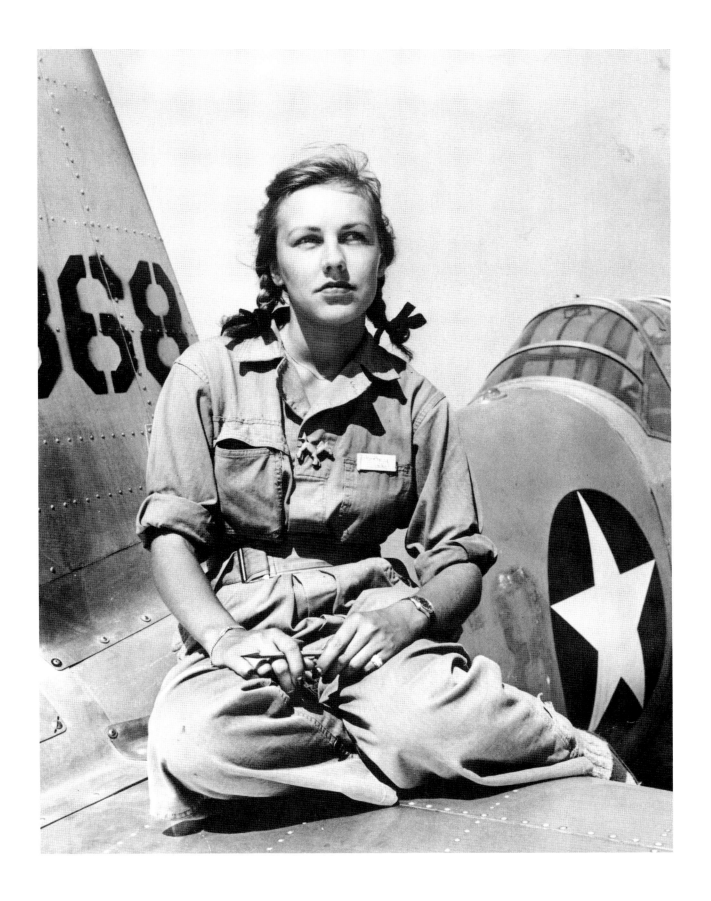

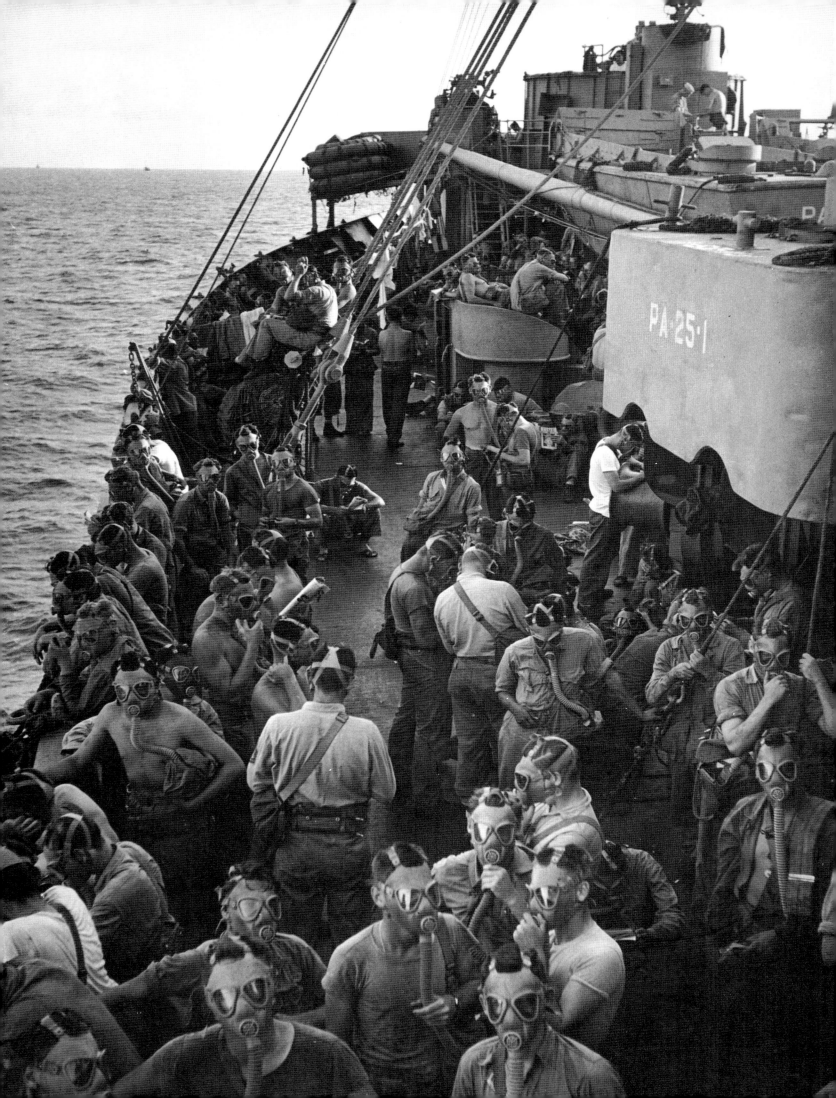

out every week and the public wanted more. Stackpole was sent to cover the action of the Pacific Fleet, but he says he would have much rather been at the European Front. "The photographers considered the European Front more glamorous," he says. "The Pacific was a really dirty war."

The way the war was covered in *Life* also brought the smaller camera into acceptance. Other photographers, like Robert Capa and Henri Cartier-Bresson were championing 35mm photography and bringing the Leica into wider use. "*Life* didn't know how to use Cartier-Bresson," says Stackpole. While Cartier-Bresson was considered a master of available-light photography, he was known more for taking the great individual photo than for telling a story through numerous photos, *Life*'s signature.

Left: A 1944 gas mask drill was a standard wartime assignment.

Below: After "LIFE" transferred Stackpole back to New York in 1952, he shot Sophia Loren as she was tailed by a Wall Street crowd.

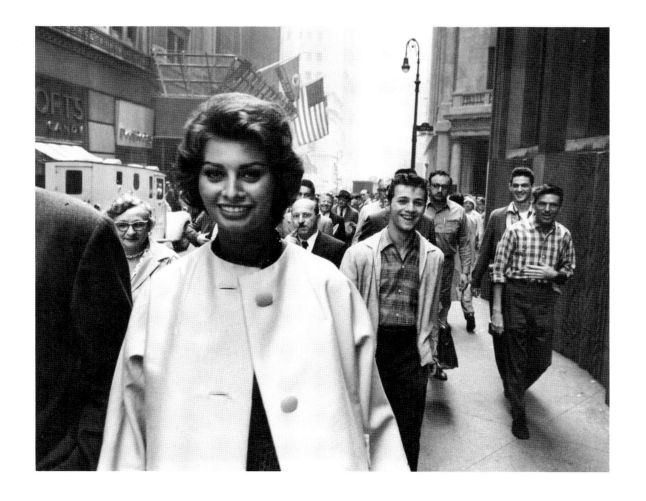

Life moved Stackpole east in 1952; he retired in 1961 and happily moved back to Oakland. He worked further on the development of underwater cases for cameras, building about a hundred of them. In 1987, he had a show of his work—more than 160 images—at Stanford University Art Gallery, and in 1991, there was a retrospective of his pictures at the Oakland Museum.

But as they were putting the Oakland show together, tragedy struck: Stackpole's treasured home in the Oakland hills went up in flames in October of 1991. It had been a rustic house of redwood with large windows overlooking a maze of trees and a panoramic view of the Golden Gate Bridge, built on land bought by his mother in the thirties. The downstairs studio was full of canvases by Ralph Stackpole, and some of Diego Rivera's work was tucked away there, too. Files and stacks of photographs were everywhere: one drawer was filled with the photographs of the building of the bridges, another was full of World War II pictures. And there were all of the Hollywood pictures. Photographing the icons of the movies for *Life*, Stackpole had met Greer Garson, Marlene Dietrich, Shirley Temple, Alfred Hitchcock, Orson Welles—all the stars, caught in their homes or at parties or on Melrose and Sunset back lots. And while he had documented the world, he had also documented his own backyard, his children and his wife.

The handmade house and the photographic work of a lifetime were reduced to rubble and ash. The canvases, the photographs, the thousands of negatives are dust. The view of the bay through a screen of charred trees is the only thing left.

Peter and his wife, Hebe, escaped the flames, taking with them only a few valued negatives and preserved prints. Today, they have a new home in Novato. In a recent article in *Life*, he said he lies in bed at night and feels a strange sensation: freedom. At seventy-nine, Peter Stackpole is starting over.

—*Nancy Nadel*

Facing page: Stackpole stands in the ruins of his Oakland home, destroyed in the fires of October, 1991.

Below: Hebe Stackpole, on the beach in Santa Monica, 1939.

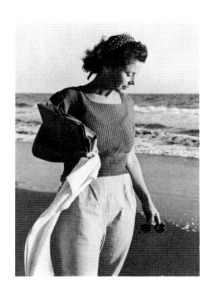

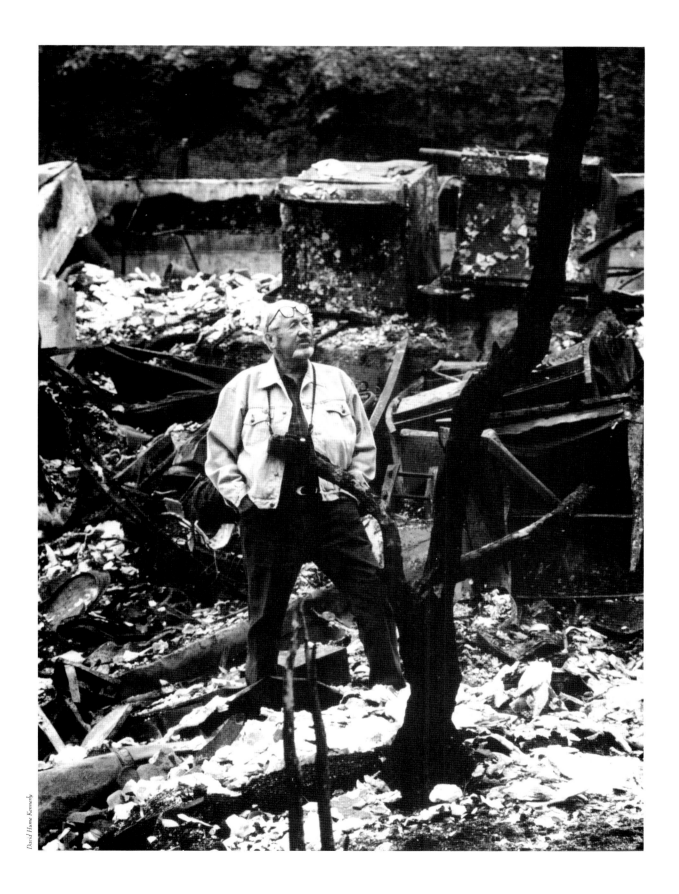

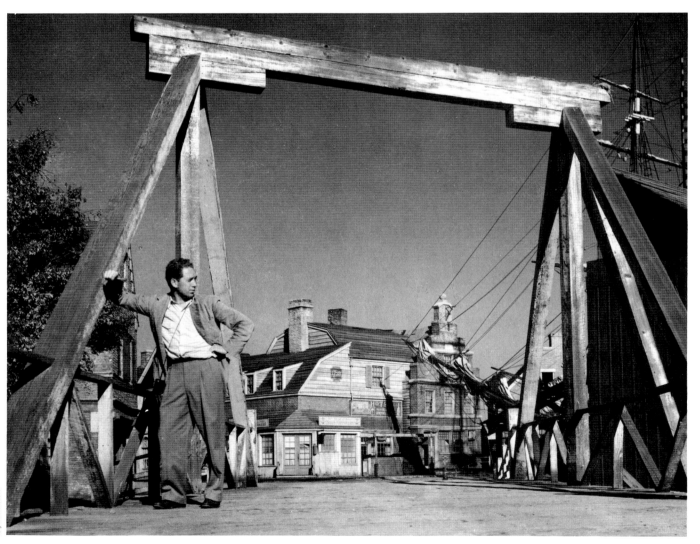

Ray Dannenbaum

LIFE IN HOLLYWOOD

1 9 3 6 – 1 9 5 2

In 1936, when *Time* magazine called and asked me to do some work on an experimental project, I was twenty-three, and hadn't developed any identifiable style. The publisher of a small paper had allowed me to hang around after school and on weekends as an apprentice with no pay, and I had spent two years photographing the building of San Francisco's great bridges, using my Leica to get shots of the bridge men on the job, hundreds of feet above the bay. *Time* and *Fortune* had used me as a freelancer to photograph prominent people in San Francisco for their files. For *Time*'s new project I was to create a few "stories in pictures," but I wasn't told what they were for. I sent them in anyway, and a little later *Time* asked me to go to Hollywood for a week. After that I was to go on to New York and stay there "until further notice."

In Hollywood, I met up with Joseph Thorndyke of *Time*, and in a week we put together a package of Hollywood photographs to present to the New York editors of the new *Magazine X*. Thorndyke and I visited several movie lots, dropping in on Shirley Temple and Darryl Zanuck at Twentieth Century-Fox. After an afternoon on the MGM set of *Romeo and Juliet*, with Leslie Howard and Norma Shearer, I was convinced that I wanted to return. I developed and printed all my film in a borrowed darkroom, and Joe Thorndyke and I headed for New York aboard a DC-3 sleeper. He was a very proper, Harvard-educated man, and tried patiently to answer my many questions about New York and the people I was going to meet. There wasn't much he could tell me about the mysterious new magazine, but he did have a copy of a promotional presentation that was titled *Rehearsal*, filled with color reproductions of subjects all over the world.

At the Chrysler Building, I took the elevator up to the Cloud Club. Through the arched windows, the view of lower Manhattan was overpowering, and I could hardly concentrate on the names of the men Thorndyke was introducing me to. I shook hands with Henry Luce, whom all referred to as "the founder," and John Shaw Billings, Roy Larson, Dan Longwell and John Martin, all from *Time*. After a long luncheon, Thorndyke finally gave his report on our trip, and then, as my

Left: Peter Stackpole, twenty-five, on the 20th Century-Fox back lot in 1938.

Below: Some members of the first "LIFE" staff: from left, Joseph Thorndyke, Jr., Editor John Shaw Billings, and Art Director Howard Richmond.

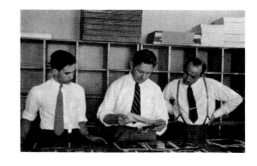

photographs were being passed around the table, it was my turn to talk about Hollywood. It went well until I was interrupted by John Martin, who asked me about "the Hollywood dames" with a gleam in his eye. Dan Longwell came to the rescue, welcoming me to the staff of the new magazine.

John Martin lasted only a week as the first editor of the as yet unnamed magazine. He was promptly replaced by John Shaw Billings—*Life*'s greatest editor, in my opinion. His instinctive ability to select the best photographs won him the respect of the entire staff. In those first Chrysler Building days I remember that we were so enthusiastic that some of us did our own lab work following an assignment. After shooting a regular feature like "*Life* Goes to a Party" I'd often return to the lab exhausted, print until dawn and sleep the rest of the day. I'd edit from what I could see on the negatives in the enlarger.

It took the press a long time to catch on to the new, unposed look in photography. On assignment in New York in the early days of *Life*, I remember the scorn the 4×5 guys would heap on me as I'd muscle my way to the front with my 35mm "pea shooter." But during World War II, *Life* had so many photographers covering the fighting and behind-the-scenes action that their coverage was pooled and made available to the newspapers, and 35mm photography was a practical necessity. I can't imagine anything worse than AP's Frankie Filan at the Tarawa landing, pinned down on the beach with his bulky 4×5 in hand.

Our job was sometimes difficult. You had to learn to respect the opinion of the managing editor, even though you might disagree. A few dedicated photographers couldn't live with the half-page format, which sometimes meant badly cropped pictures; a few others left for more serious reasons, like not wanting to photograph subjects they felt were irrelevant or against their political beliefs. Some wanted control over the pictures used and even the text, some wanted to do all their own printing, some expected bylines on everything. Photographers had to be available to go almost anywhere on short notice. And you sometimes found yourself confronted with risks that you were expected to take. I remember when *Life*'s great picture editor, Wilson Hicks, gathered a few staffers in his office one day. He hauled out a news-service photo that showed a guy partly behind a tree with a pistol still smoking and now aimed at the photographer. "Why can't you bring back pictures like this?" he said, with only a half-smile.

The assignments came quickly after the first issue, dated November 22,

Above: Earl Carroll, theater impresario, with a bevy of dancers in 1938.

Facing page: Leslie Howard on the MGM set for "Romeo and Juliet" in 1936.

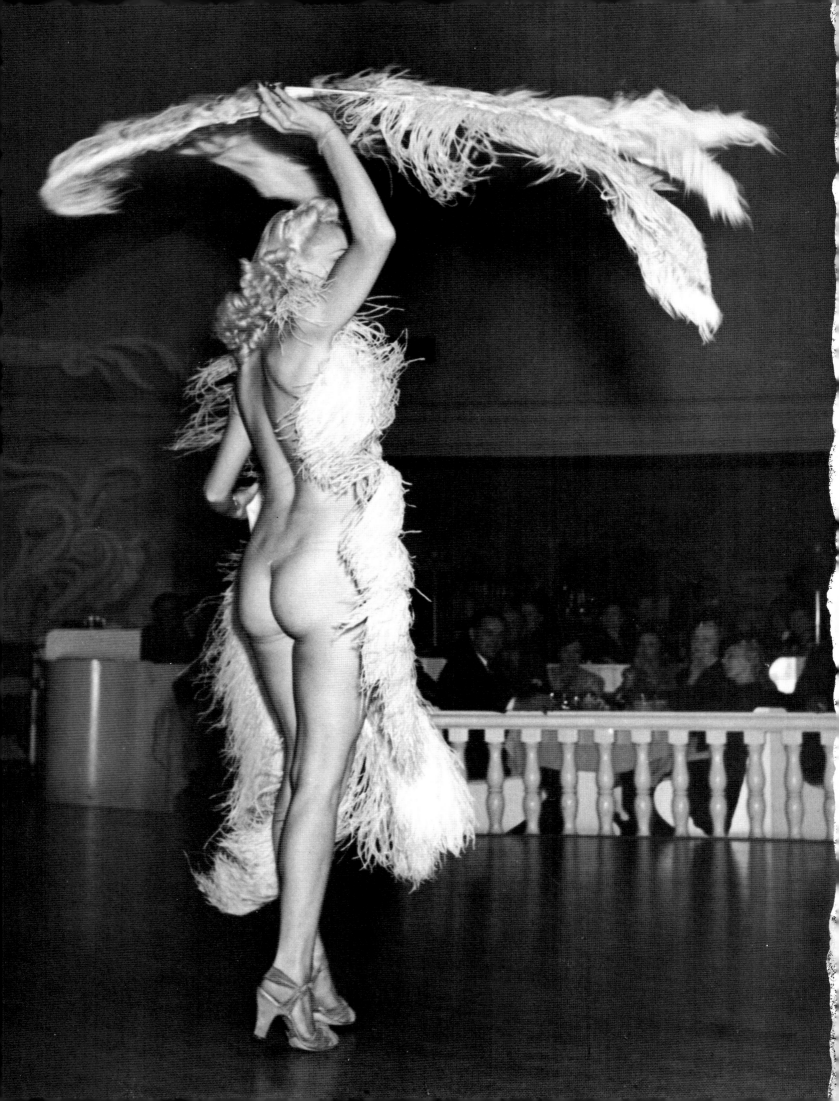

1936. I was photographing everything imaginable—nightclubs, plays, sports, celebrities, parties, even Gertrude Lawrence playing chess with her maid. My subjects tended to be women—my father's sculpture had emphasized the strength and ageless plasticity of the female form, and maybe an early awareness of these wonders prepared me for the way I'd use my camera later on. One job took me to Minsky's Burlesque, where it was hard to decide which stripper to focus on. Another assignment, "The School for Undressing," brought *Life* some trouble: one gorgeous blond was shown undressing provocatively in a series, and another girl showed how to undress unattractively. Editor Billings chuckled with delight as he laid out the sequence, and it ran the following week. Headlines like LIFE BANNED IN BOSTON followed immediately. The battle of the reader mail fol-

Facing page: A fan dancer at a Hollywood nightclub, 1937.

Below: A 1937 assignment took Stackpole to the Gilbert School of Undressing in Manhattan, where students modeled right and wrong techniques. "LIFE" was banned in Boston because of this series; elsewhere the issue sold out.

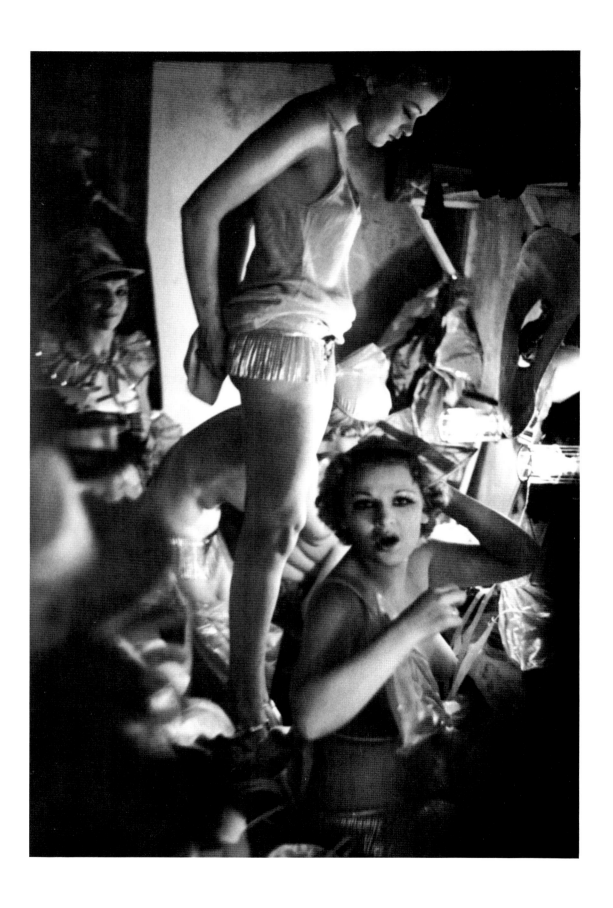

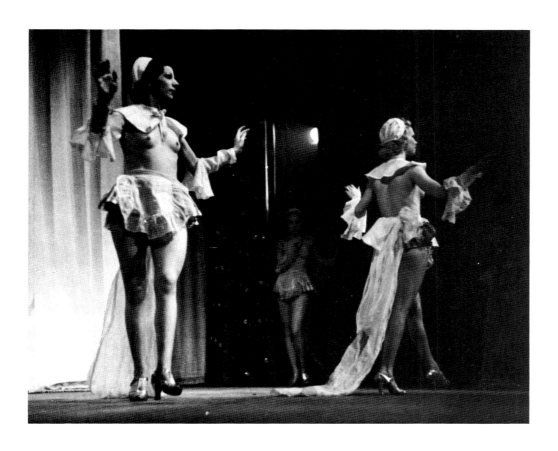

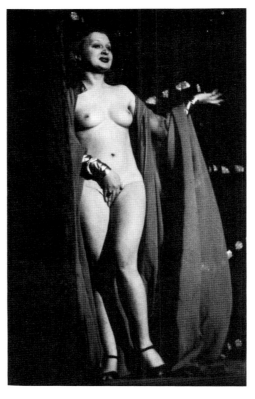

The Minsky brothers were famous for their New York burlesque houses, but this venue was padlocked by city authorities after only a week in 1937. Stackpole captured the dressing room (facing page), a Puritan sketch (top), a routine featuring Hitler and Göring (far left), and one of Ann Corio's stripteases (near left).

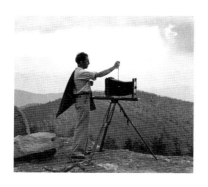

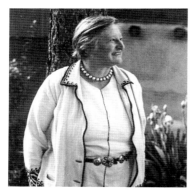

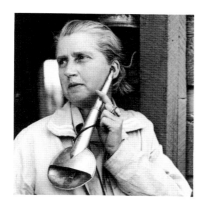

lowed—most approving, but others threatening to cancel their subscriptions. The editors didn't seem a bit worried, and the issue sold out at most newsstands.

Several months after the first issue of *Life* arrived on the stands, I hadn't yet had a cover, which bothered me. Then somebody noticed an item in a Walter Winchell column with the headline, "Prettiest Girl in Paradise," referring to a young, pretty chorus-line dancer named Hope Chandler at a Broadway night-club. I photographed her in her dressing room and then during the stage show; I even photographed her on the subway on her way home at three in the morning. She became my first cover, and when David Hearst, a young member of the news-paper family, saw her picture, he asked to meet her. Hope Chandler soon dropped her show-girl career and married him.

After ten months in Manhattan, the staff had grown by leaps and bounds and there was no doubt that *Life* was there to stay. During that first year I spent in New York, the prospect of working in Hollywood never left my mind. I worked hard and saved every penny I could so I could buy a convertible and head back West, to marry an artist named Hebe Daum and live in Hollywood. I accepted every "girl story" they'd give me. By year's end, a Los Angeles bureau was es-tablished in Beverly Hills. I turned my savings into a 1937 Buick roadster, and I was off to the West again, with an assignment to photograph the land and its people on the way. Willard Van Dyke traveled with me, carrying an 8×10 for large subjects. Willard dealt with the mountains and the plains, and I shot the people of the Smokies, the South, the Panhandle, and the Southwest, including Freda Lawrence and Lady Brett.

Our little office in Beverly Hills was upstairs from Will Rogers' newspaper, the *Beverly Hills Citizen*, and occupied by Alan Brown, Dick Pollard, Helen Mor-gan and fellow photographer Rex Hardy, Jr. The teletype machine kept us in touch with the New York office, making us feel vital despite our size. I used the *Citizen*'s darkroom downstairs. In 1940 we rented a larger office near the western end of Sunset Strip and built a better darkroom. Bob Landry from the *L.A. Her-ald*, a 35mm man who also handled a Rolleiflex well, was one of the new pho-tographers on staff; his Rita Hayworth and Jane Russell pin-ups became two of the most memorable ever featured in the magazine. When we weren't on assign-ment, Bob and I could usually be found across the street from the office at the Cock 'n Bull, sipping Moscow Mules and throwing darts.

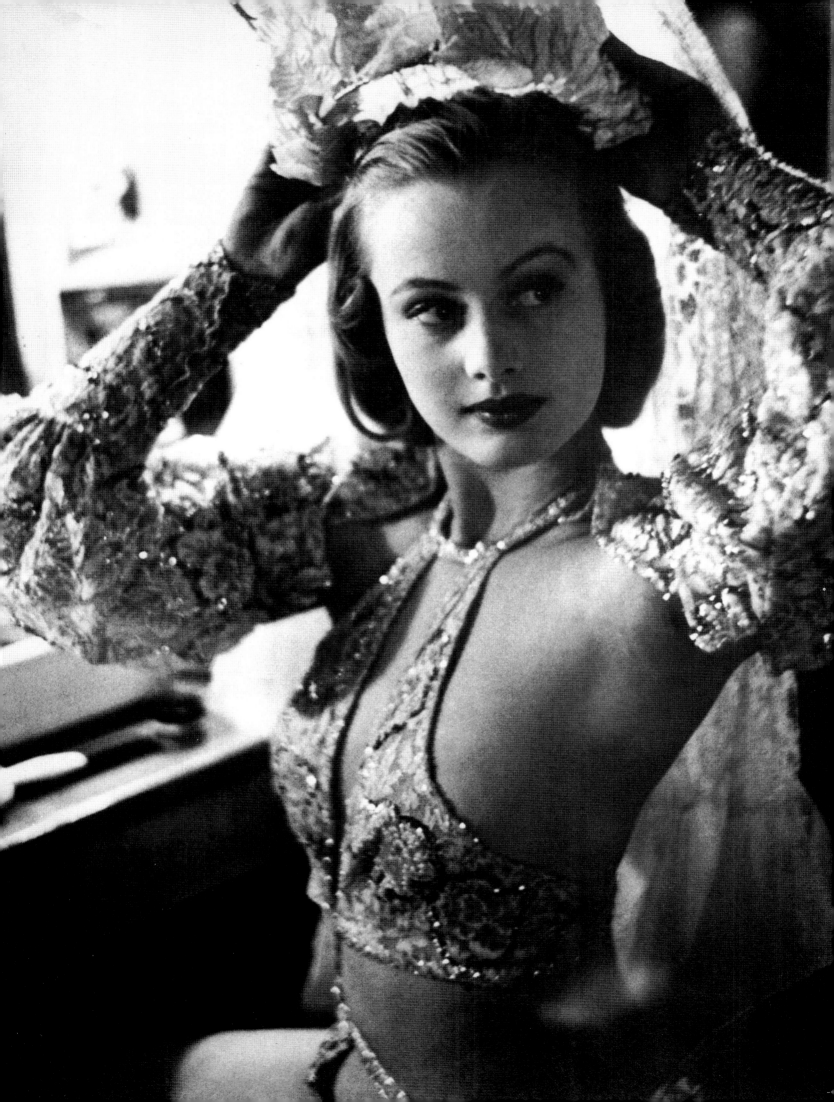

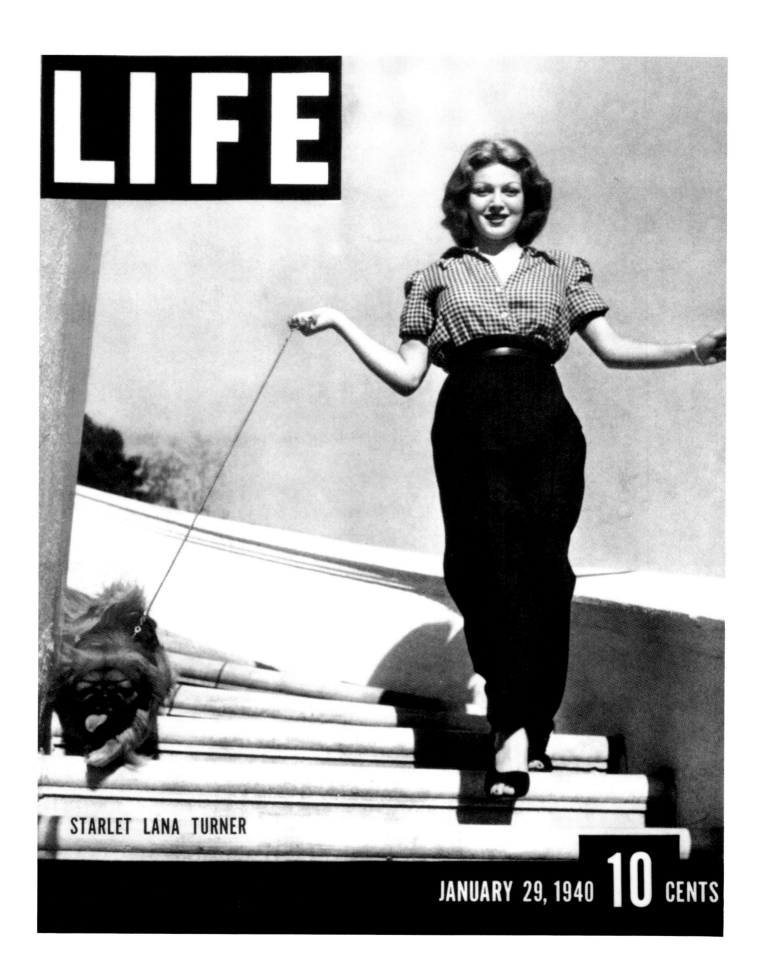

LIFE

STARLET LANA TURNER

JANUARY 29, 1940 **10** CENTS

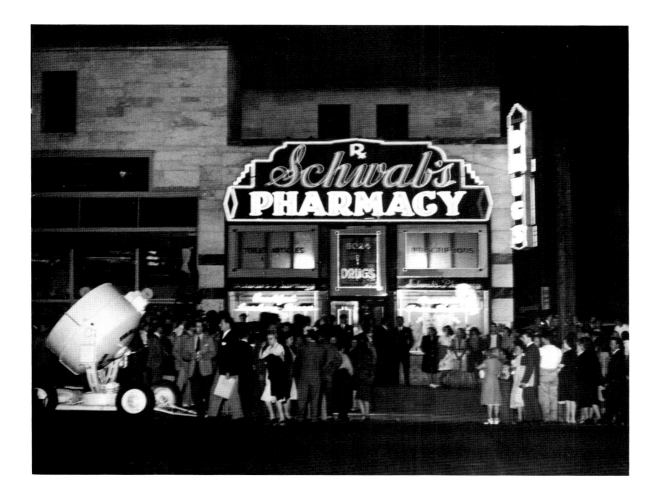

The place to live was near the beach in Santa Monica Canyon. I would drive Sunset Boulevard all the way to the office. Our first house was a small white hillside shack, but the second rental was a virtual mansion—three stories, surrounded by sycamore trees, on Mesa Road, where our neighbors included Edward and Brett Weston. This "white elephant" eventually proved too large for us, and Hebe found a Mexican-style house in Pacific Palisades. Nazimova had built the place in the twenties, and we bought it for $8,300—a fortune at the time.

Assignments were not always movie-oriented. There were parties, Silver Saddle parades and just about everything of a non-newsworthy nature that would enhance the lighter side of a growing magazine, including a photo I took of the world's largest pig. And the war brought grim but fascinating variety to the usual routine: I returned from a battleship tour of Pearl Harbor a month before the bombing, and assignments soon included rides on bombers, bond drives, the internment of Nisei truck farmers and rationing lines.

Facing page: Lana Turner, 1940.

Above: Schwab's Pharmacy gave a party for columnist Sidney Skolsky, who made the store his other office.

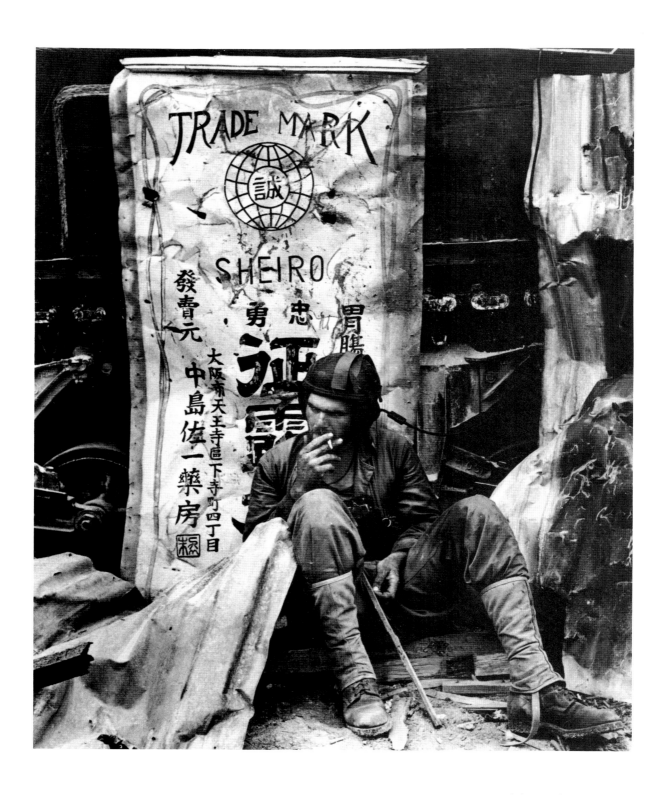

A tank driver smokes a cigar after camouflaging his vehicle with metal Japanese signs in 1944.

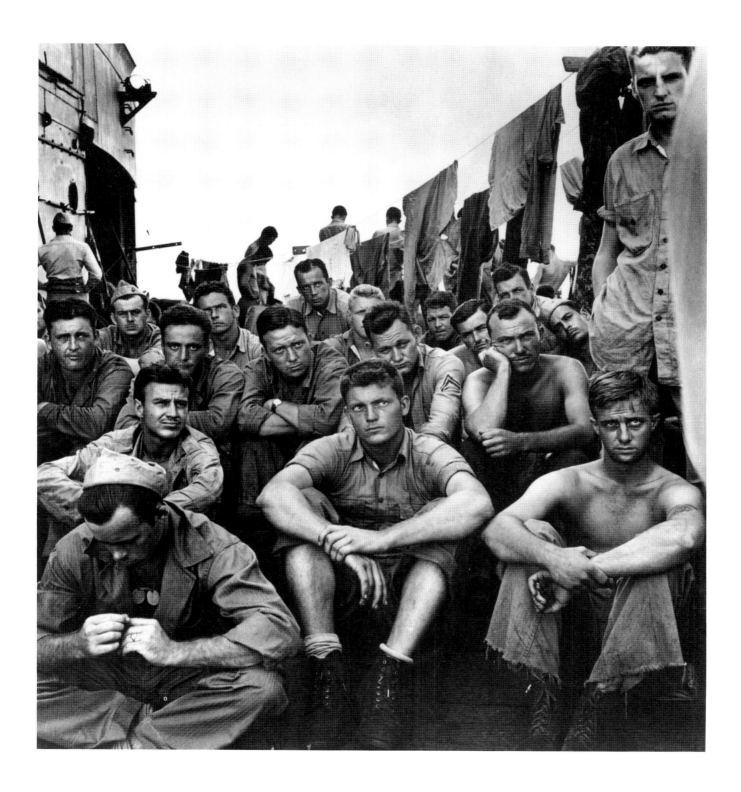

Stackpole titled this 1944 portrait
of the veterans of the Tarawa
landing "The Stare."

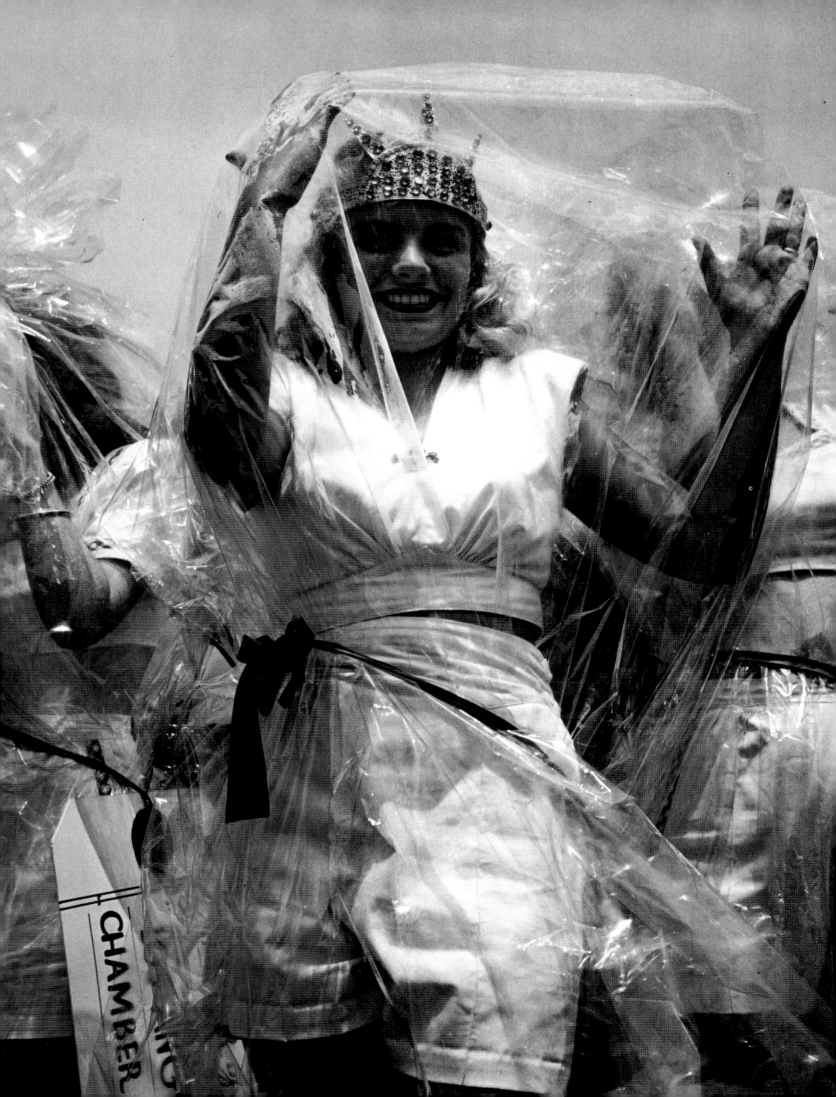

I often worried about the typecasting that photographing the more frivolous side of life was bringing me. Much of what I did had an obvious publicity-department aroma to it, like a party for a girl with five-inch fingernails or Florida poster girls arriving at the airport, wrapped in plastic with mailing tags. All studios made bevies of starlets available for fashion shoots, and in 1939 we used Rita Hayworth for a piece on tennis styles. The magazine didn't bother using her name in the captions, but made up for it later. If the subject matter began to get me down when I thought about the great photographers whose work would hang in museums and galleries, it was easy to get out on a weekend and photograph objects that had more meaning to me.

The studio beat introduced me to the big publicity factories. Nothing I'd encountered in New York prepared me for the VIP treatment I received. Call a studio, and the operator called you honey. Drop by, and lunch was free. Need to

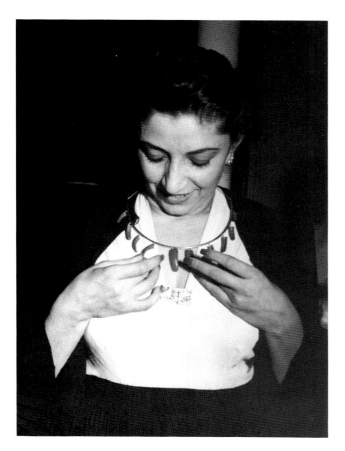

Facing page: Florida poster girls, wrapped in cellophane and wearing tags addressed to the L.A. Chamber of Commerce, arrive at the airport for a 1940 competition with their California counterparts.

This page: Juliette Marglen, proprietor of "The Fingernail Hospital," displays her wares and her technique at a Hollywood party in 1939.

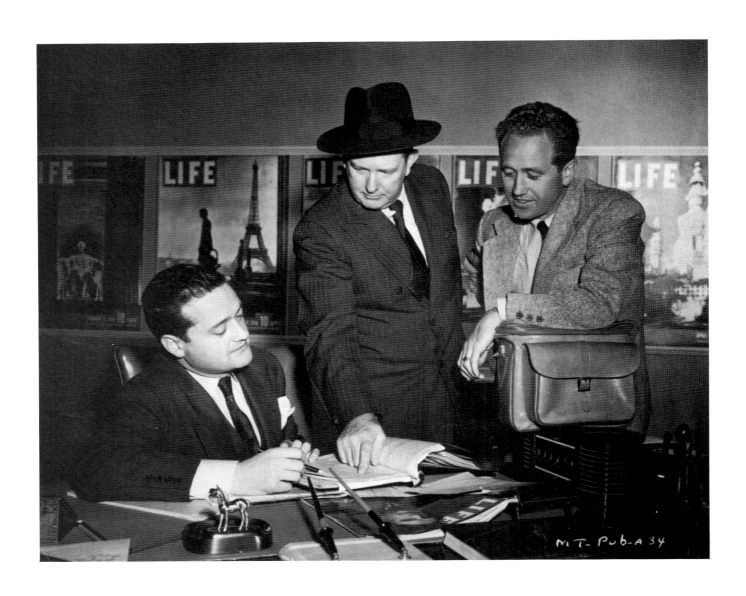

be somewhere, and they'd send a limousine. Express interest in a star and an appointment was made. Around Christmas, baskets of liquor, fruit, candy and wine arrived, again by limousine. The studios would send tickets to all the premieres and previews, some of which we covered for the sake of the Kleig-lighted spectacle.

Such was the power of *Life* in those days, but I remained a determined voyeur, not a fan. I detested the fan magazines; I was there to shoot real people. It wasn't always easy trying to get around the publicists or the publicity-oriented players, whose total experience with still photographers was to provide set poses—I never knew what Jane Withers really looked like because she opened her eyes wide for every shot. *Photoplay* photographer Hymie Fink specialized in "posed candids"; at nightclubs and premieres he'd yell out, "Cheat a little this way, honey." Any failure to cooperate got around quickly: once at a large premiere at Grauman's Chinese Theater a score of photographers raised their cameras when an important star arrived. She smiled and posed, but not one flash went off and not one camera clicked.

Driving to work on Sunset Boulevard one morning a car pulled up next to me while I waited at a stoplight. I looked over to see two girls staring at me intently. "Aren't you someone?" the driver asked.

"Certainly I'm somebody," I said. "Aren't you?"

—*Peter Stackpole, 1992*

LIFE IN HOLLYWOOD

1936 – 1952

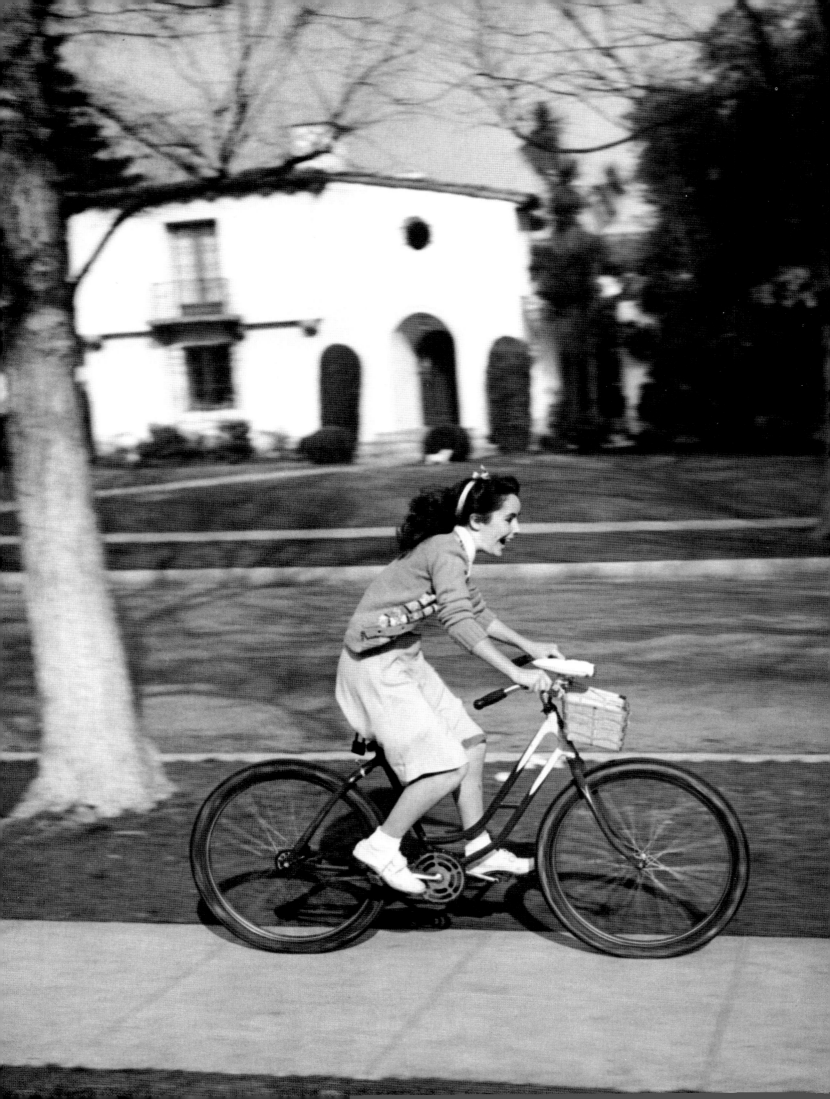

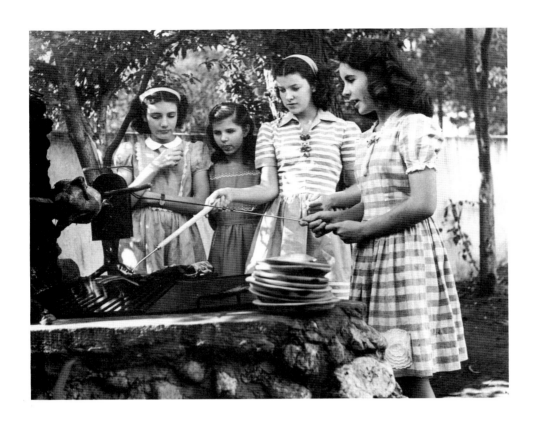

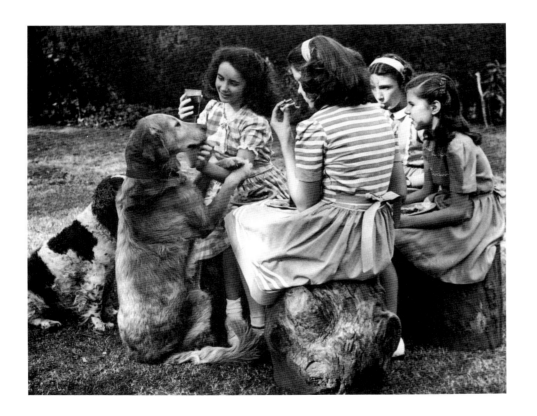

Elizabeth Taylor gives a backyard barbecue for friends (left): feeds treats to her springer spaniel and golden retriever; hugs Nibbles, one of her seven chipmunks (right); and pulls her boots off in a bedroom crammed with riding tack and mementoes.

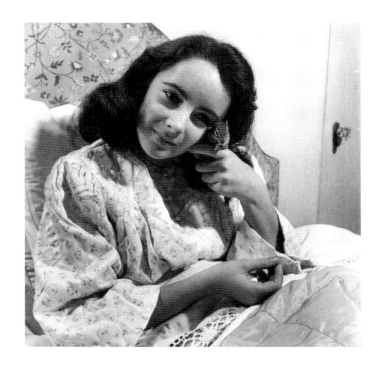

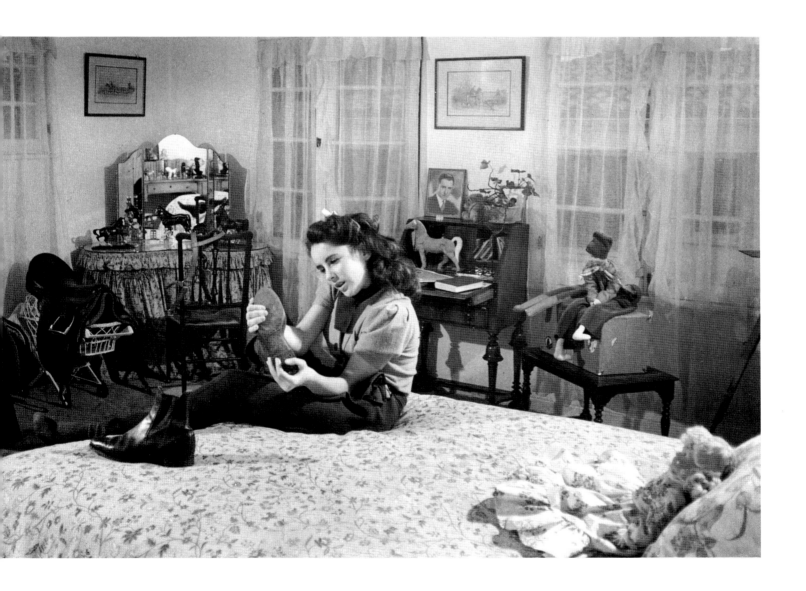

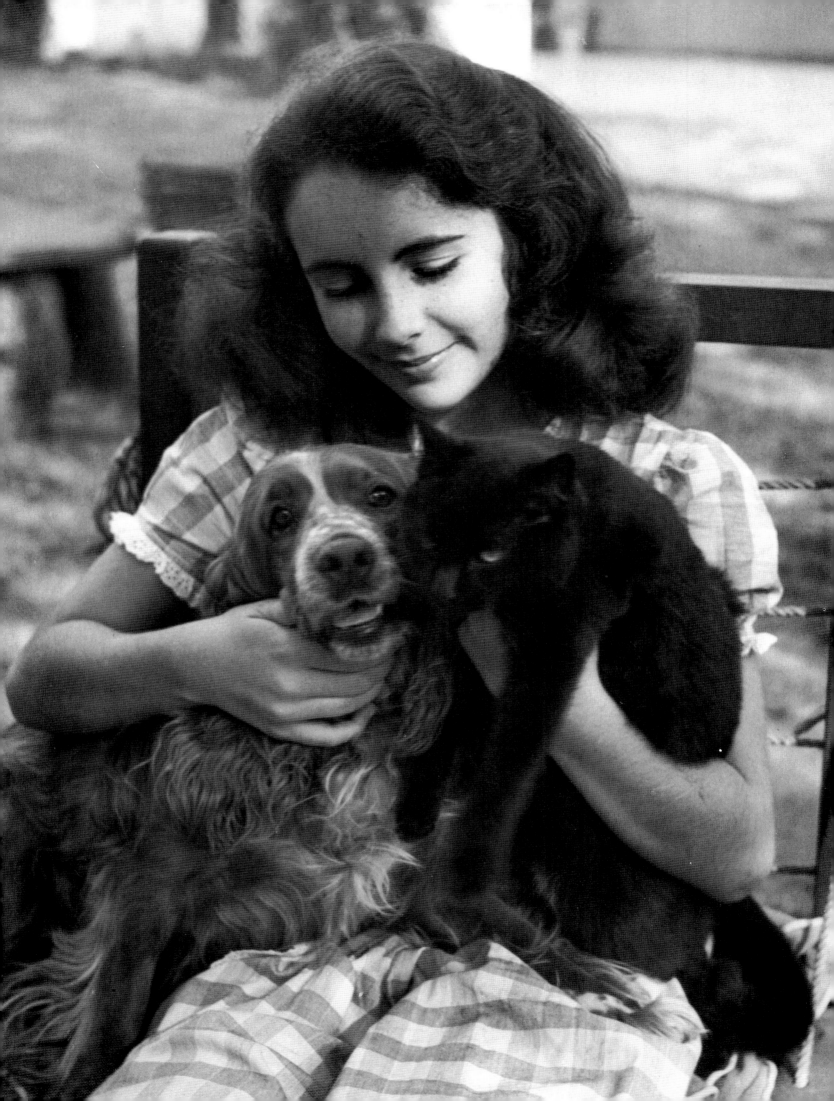

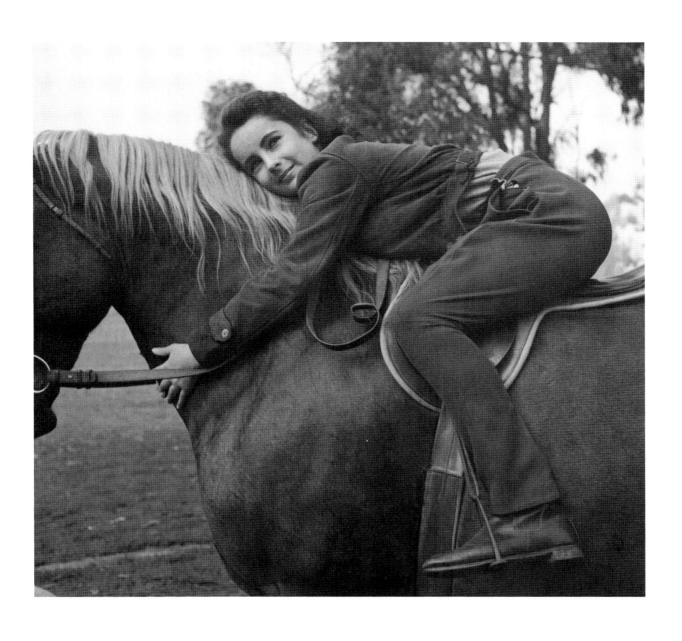

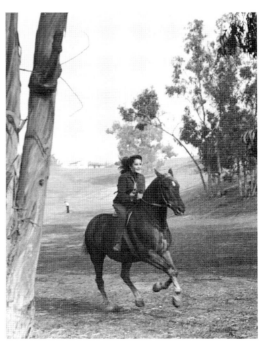

Elizabeth shows off her springer and her cat, Jill (left), and rides Peanuts, the thoroughbred she trained on for "National Velvet." She began riding at age three and a half.

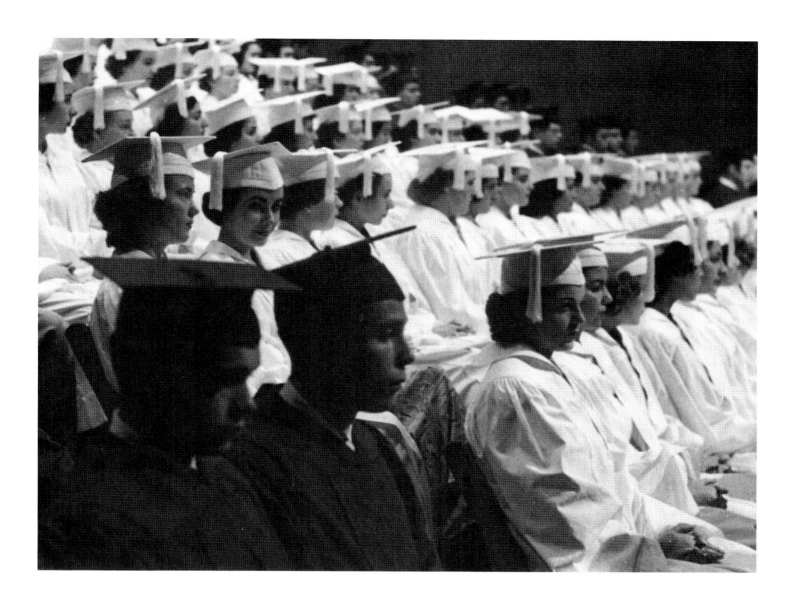

Elizabeth Taylor at her last day of classes on the MGM lot in 1950 (left), and during graduation at Hollywood's University High School, where she never actually attended a class.

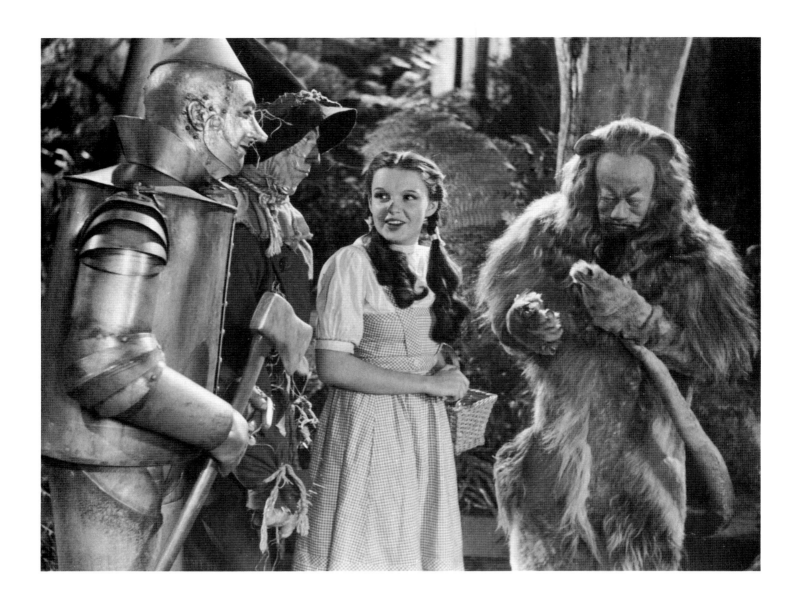

Above: Judy Garland in 1938 in the ''Wizard of Oz,'' flanked by Jack Haley as the Tin Man, Ray Bolger as the Scarecrow, and Bert Lahr as the Cowardly Lion.
Right: Garland arrives with date Mickey Rooney for the 1939 premiere of ''Babes in Arms.''

Facing page: W. C. Fields, 1941.

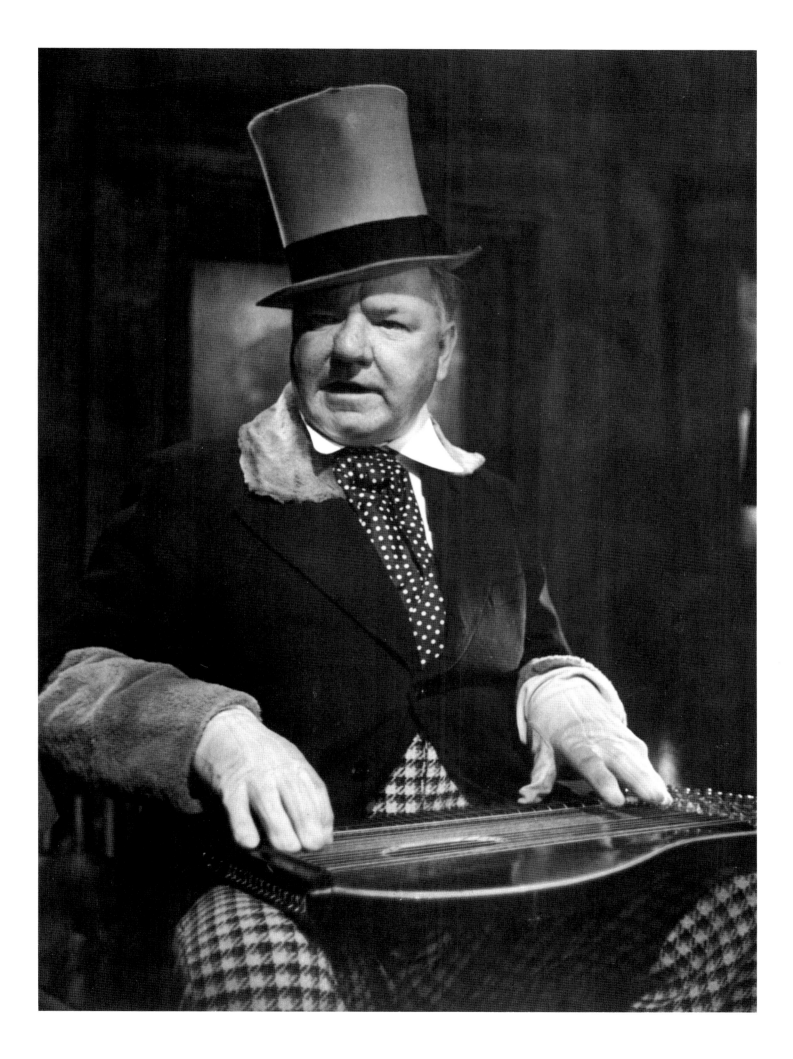

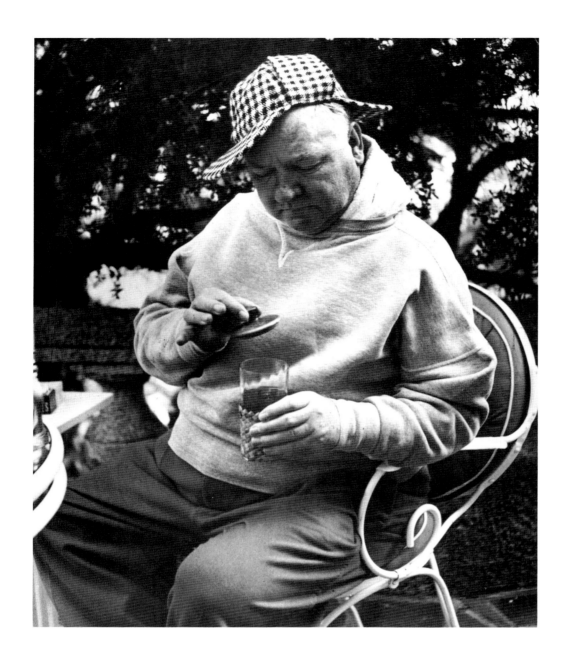

When bureau chief Dick Pollard, who wanted W. C. Fields to write an article titled ''Will Alcohol Replace Man's Best Friend, the Dog?,'' assigned me to photograph the actor in his home, I brought along Maria Montez to liven Fields up. He took to her with relish, chasing her around the garden pond, exercising in tandem, popping Ping-Pong balls out of his mouth for her benefit. When it was time for an afternoon grog in the shade, Fields used a lidded stein to keep bugs out of his rum and Coke. Certainly it was gag stuff, but how else could you work with Fields? —PS

During the 1941 photo shoot, W. C. Fields tries to keep bugs out of his drink (left), displays his muscles to trainer Bob Howard, spars, and shows off for Maria Montez (right).

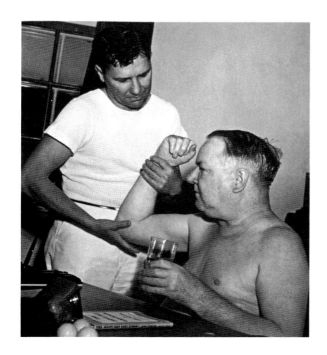

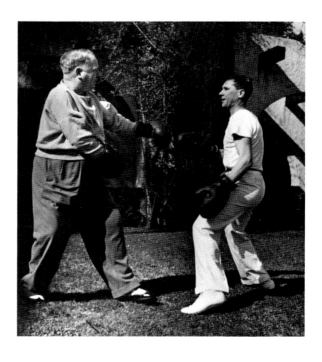

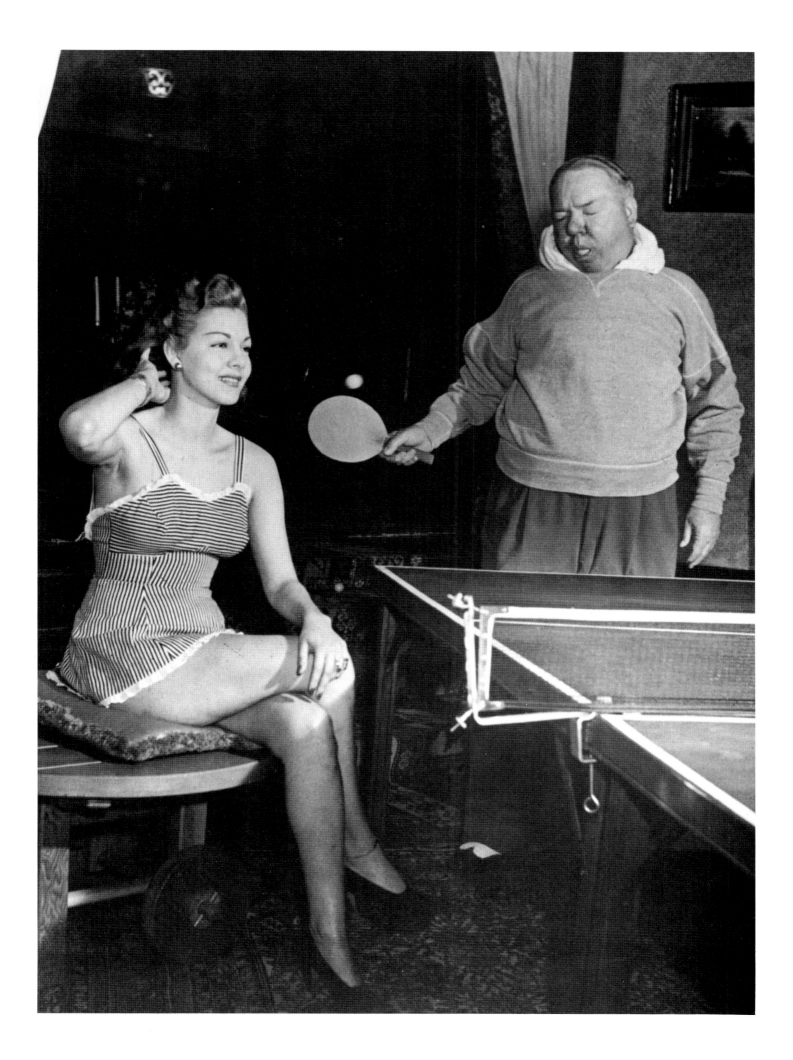

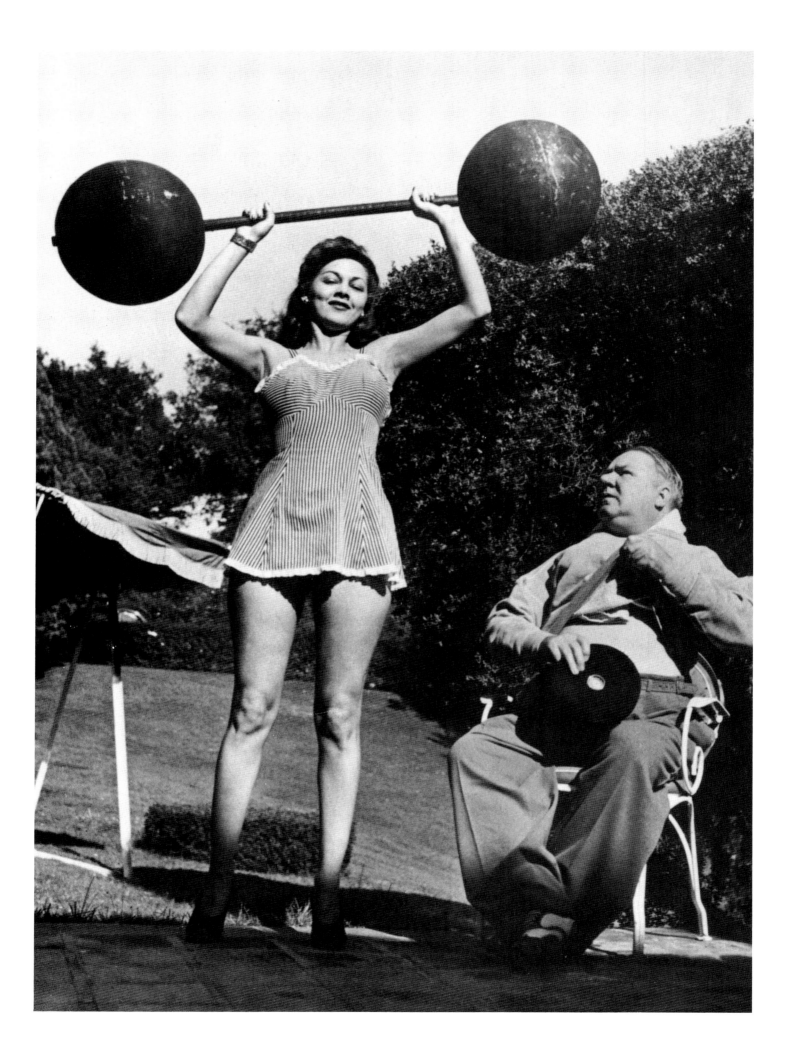

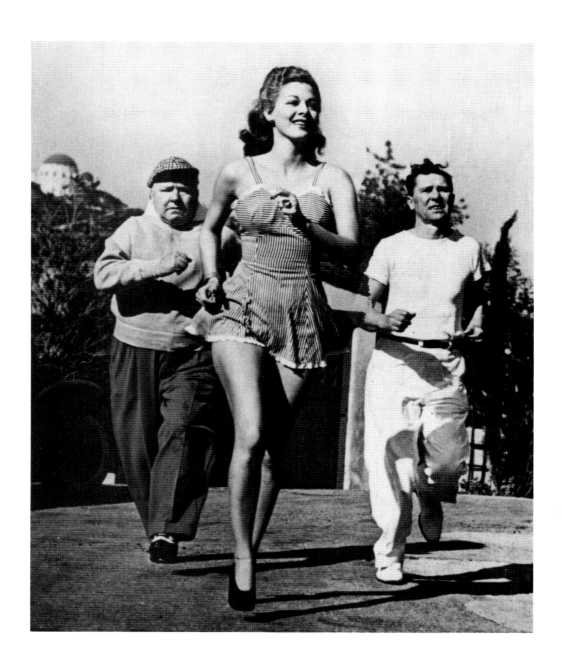

Fields admires Maria Montez's weight-lifting form (left) and strains to keep pace with her (right). Below, Fields and Bob Howard disagree about methods of weight loss.

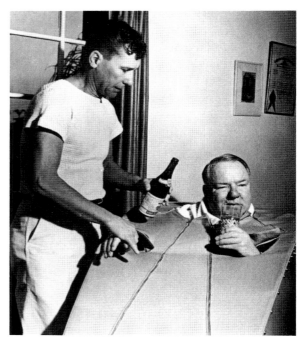

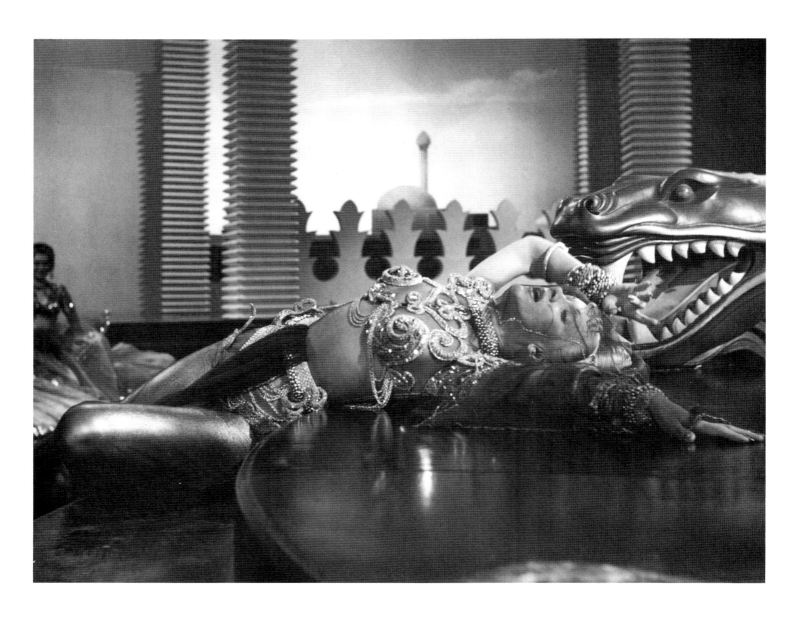

Above and facing page: Marlene Dietrich in "Kismet" (1943), as the "Queen of the Baghdad Dancers." Her legs were covered with four coats of golden paint, and her hair sprinkled with powdered gold. At right, Dietrich sings in Billy Wilder's "A Foreign Affair" (1948).

MGM's "Kismet" was meant to capture the last vestige of Marlene Dietrich's gilded image, and the stage and costumes matched this rather desperate intent. I'd been warned that she liked to control lighting but she made no special demands during our shoot. Later I heard that she was worried after seeing some rushes, complaining about the cinematography and comparing it poorly to the job the same cameraman had done in "Garden of Allah." "Ah, I think I know what the problem is," said the producer as he tried to comfort her. "The cameraman is now twenty years older." —PS

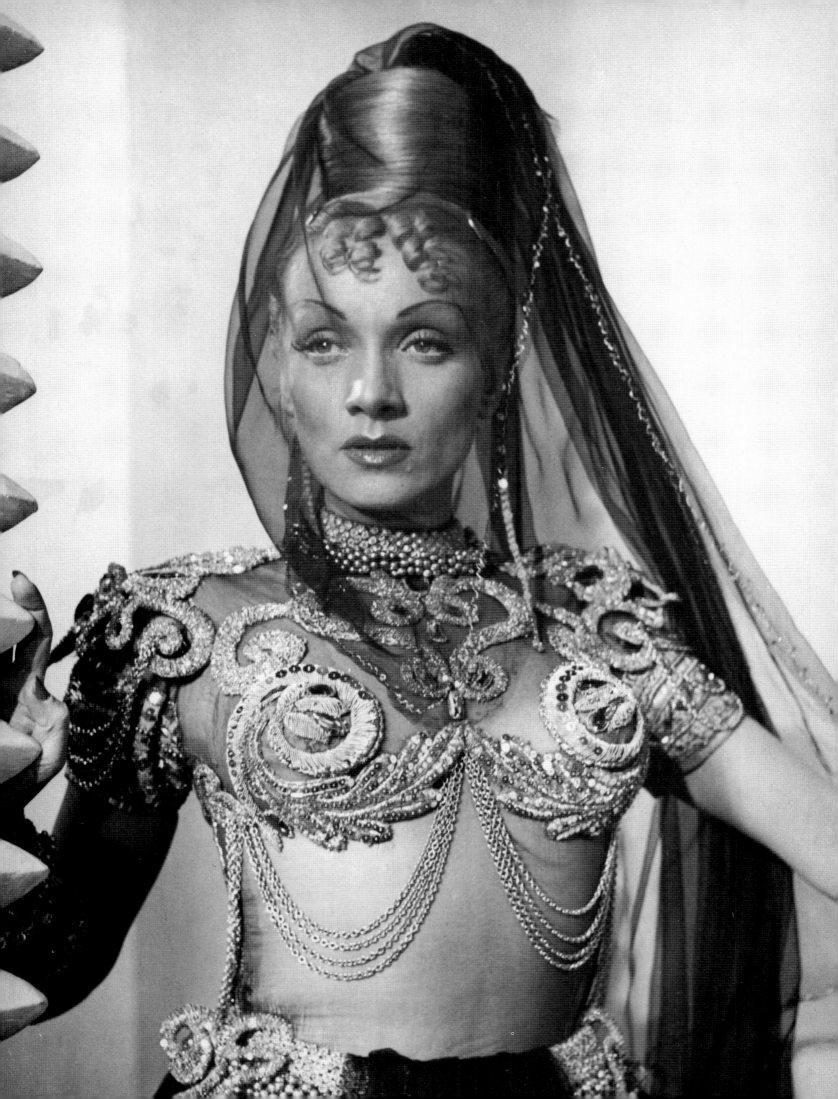

Los Angeles began as a ranching
center, raising beef for gold miners
in the surrounding hills; in 1892
the first oil well was drilled and
within a decade there were 1400
wells within the city limits. The
population tripled from 100,000 to
300,000 in the wake of San
Francisco's 1906 earthquake, and
the completion of the L.A.
aqueduct in 1913—fictionalized in
"Chinatown"—marked the
beginning of another boom.

*Right: The 20th Century-Fox
back lot, with Beverly Hills
in the distance.*

Below: Discarded props.

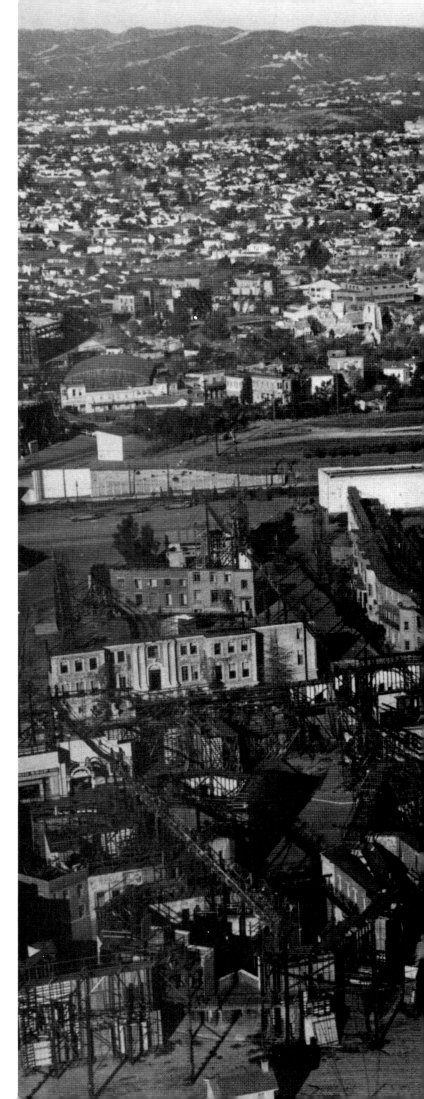

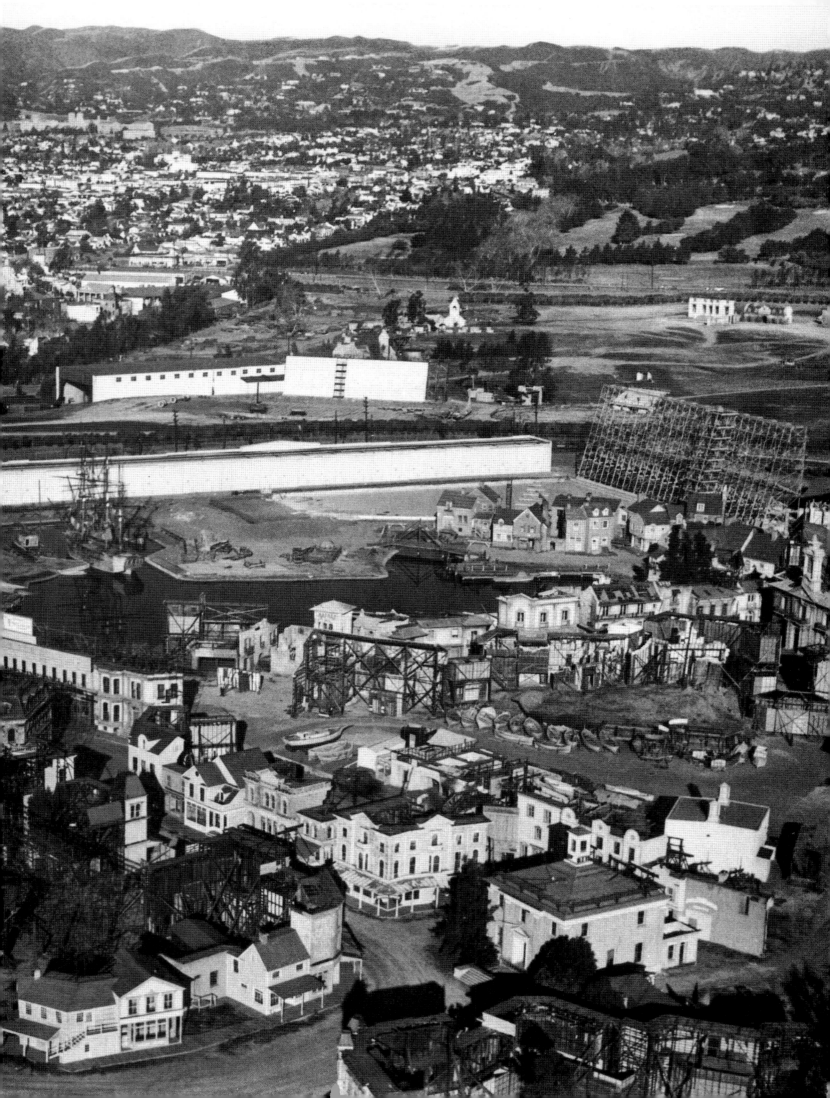

Hollywood began life as a subdivision in 1887, laid out by a Prohibitionist who imagined a community based on sobriety and religion; by 1910 the young film industry had settled in and soon after Bertrand Russell wrote that "Los Angeles represents the ultimate segregation of the unfit." Such language failed to discourage a wave of Depression immigrants and would-be actors and actresses; casting calls were routinely swamped and premieres were often mob scenes.

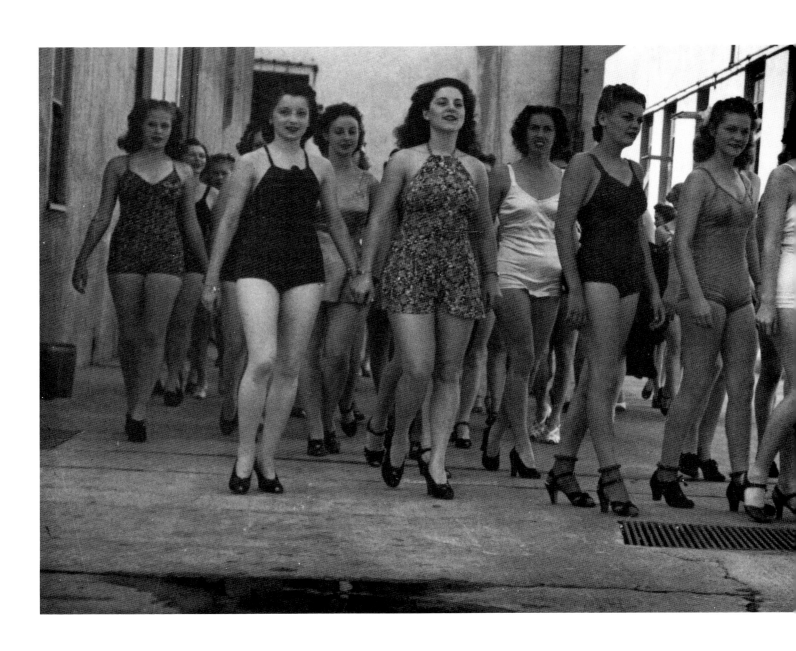

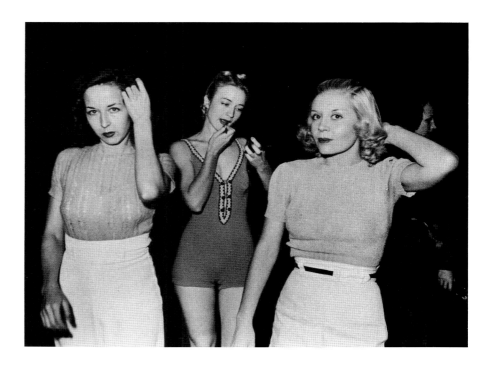

Right: Three women adjust their hair and make-up before an audition.

Below: An Earl Carroll cattle call, 1938.

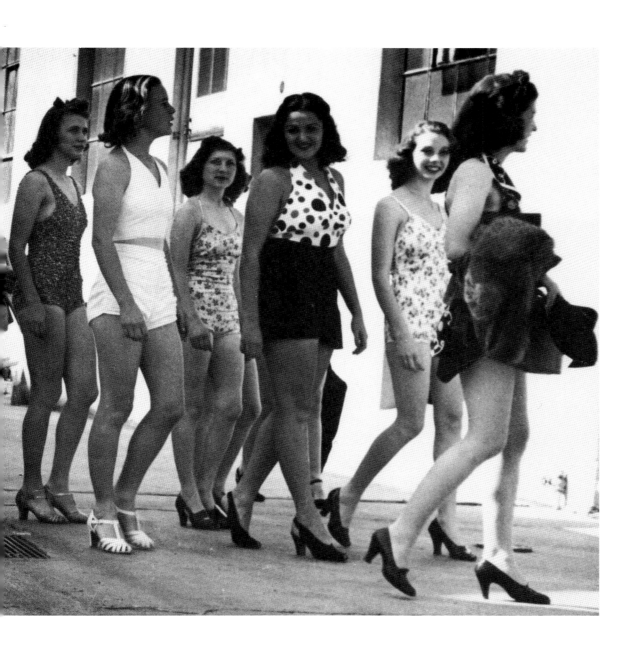

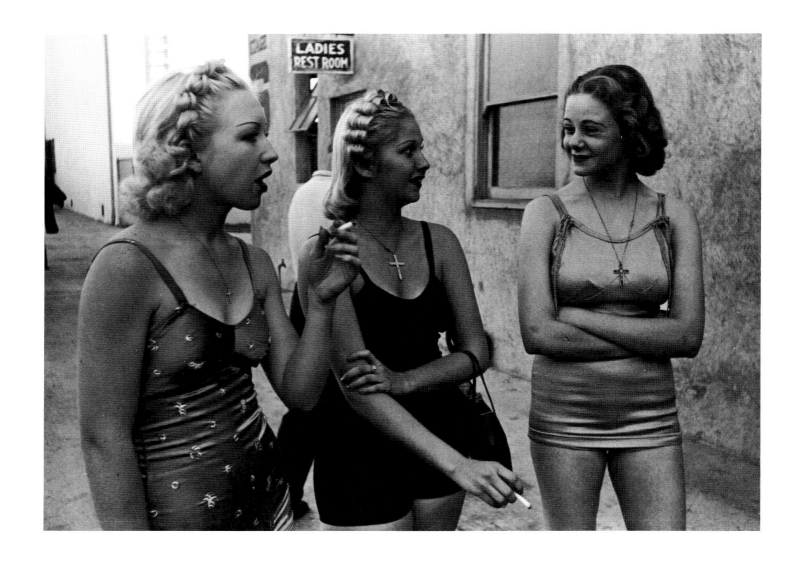

Back lot Hollywood: Unidentified
women wait to audition on the
20th Century-Fox lot in 1938
(above). Crosses served to identify
"good girls." The hopefuls on the
upper right are also unidentified.

Bottom right: Florence Enright
coaches would-be starlets at
the Fox Drama School.

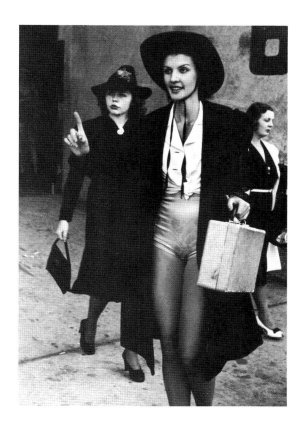

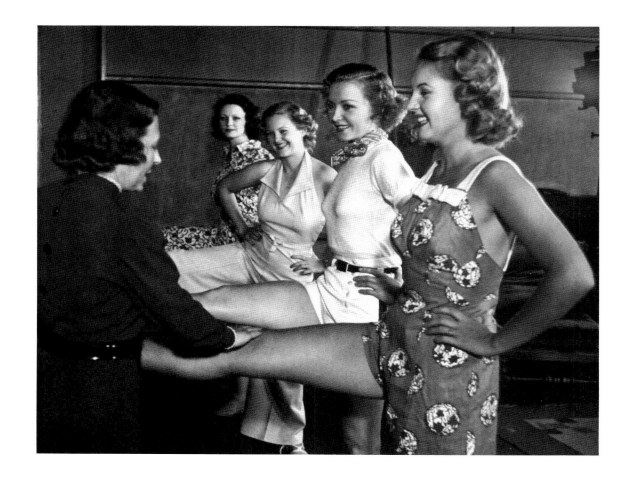

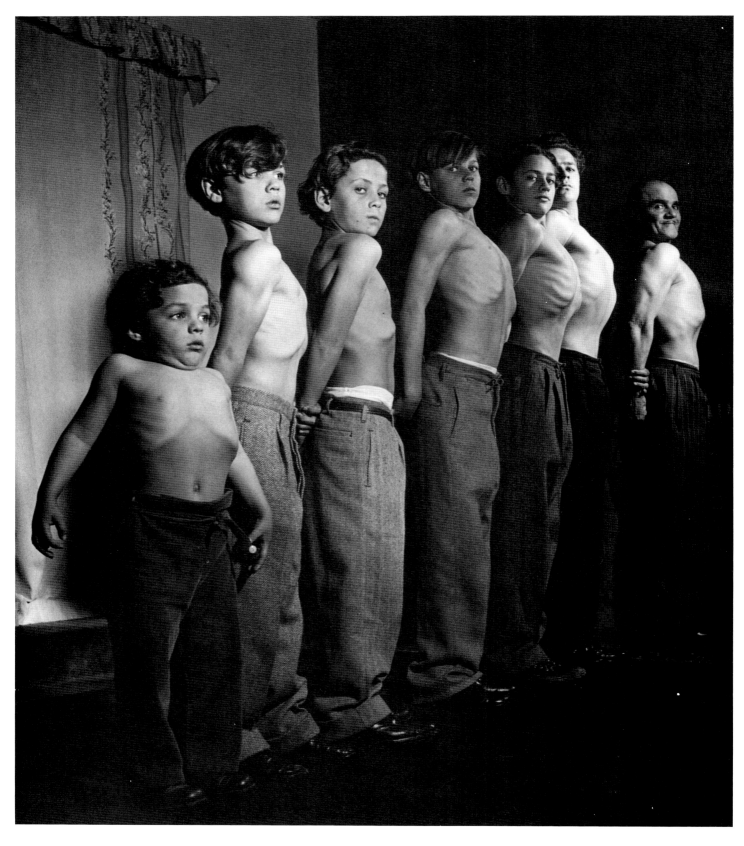

Clifford Brill Severn, actor and osteopath, was proud of the fact that under his guidance, his wife, two daughters, and six boys had appeared in ninety-six feature films, and he was happy to display the family form to Stackpole in 1947.

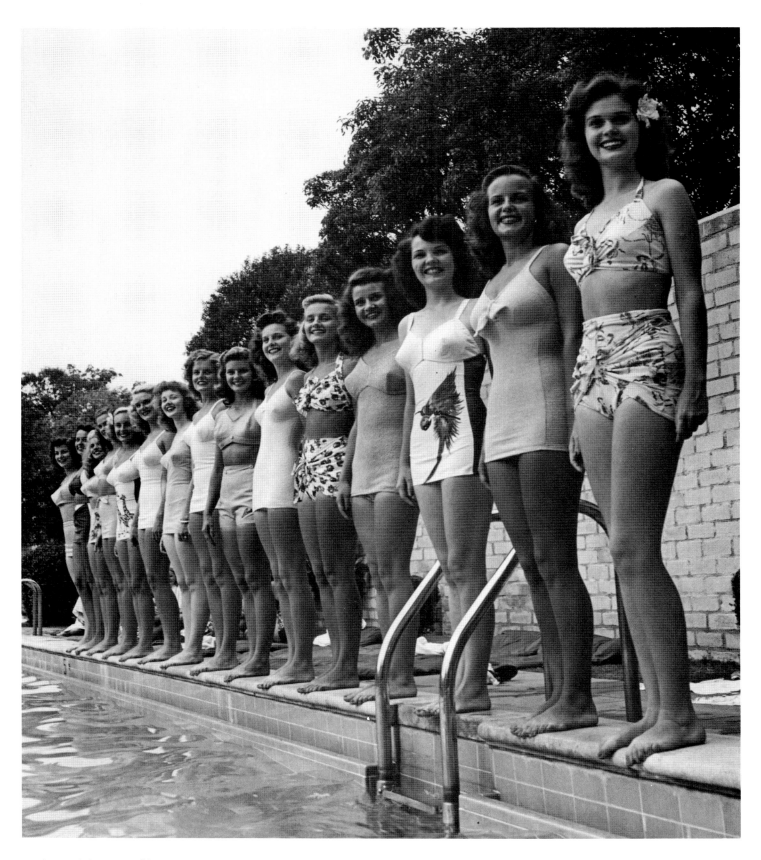

A line-up of alternating California and Florida poster girls, together for a Chamber of Commerce competition in 1940.

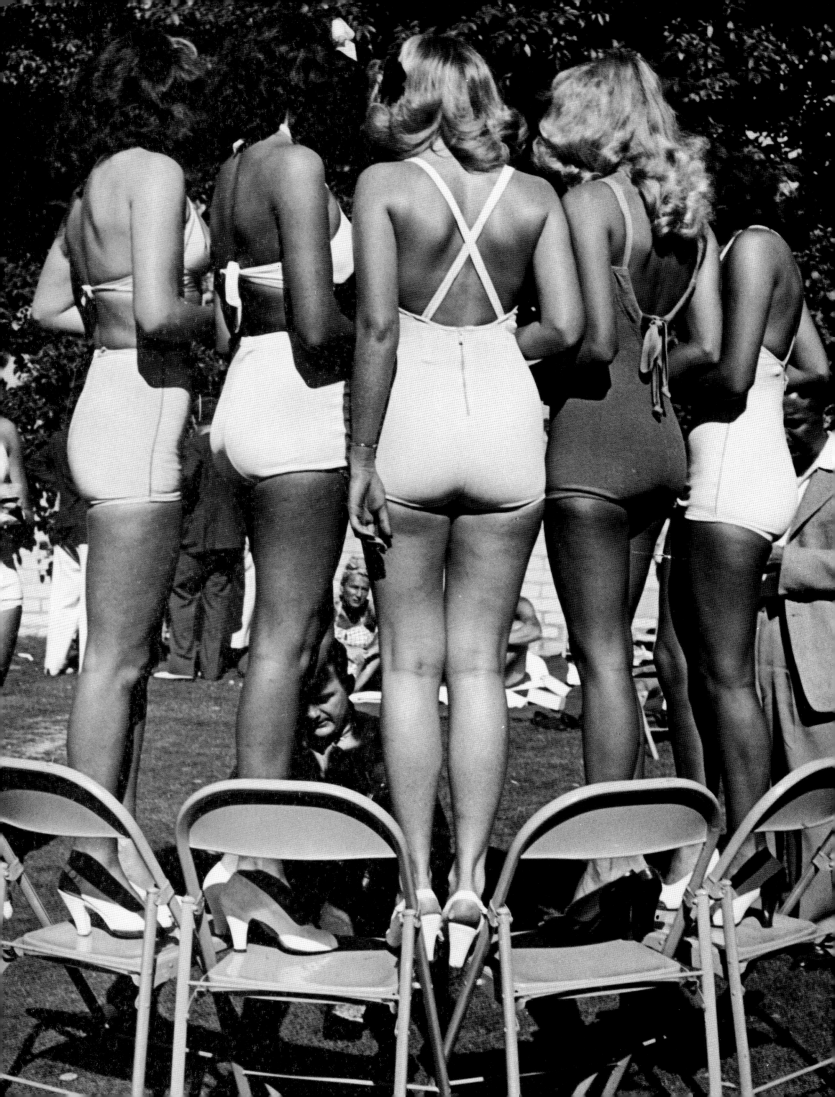

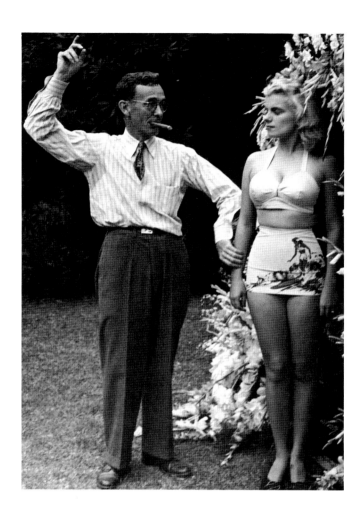

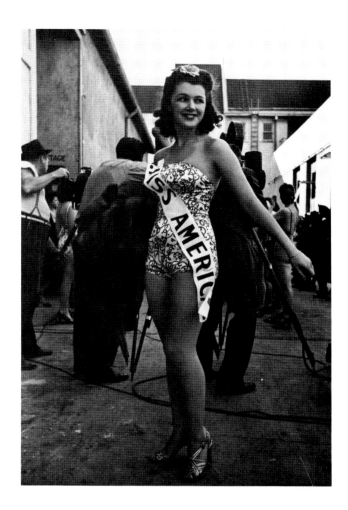

The poster girl competition was dreamed up by a St. Petersburg businessman, who sent his protégées to Los Angeles wrapped in cellophane, bearing tags addressed to the L.A. Chamber of Commerce. A tie was proclaimed, though "LIFE" opined that the California girls (left) tended to be leggier.

Upper right: Claire James, a Miss America runner-up, poses for the newsreels before the opening of the Earl Carroll Theater in 1938.

Lower right: Follies dancers picket near Sam Goldwyn's plane, 1941.

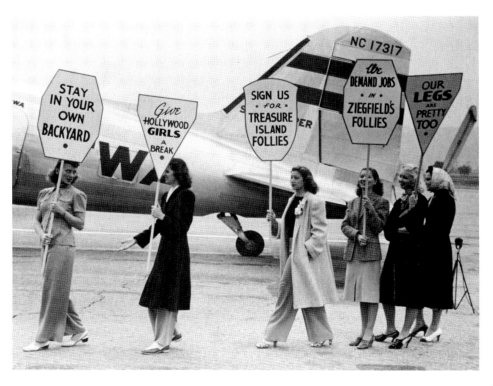

Below: Starlets "kick legs to limber backs" at the Fox Drama School, 1937. Every student had a screen test, and Darryl Zanuck viewed all of them. Right: A Fox student faces a sunlamp.

Facing page: RKO choreographer Charlie O'Curran rehearses "limited talent" dancers for "If You Knew Susie," 1947.

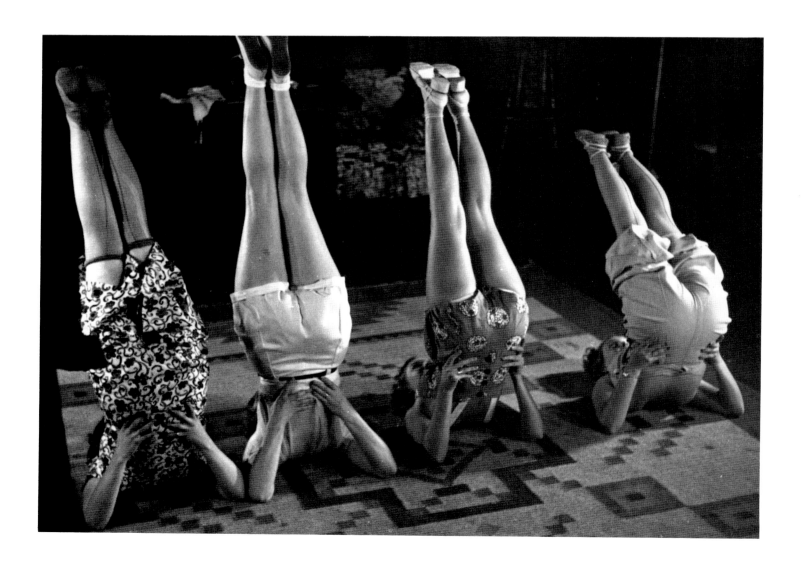

Above: Charlie O'Curran takes a
dancer through her paces.

Facing page: A bored extra on the
Paramount set; extras answer a
Fox call for Russian housewives;
munchkins on the MGM
back lot during the filming of
"The Wizard of Oz," 1938.

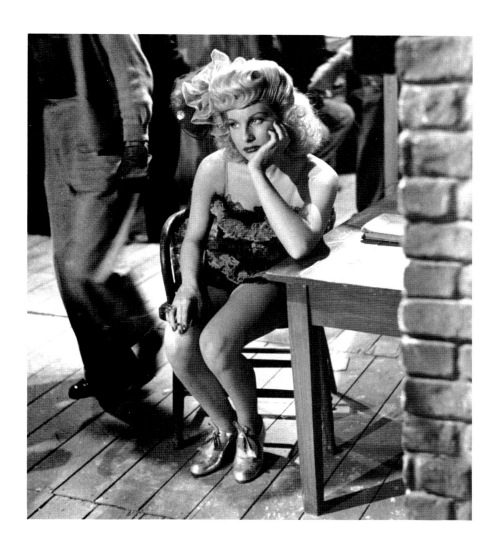

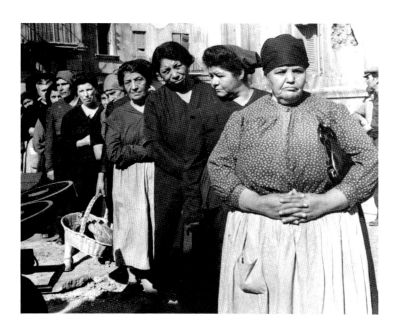

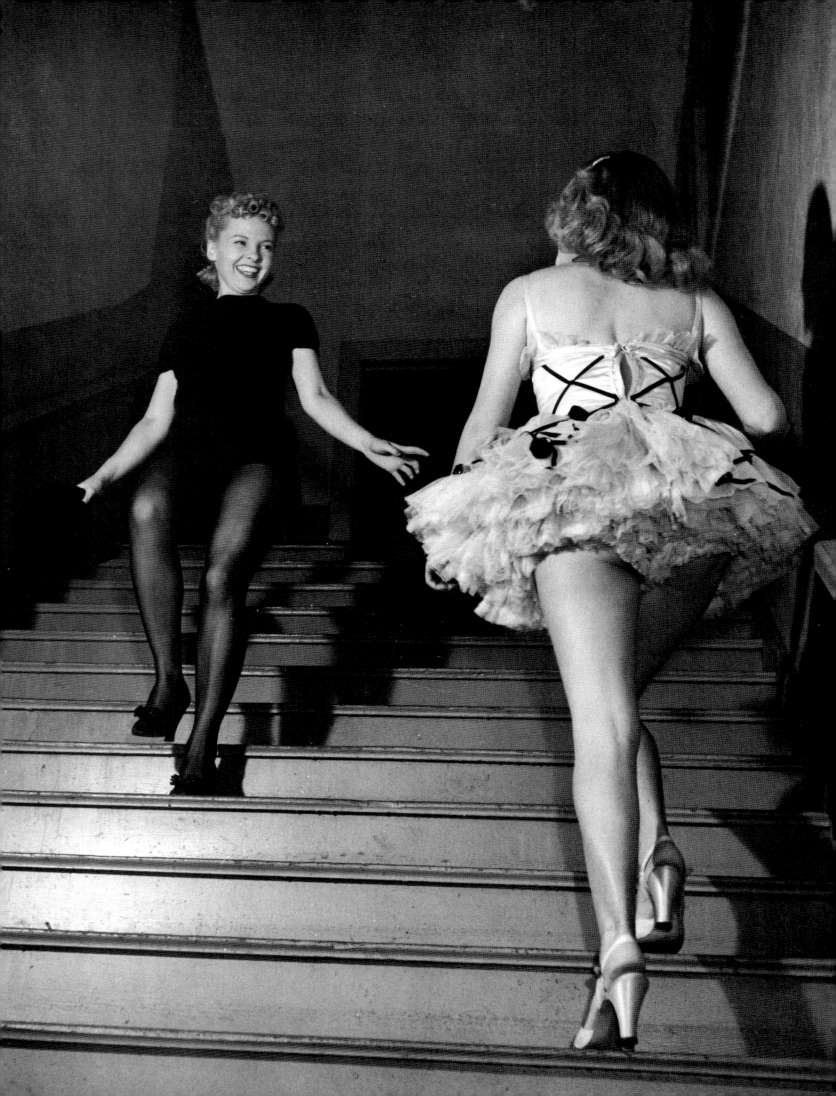

Facing page: Eleanor Counts (left) and Virginia Gilmore on the steps of the publicity department of Goldwyn Studios, and (right) in the office of publicity head Johnny Miles. Gilmore won a 1939 best legs in Hollywood contest; runners-up were Ann Sheridan, Linda Darnell, and Marlene Dietrich. Counts was challenging her victory.

Below: Goldwyn Girls, who reportedly averaged 5'5½" and 118 pounds, were often used for publicity events (1944).

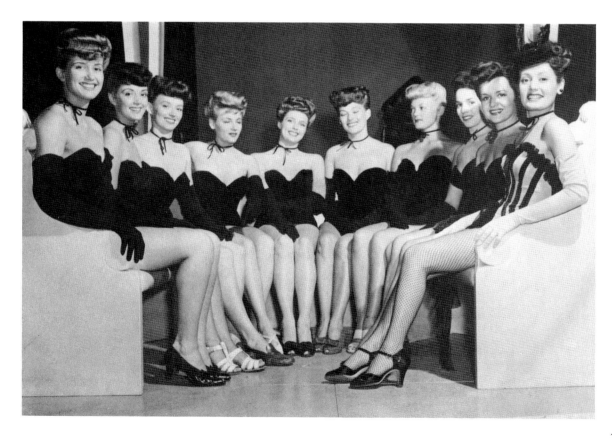

There were women coming up in the movies like Betty Grable, Lana Turner, Veronica Lake and Anne Miller who you could shoot in fairly provocative pin-up poses. Carole Landis was one of them, and though her acting ability was a mystery, she had no hang-ups about showing her attributes. "LIFE" wanted something new, so the studio pooled C gasoline rations, and Carole, her fan-club president and I headed up the coast, traveling at ninety miles per hour in a white convertible and undoubtedly standing out among the trucks and personnel carriers. When my photographs ran,

Carole's studio was so pleased that they asked our office head if he would like to have a date with her. He politely refused, but he said he would like to have a red Boy Scout knife. Three years later, with her career flagging and after an unhappy love affair with Rex Harrison, Carole Landis took an overdose of sleeping pills. —PS

Above: Carole Landis in a pin-up shot, 1939. Stackpole had Landis and fan-club president Peggy McKenna pose in their car and roll down a sand dune near Carmel in 1941. Upper right: Stackpole, Landis, and McKenna.

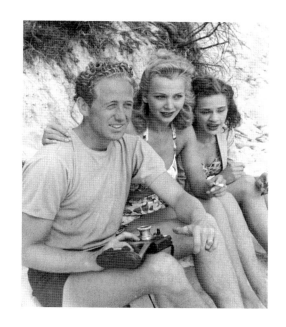

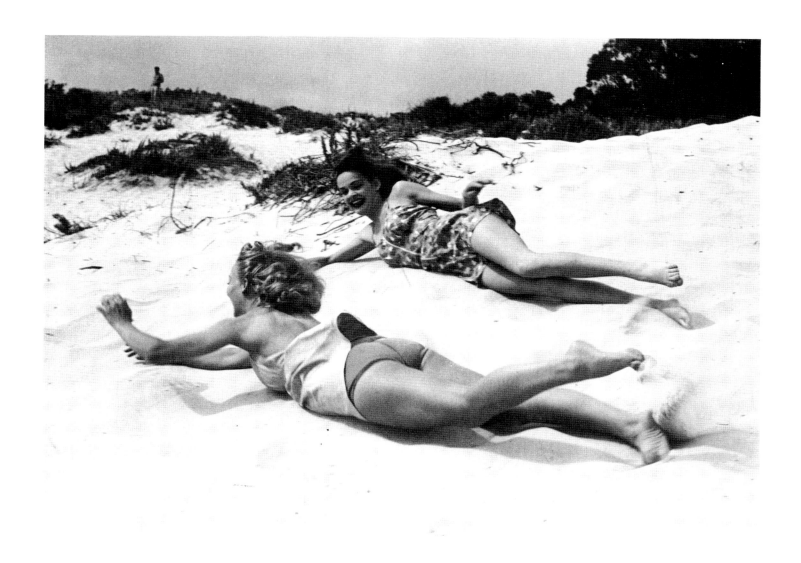

Clockwise, from left: Frank Capra, director of "It Happened One Night," "Mr. Smith Goes to Washington," and "It's a Wonderful Life," in 1936; George Stevens, director of "Woman of the Year," "A Place in the Sun," and "Giant"; Sam Wood, director of "For Whom the Bell Tolls," "A Night at the Opera," and "Goodbye Mr. Chips."

Facing page, right: Mervyn LeRoy, producer of "The Wizard of Oz" and director of "Little Caesar," "Blossoms in the Dust," and "Gypsy."

Above: In 1944, "LIFE" called
Charles Brackett (left) and Billy
Wilder (right) "The Happiest
Couple in Hollywood"; their
partnership, with Brackett as writer
and producer, and Wilder as writer
and director, resulted in such films
as "Ninotchka," "The Lost
Weekend," and "Sunset
Boulevard." When they parted
ways in 1950, Brackett, a
graduate of Harvard Law, went on
to head the Academy of Motion
Picture Arts and Sciences, while
Wilder, an Austrian immigrant,
directed "Witness for the
Prosecution," "Some Like It
Hot," and "The Apartment."

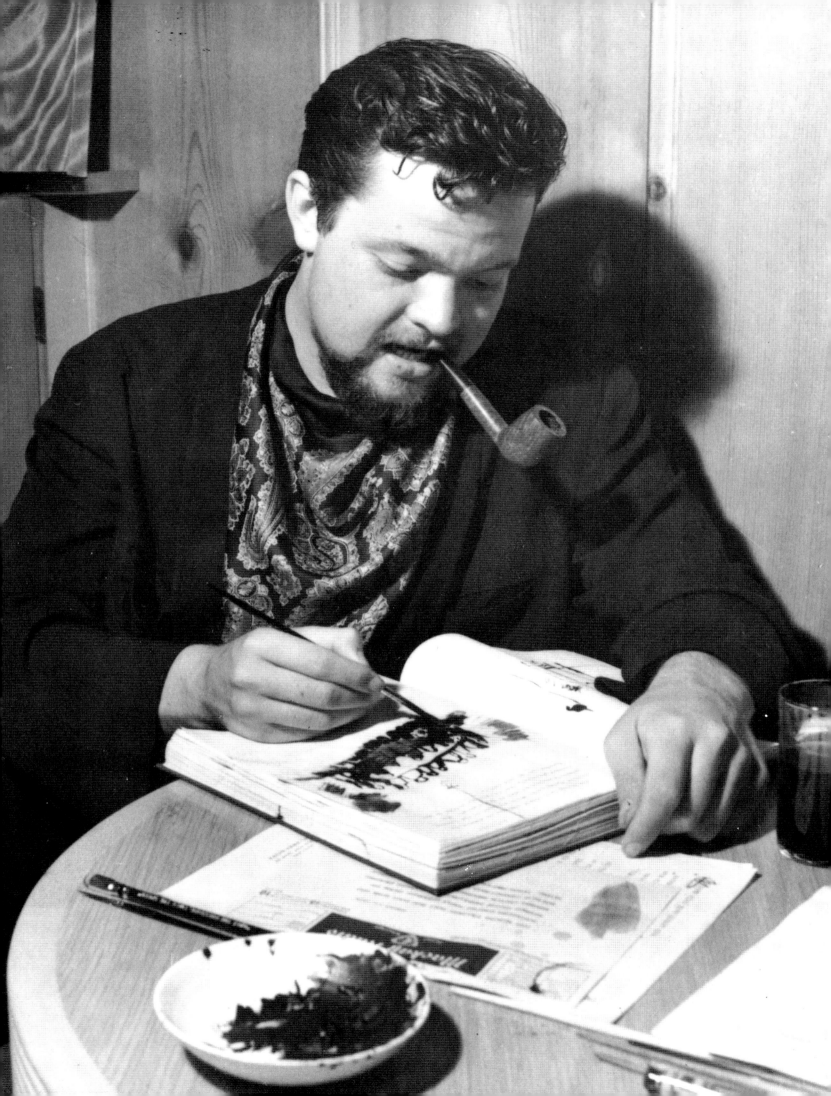

Facing page: Orson Welles, director of "Citizen Kane" and "The Magnificent Ambersons," with watercolors.

Above, left: Gregory Ratoff directed "Intermezzo" and "The Corsican Brothers," and acted in "The Sun Also Rises" and "All About Eve."

Above, right: John Ford, director of "The Grapes of Wrath" and "How Green Was My Valley," during the filming of "Stagecoach" in 1939.

Right: Walt Disney with a secretary during the making of "Snow White" in 1937.

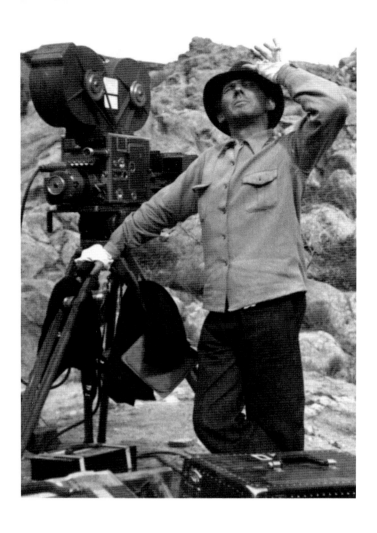

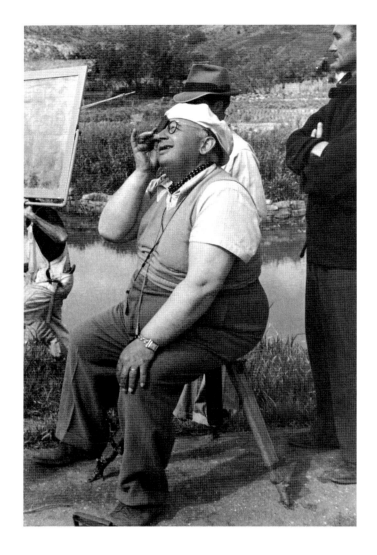

Above, left: Zoltán Korda shoots "Thief of Baghdad" in the Grand Canyon, 1940.

Above, right: Cinematographer Karl Freund waits for sunlight during the filming of "The Good Earth," which brought him an Oscar in 1937.

Left: Wife Alma Reville and assistant and screenwriter Joan Harrison struggle to keep Alfred Hitchcock awake following a meal in 1939.

Right: Location work often led to minor roles. During the filming of "Janie" in 1944, Mike Curtiz (director of "Casablanca" and "Mildred Pierce," shown with microphone) cast Stackpole (right) as a "LIFE" photographer covering a party.

Below, right: Carole Lombard, columnist Fred Oatman, and Peter Stackpole.

Below: Stackpole stands just behind George Stevens on the set of "Gunga Din," 1938.

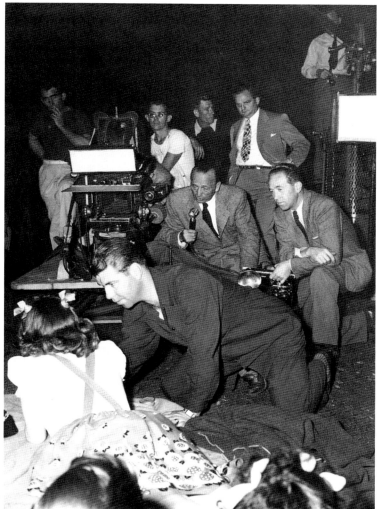

 Marty Crail

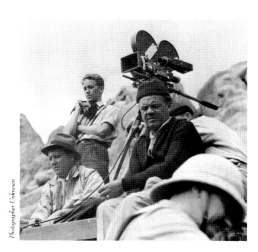

Photographer Unknown

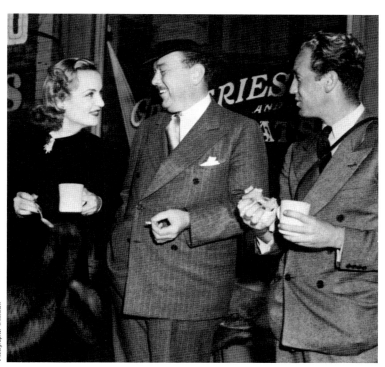

Photographer Unknown

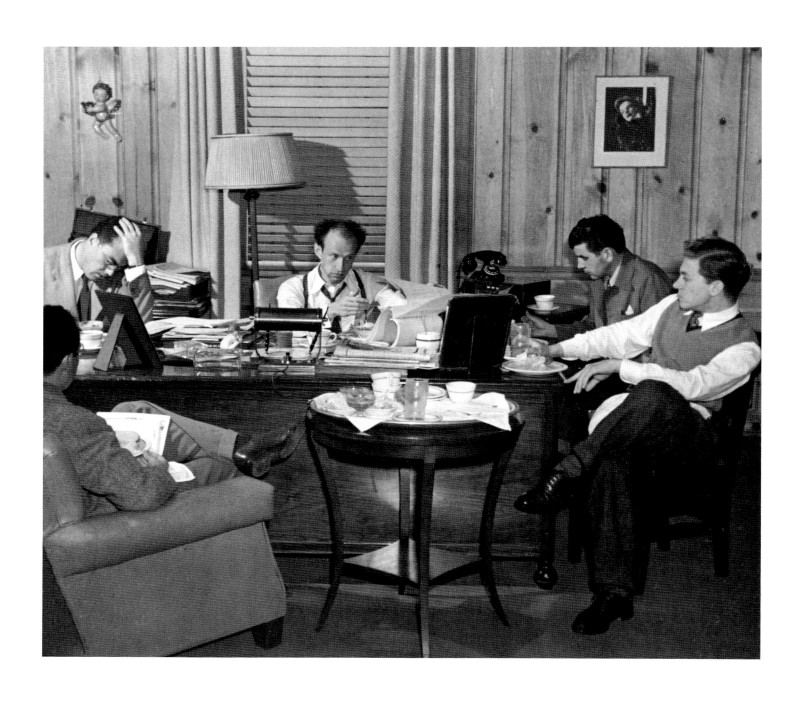

Garson Kanin, director of "My Favorite Wife" and "Tom, Dick and Harry," during a script conference, 1940. After World War II he turned to writing, and produced scripts like "The Marrying Kind," "Pat and Mike," and "Adam's Rib" with wife Ruth Gordon.

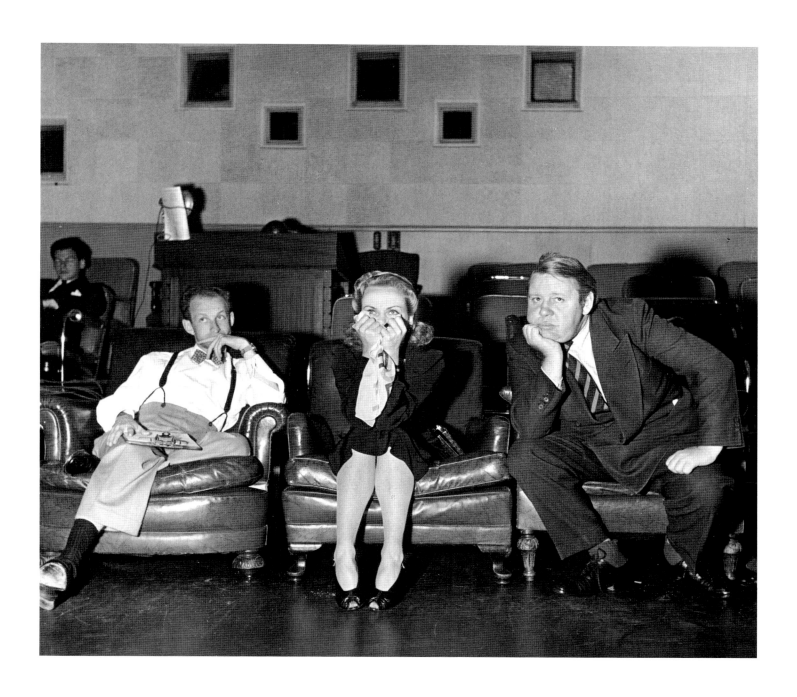

Garson Kanin, Carole Lombard, and Charles Laughton (left to right) watch rushes for "They Knew What They Wanted," 1940.

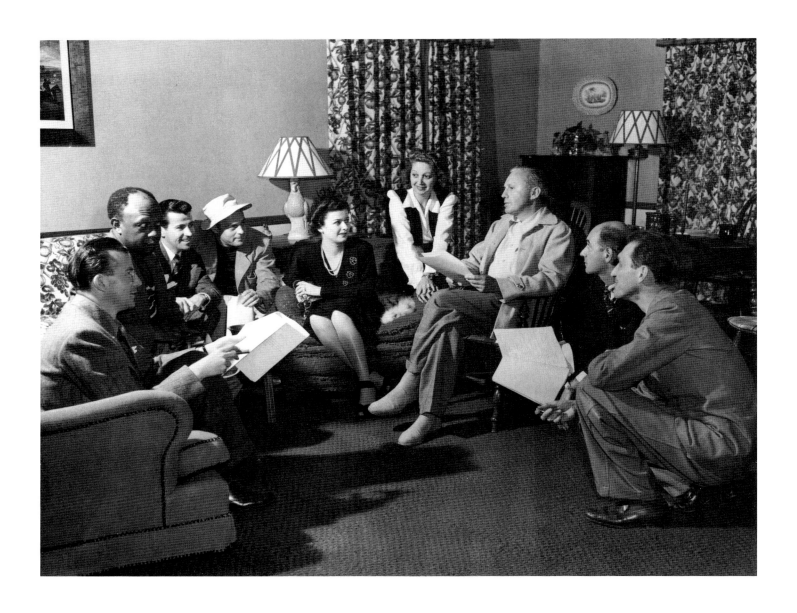

Above: Jack Benny (third from right) holds a rehearsal attended by Eddie "Rochester" Anderson, Dennis Day, Joan Bennett, and Mary Livingstone.

Facing page, top: Frank Capra (right) and Harry Cohn in Cohn's Columbia office, 1936.

Bottom, left: Warner's Graham Baker (top) and Gene Towne work late on a script in a Turkish bath.

Bottom, right: George Cukor, director of "The Women," "Philadelphia Story," "A Star Is Born," and many of Garson Kanin's scripts, on the set of "Romeo and Juliet" in 1930.

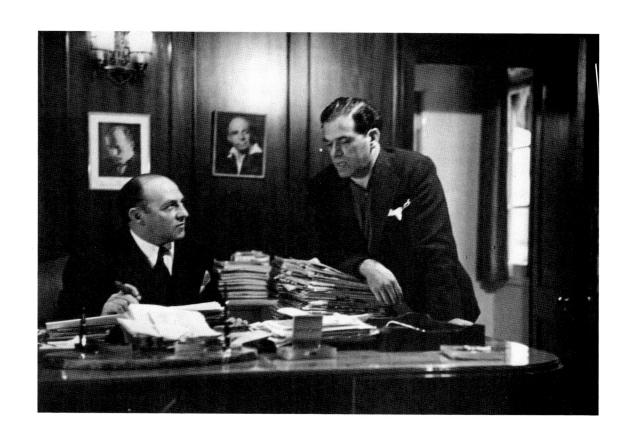

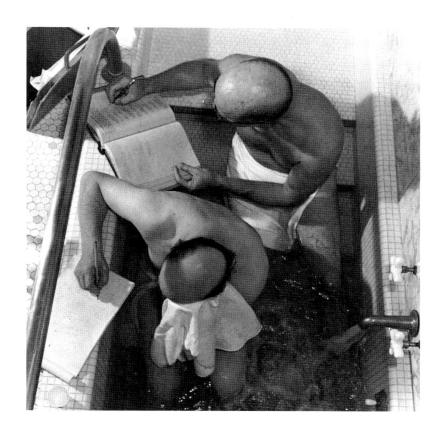

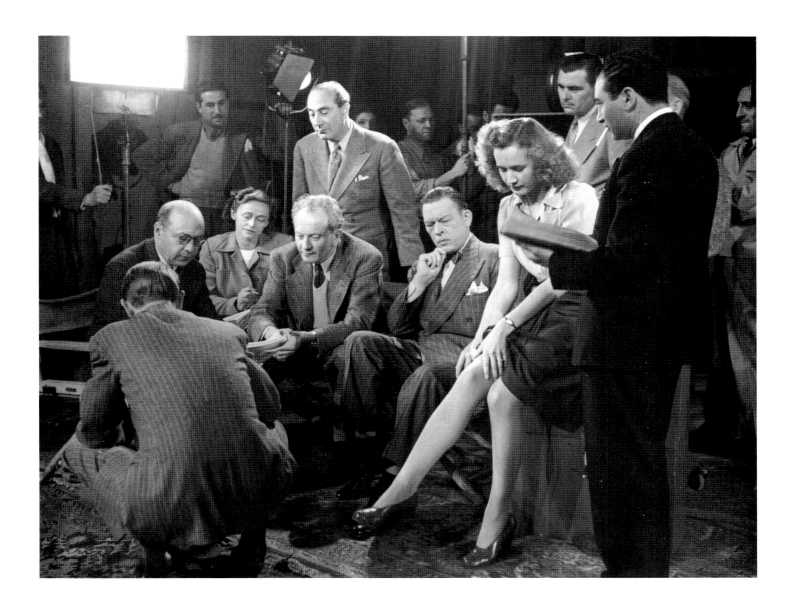

*Facing page: Graham Baker
reads a script in a steambath.*

*Above: Comedian Fred Allen
claimed to dislike distractions
on the set.*

Top: David O. Selznick
congratulates Ingrid Bergman
moments after she wins an
Academy Award for
"Gaslight" in 1944.

Bottom: Preston Sturges, director
of "The Great McGinty" and
"The Lady Eve," with Frances
Ramsden, 1946. Ramsden wears
"Francie Pants," a kind of
wrap-around pant that
Sturges designed for her.

Top: Sam Goldwyn with a Goldwyn Girl, 1944.

Bottom: King Vidor, director of "Our Daily Bread" and "Duel in the Sun," coaches Hedy Lamarr during the filming of "H. M. Pulham Esq.," 1941.

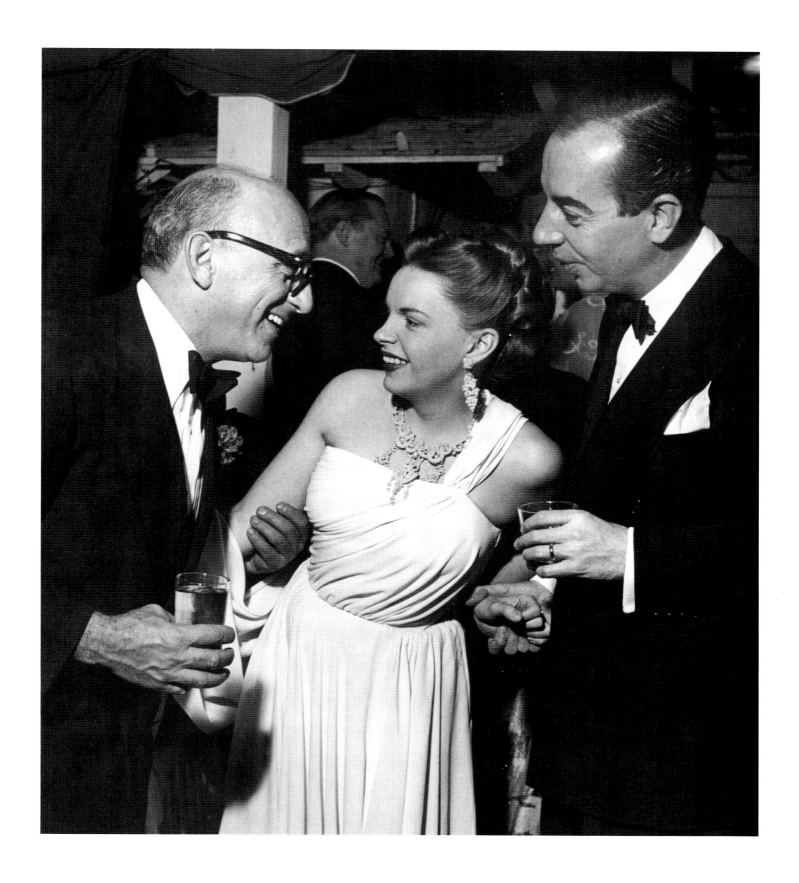

Facing page: King Vidor tries
desperately to elicit more emotion
from Hedy Lamarr on the "H. M.
Pullham Esq." set, 1941.

Above: Judy Garland and Vincente
Minnelli (right, director of "An
American in Paris," "Gigi," and
"Lust for Life") with director
Robert Siodmak at a 1949
New Year's Eve party.

89

Above: Writer, producer, and director Nunnally Johnson, 1936.

Nunnally Johnson, whose scripts eventually included "The Grapes of Wrath," "The Man in the Gray Flannel Suit," "The Three Faces of Eve" and "The Dirty Dozen," was Twentieth Century-Fox's most valued writer by the late thirties. On my first trip to Hollywood, Joe Thorndyke and I were in head of publicity Harry Brand's office when Johnson walked in just as Shirley Temple and her mother were leaving. He confided to us, in a hushed voice, that Shirley was actually a forty-year-old midget. Down the hall, on his office door, Johnson had tacked this notice of consulting fees:

For reading a story, with one-word comment - $5 a page

For same, without comment - $10 a page

For listening to a story while dozing - $500

For listening to a story jovially described as "just a springboard" - $10,000

For listening to a story while wide awake - $1,000

For reading stories, plays or scripts written by actors or actresses to star themselves - $25,000

For attending amateur performances in a converted shoe store on Highland Ave. to "catch" promising new material - $10,000 (and transportation)

For looking at talented children - $500

For talking to same or their mothers - $50,000

For meeting "new faces" (male) - $100

For same (female) - $1

For same (female), door closed - No charge

Facing page: Shirley Temple in Harry Brand's office, 1936.

Harry Brand didn't mind this in-house kind of wit, and became known with the press for his own humor about the people he worked for. He had the unenviable job of damage control—what to do, say, when Marilyn Monroe needed extra money and posed nude for a calendar; how to make a scandal an asset. The role of being Zanuck's head servant wasn't easy, either. Brand was once quoted as saying, "When I die there is just one more thing I can do for Darryl. I'll have my ashes spread on his driveway so his tires won't skid." —PS

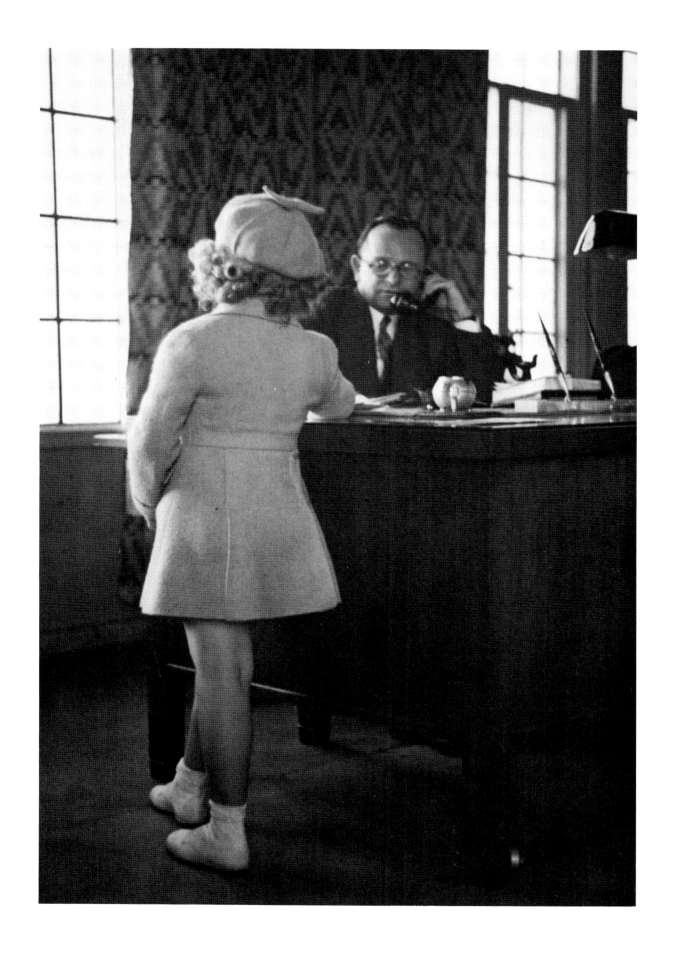

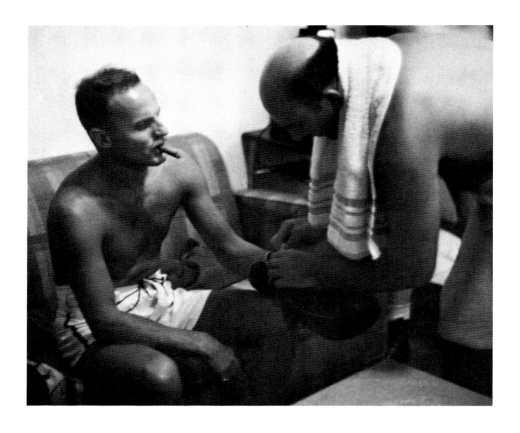

I covered Darryl Zanuck's sessions in his office workout room and steam room on my first day in Hollywood, and often had to hide my laughter behind the camera. A tough physical image was important to him—he'd smoke a cigar while his trainer massaged his head with hair tonic. A trapeze act was arranged at Ciro's, which friends and coworkers felt obliged to attend. His performances ranged from fair to embarrassing, and applause from loud to quietly sympathetic. —PS

Darryl Zanuck, head of 20th Century-Fox, in his office gym with trainer Sam Silver in 1936 (above, left) and with Joseph M. Schenck, co-founder of 20th Century-Fox and the producer of many Buster Keaton and D. W. Griffith movies. The zebra skin is from one of Zanuck's African safaris.

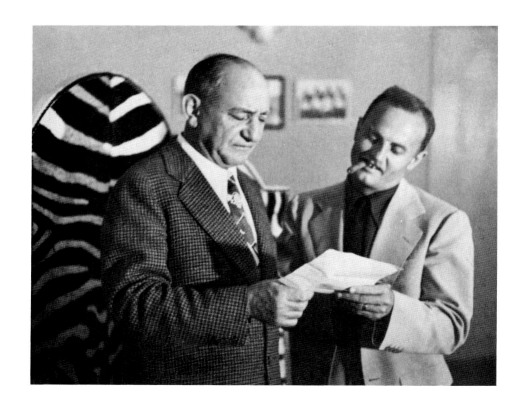

Facing page: Alfred Hitchcock at Chasen's, 1939.

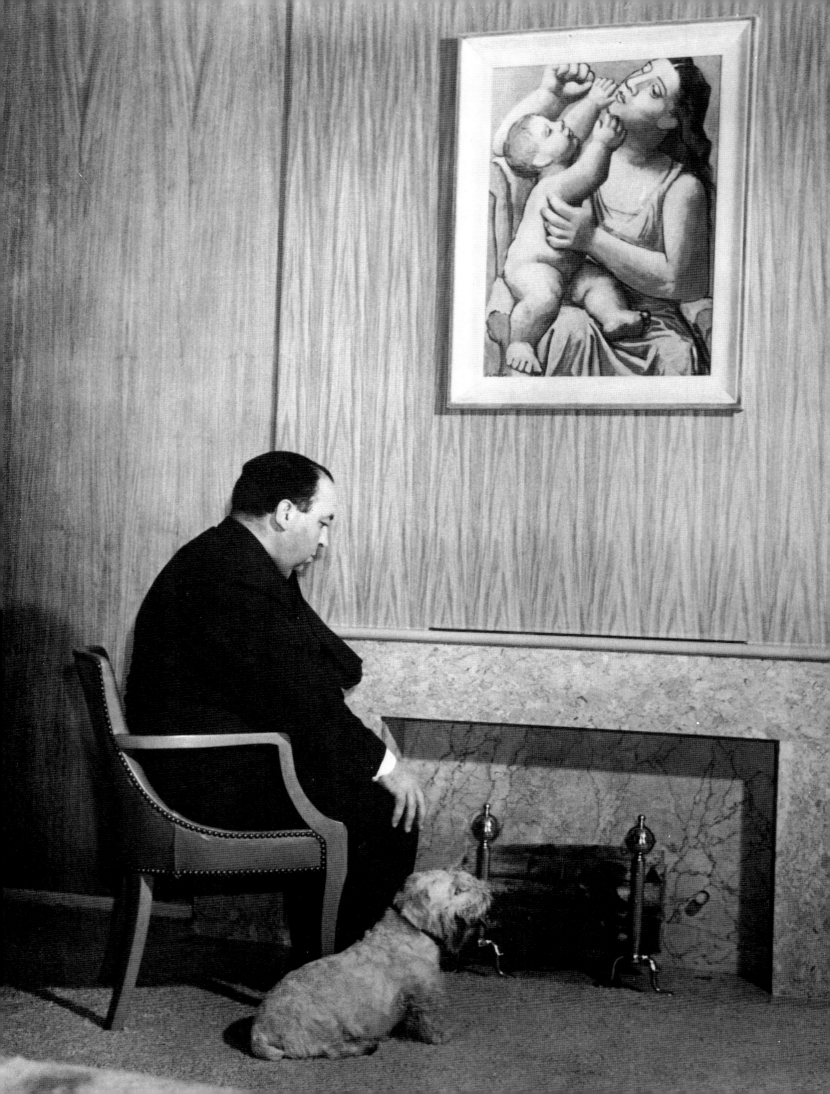

"Lifeboat" presented Hitchcock with numerous practical problems—a huge tub of water had been constructed in a Fox soundstage, and ringed with giant fans to create whitecaps. Tallulah Bankhead sat in a damp lifeboat for days on end surrounded by actors and crew. Bankhead was never one to lose identity because of simple discomfort, and it was only natural for her to not bother with underpants. She sat as she pleased in her director's chair between takes, day after day, and the less broad-minded of the technicians, especially those who needed to look up from the soundstage floor, decided that she wasn't wholesome entertainment. They formed a committee and approached Hitchcock, who said it wasn't his duty and suggested they approach Darryl Zanuck. Zanuck was bored by the request and sent them back to Hitchcock, who was still uninterested. "I'm sorry," he said. "I can do nothing about it. Maybe you should take it up with the makeup department, or perhaps the hairdresser or the prop department." The camera crew's slogan became "On a clear day you can see Catalina," but "Lifeboat" became one of the most successful war films of the decade. —PS

Facing page: Stackpole described this 1939 portrait as "an Englishman spending a winter evening at home," but Hitchcock titled it "A Dislike of American Fireplaces." The Sealyham's name was Mr. Jenkins.

Right: Tallulah Bankhead on the set of "Lifeboat," 1043.

Bottom: Stills from "Lifeboat"; Hitchcock is the large figure at far right.

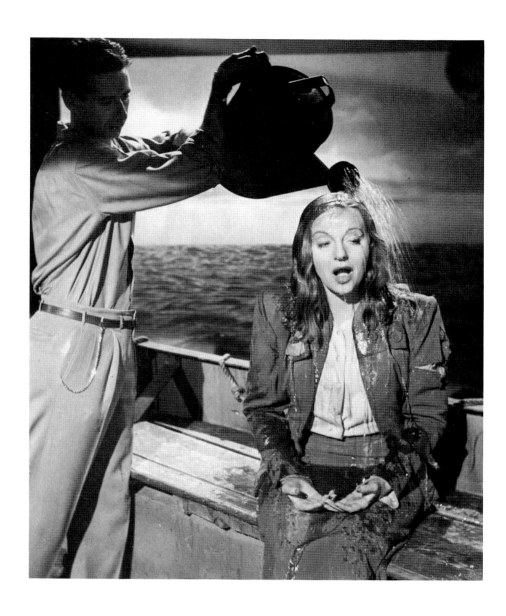

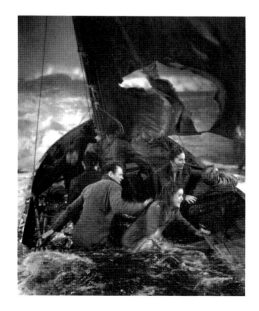

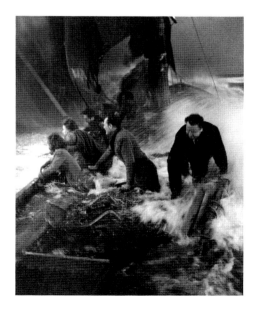

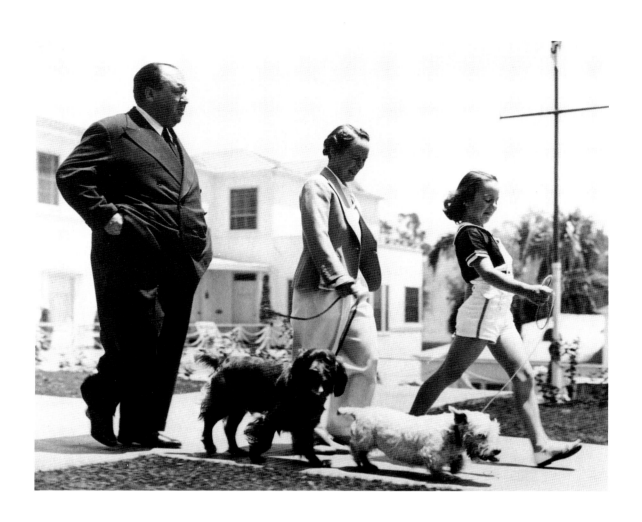

Above: Hitchcock, wife Alma, and daughter Patricia take Mr. Jenkins and a spaniel named Edward IX for a morning stroll in Hollywood in 1939.

Right: At the 1941 Academy Awards banquet, an unidentified hand holds up the number thirteen while Hitchcock discusses the proceedings with Joan Fontaine, who lost for "Rebecca" (Ginger Rogers took the award that year for "Kitty Foyle").

Facing page: David Selznick comforts Joan Fontaine for her loss while Hitchcock reaches for a mint. Fontaine won the next year for her role in Hitchcock's "Suspicion."

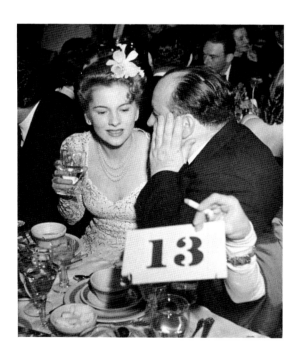

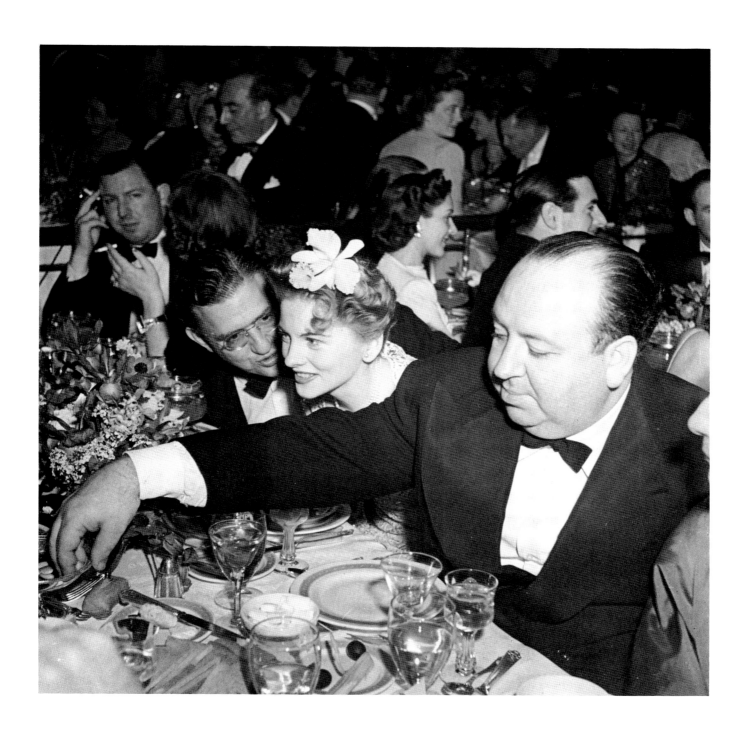

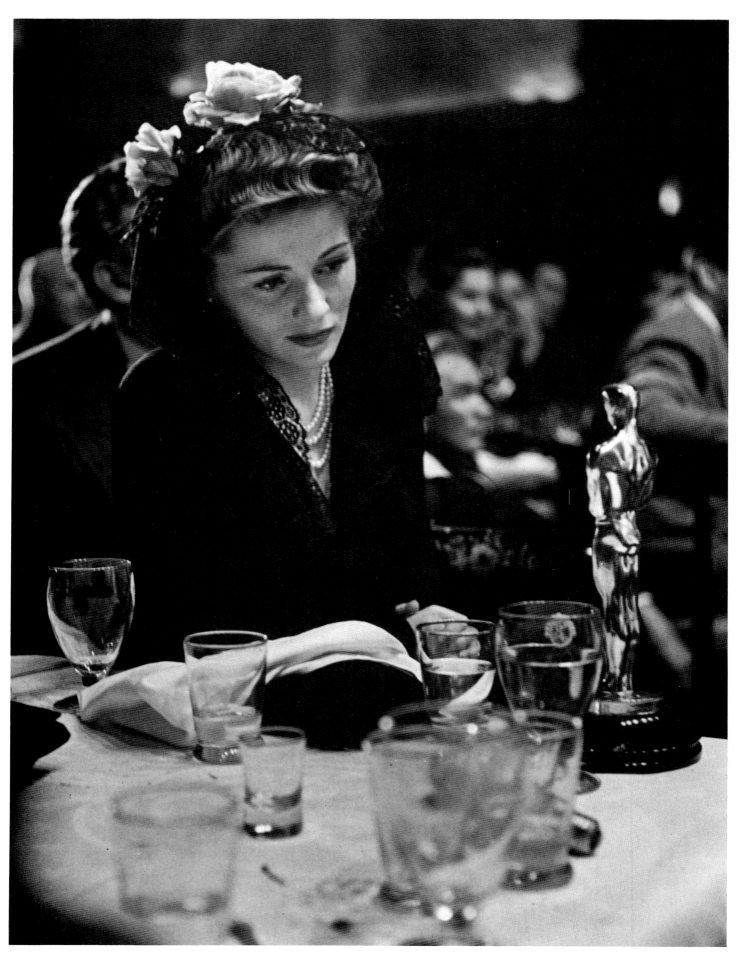

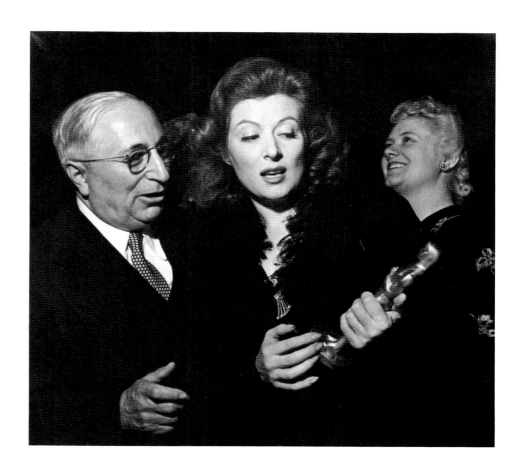

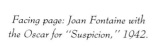

Facing page: Joan Fontaine with the Oscar for "Suspicion," 1942.

Top: Louis B. Mayer with Greer Garson, who won for "Mrs. Miniver" in 1943.

Bottom: Producer David Hemstead (later blacklisted) with Ginger Rogers and her mother after Rogers received an Oscar for "Kitty Foyle" at the 1941 ceremony.

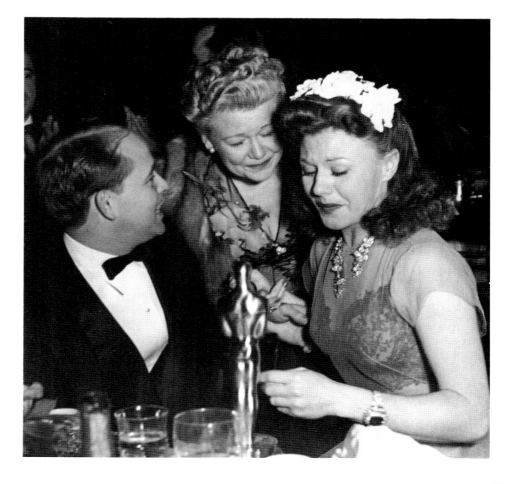

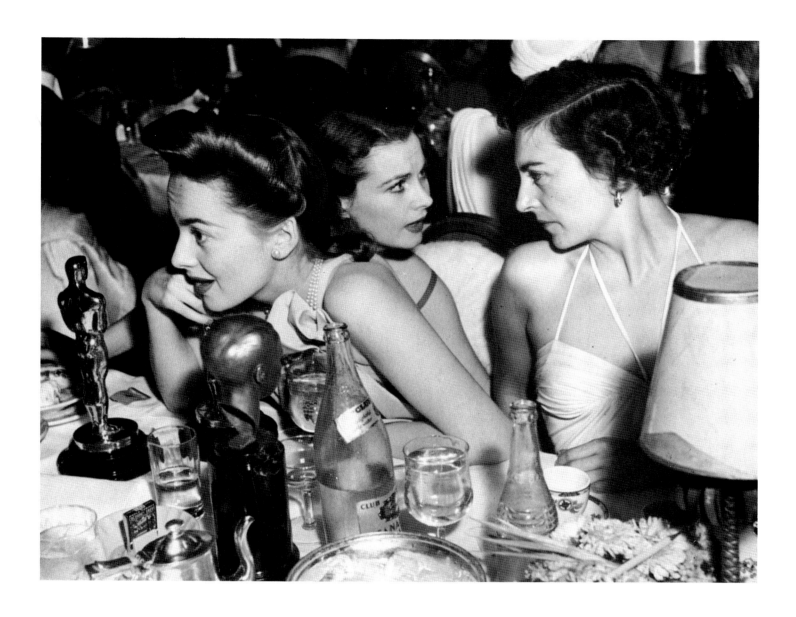

Facing page: At the Academy
Awards banquet in 1940, Vivien
Leigh, winner for "Gone with the
Wind," watches as husband
Laurence Olivier, loser for
"Wuthering Heights," gives a
slightly drunken Bronx cheer. John
Hay "Jock" Whitney, one of
Selznick's backers, is at left.

Above: Olivia de Havilland, Vivien
Leigh, and Irene Mayer Selznick at
the Academy Awards, 1940.

Right: At 2.00 a.m. after the
1940 ceremony, Vivien Leigh puts
her Oscar on the mantel.

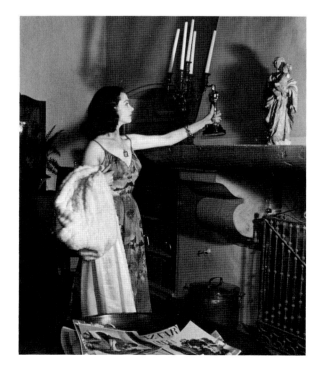

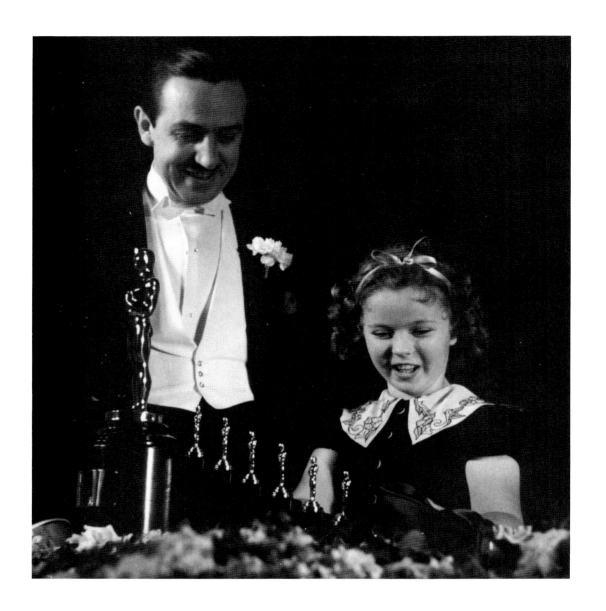

Above: Shirley Temple presents
Walt Disney with one standard
Oscar and seven small ones for
"Snow White," 1939.

Left: Merle Oberon and James
Roosevelt, a vice president at
Goldwyn, at the 1940 ceremony.

Facing page: Fans at premieres.

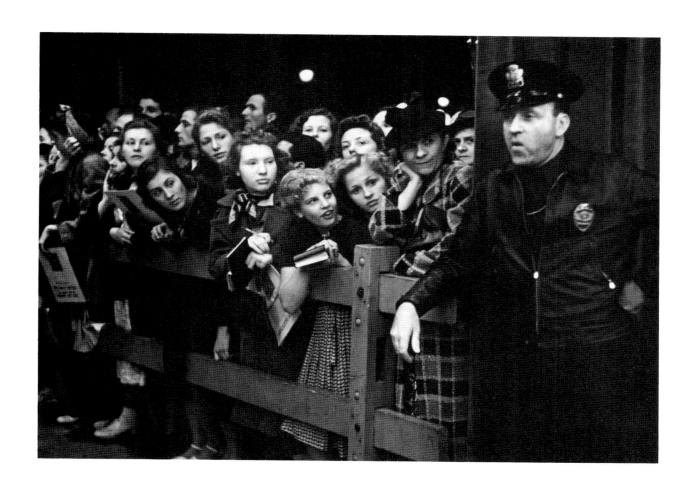

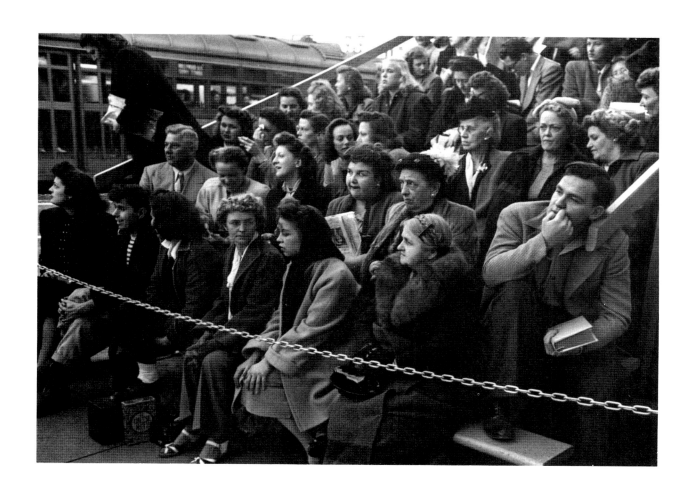

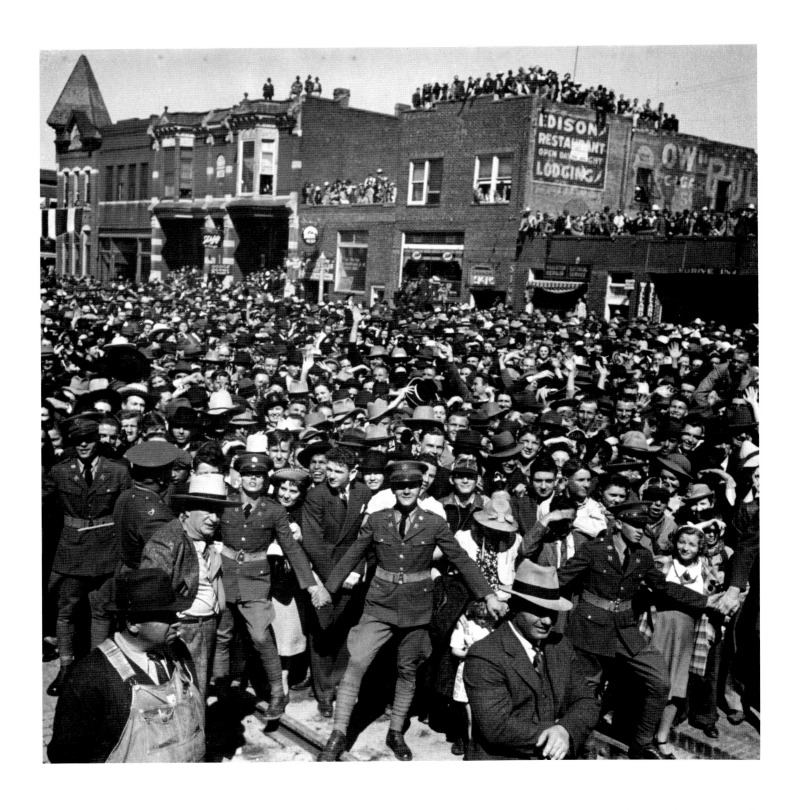

Above: A crowd awaits Errol Flynn and other stars on a publicity trek train in Dodge City, Kansas, on April 1, 1942.

Facing page: Errol Flynn and his schnauzer Arno on the yacht "Sirocco," 1941.

I was often on call at the jetty on Santa Monica Beach, where the waves were good, and friends and I would bodysurf to our hearts' content. Marion Davies' cottage was a few yards down the beach, and we'd often hear laughter from behind the white fence, and see her guests spring across the public beach to "fanny dip" in the surf. One morning in July of 1941 my beach diversion was cut short by an unusual assignment: would I take some underwater pictures of Errol Flynn wearing goggles and spearing fish? I'd never seen an underwater camera, fins weren't invented yet, and face masks were few. There wasn't much I could do except get a plastic case made for my oldest, most expendable camera. After a dubious test in the bathtub, the fragile box and I were off to Catalina Island for a rendezvous with Flynn on his yacht, "Sirocco."

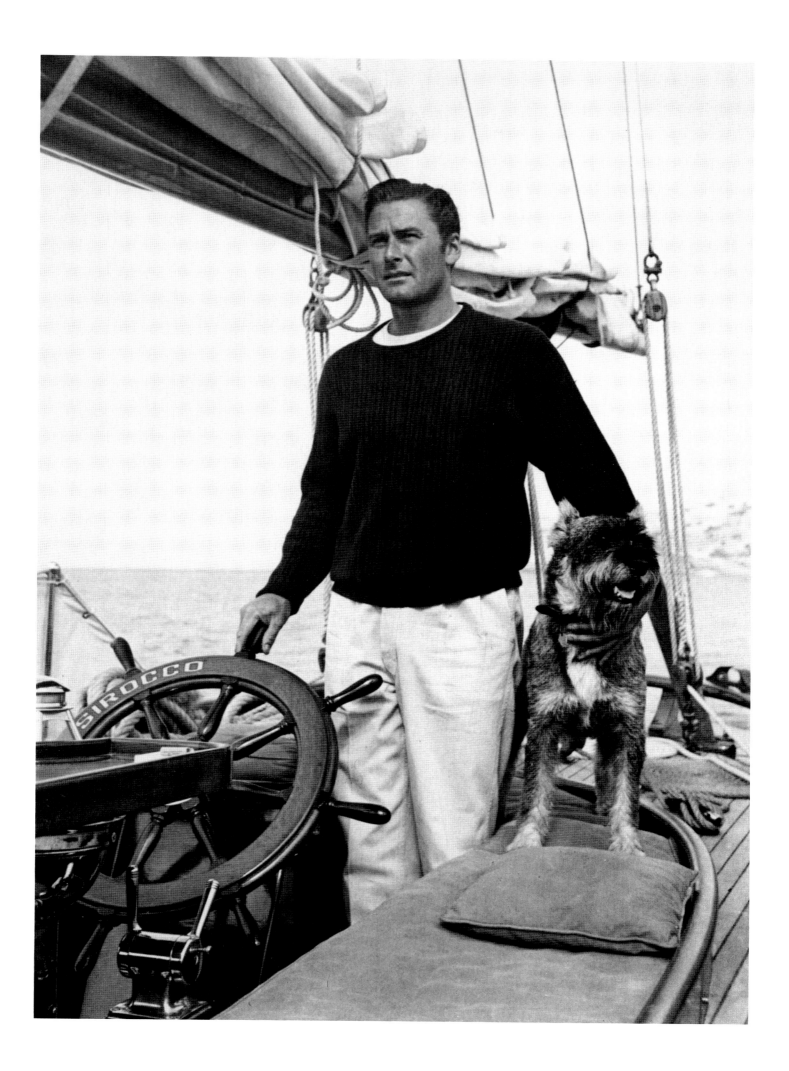

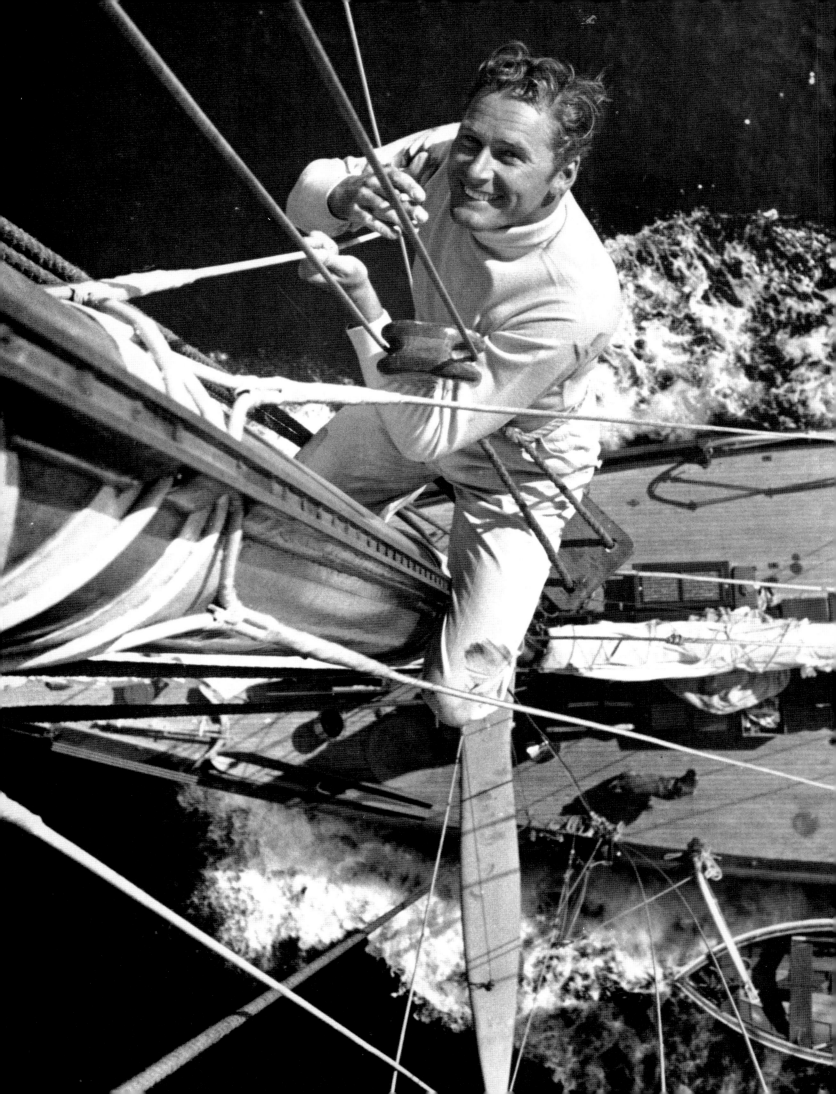

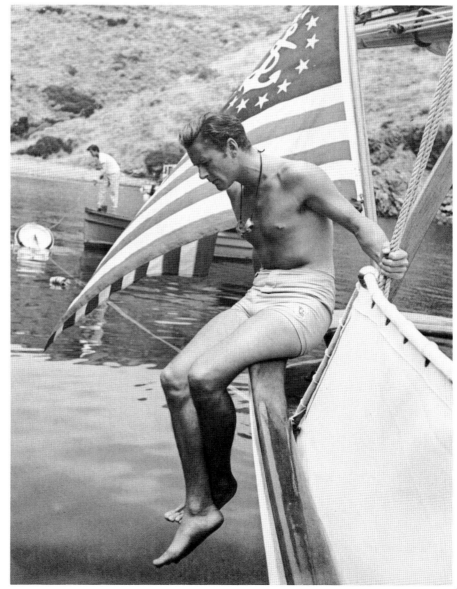

A nautically dressed guy found me in the crowded lobby of the St. Catherine Hotel. "I'm Buster Wiles, Errol's double and stuntman," he announced. I felt my knuckles pop with his handshake. The ride with Wiles aboard Flynn's speedboat took only a few minutes, and my handsome host appeared on deck a few minutes later. Errol had learned to dive in the South Pacific, and as he helped adjust a pair of hand-carved wooden goggles to my eyes, my attention was diverted by a girl with long black hair and a Venus body. My host introduced me to Miss Peggy LaRue.

By 11:00 a.m. we were set for diving. I tried on a heavy, shallow-water diving helmet complete with pumped air. As I dove down, my ears ached and I watched small drops of saltwater appear inside the camera housing. I wondered what I had gotten myself into. Flynn did wonderfully spearing kelp bass, delivering each fish to his waiting mess boy. But the picture situation looked hopeless. I decided to surface-dive every time Flynn did, trying not to scare the fish. It worked until the water level inside the frail underwater box meant the camera was probably ruined.

At lunchtime we relaxed in the cockpit, downing some fancy sandwiches and Drambuies. Flynn talked of the night he rowed over to Charles Chaplin's yacht and fired

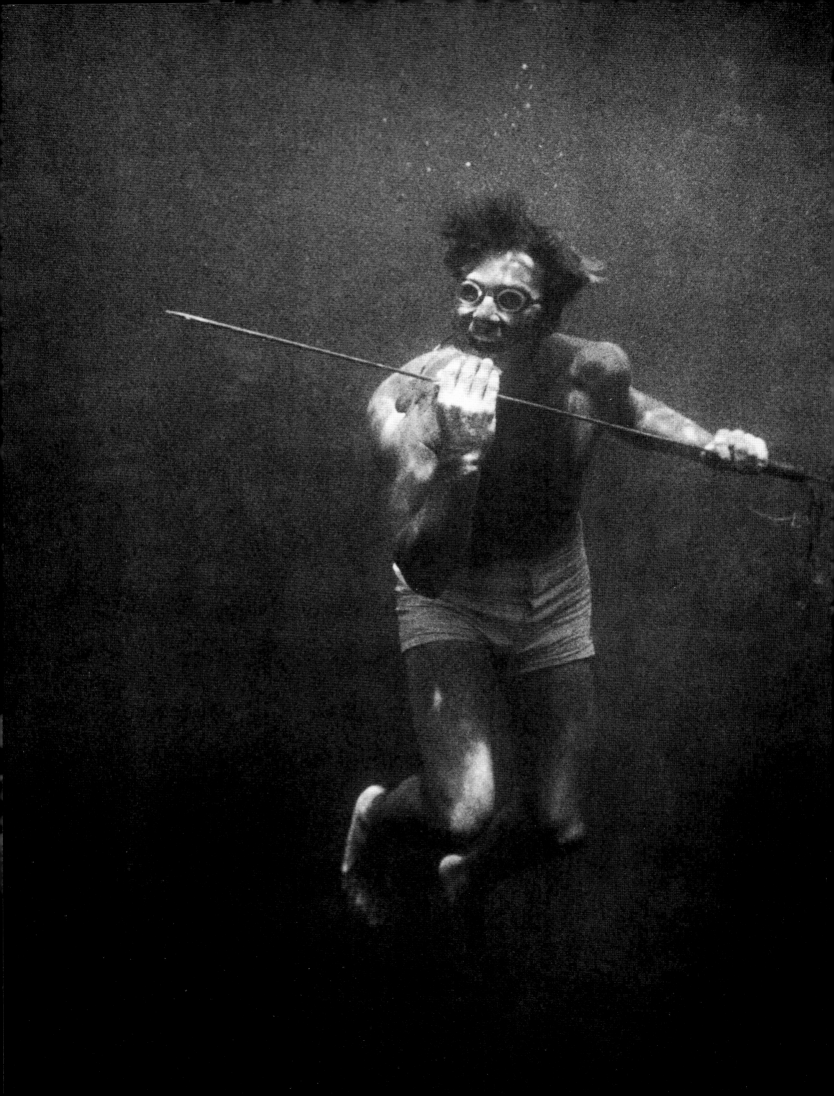

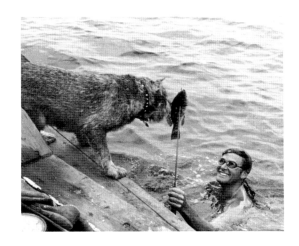

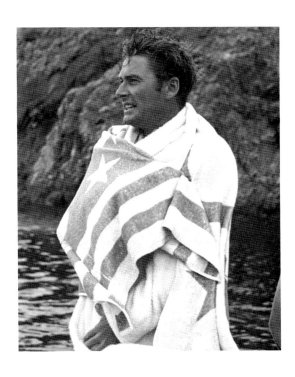

a flashbulb in his porthole for laughs. When Peggy appeared in a bathing suit he asked if I'd mind taking a few shots of her, and I was careful to put these pictures on a different roll of film. There wasn't enough wind for a sail, so the crew raised me to the top of the mast, hoisting Flynn just below the spreader. He wanted to dive from the mast for me, but his inner ear was bothering him. At sundown, we feasted on the kelp bass, then headed under power for the mainland, some twenty miles away. Flynn and Peggy were below deck most of the trip across the channel, and as we approached San Pedro, Flynn appeared on deck and asked me to drive Peggy home. I thanked him for his hospitality.

We drove up Highway 101 through a fog. Peggy was very angry with Flynn but gave no details; she seemed mixed up and juvenile. I let her off at her apartment building at what must have been around 1:30 a.m. and left for home, tired and salty.

About a week later, I got a call from Errol asking if I would join him for a drink at the Beverly Hills Hotel. Something had come up, he said, that he wanted to discuss with me. I grabbed the pictures and joined him on the veranda overlooking the tennis courts. "Great pictures," he said as he thumbed through them.

Then I opened the envelope that contained the shots of Peggy and his expression changed into a knowing grin. "This is what I wanted to talk to you about," Flynn said with some concern.

"They're trying to shake me down for $5000. Can you remember anything she talked about when you drove her home?" I couldn't remember a thing. I visited the yacht a few weeks later but the trip was uneventful except for Flynn's schnauzer Arno jumping overboard, chasing flying fish. And that was the last I saw of Flynn for a long time.

Three years later, I was at the beach again, testing a camera on my three-year-old daughter, when two well-dressed men approached. "Are you Stackpole?" one asked. "We're from the D.A.'s office."

"Were you on Errol Flynn's yacht back in August of '41?" asked the other.

I admitted I was. "What's the trouble?"

"We've got a subpoena for you, and they want you to testify on a rape charge against Errol Flynn. Would you come with us?"

I followed them to the curb where a sedan was waiting. In the back seat a lady cop sat next to a pretty young girl in pigtails. All that was missing were the schoolbooks.

Flynn laughs underwater in what Stackpole describes as his "first good shots before my camera got wet" (facing page and above). He teases Arno with his catch (upper right), warms up after diving, and hands the kelp bass over to his cooks (right).

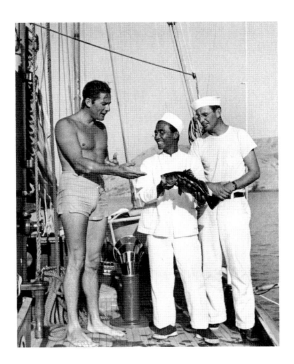

For everyone's benefit, she recognized me immediately. This time, her name was Peggy Satterlee.

During the subsequent trial, movie fans of all ages cluttered the courthouse to await Flynn's arrival. He never showed a worried moment throughout the trial, but that was probably Flynn the actor. When one of my pictures of Peggy was in danger of leaking to one paper, I made sure it leaked to all of them. My most unnerving moment came with the tip from Humphrey Bogart that the studio was considering making me a fall guy: Peggy Satterlee's doorman was ready to testify that I hadn't dropped her off until three a.m. I fought back by letting a Warner Bros. publicist know that I was liable to remember many more things about my trip on the yacht if Flynn's lawyer, Jerry Geisler, put me on the spot. The next day, Geisler was charming and kind, and I was only on the stand for about fifteen minutes. That evening, one newspaper columnist wrote, "Stackpole's testimony was noteworthy for the questions not asked of him." Soon after the defense found a photograph showing Peggy seminude, leaning over, looking back at the camera with her head upside-down and legs apart; the final verdict was a swift not guilty. —PS

I was at the L.A. air terminal in 1948, on my way to a story on the coed atmosphere at the University of Missouri, where Wilson Hicks would be receiving a journalism award, when I became aware of a small commotion. "I'm passing the hat to take up a collection for that miserable bastard, Howard Hughes," I heard someone say. "He can't even come up with an airplane when you want to fly." It

was Errol Flynn. He was loaded. I went to the ticket counter, hoping he wouldn't see me as he weaved among the amused travelers. "Your plane for Kansas City left forty minutes ago," the girl behind the desk told me. Maddened by the error, I forgot Flynn for the moment. I got a ticket instead on a flight leaving for St. Louis, where I could get a train to Columbia in the morning. I risked a look at Flynn. He was headed my way.

He reached the counter and spilled the story: his ticket had been made out for the wrong time, too. "Where the hell are you going, Stack?" he asked. The next thing I knew he was changing his ticket and coming with me.

We sat together in our almost empty DC-6, and at daybreak, I woke up with a vague memory of some problem the night before. I eyed two feet covered with heavy argyle socks and my heart sank. But when he woke up, Flynn said, "Don't worry about me going with you, old boy. I'll tell them that I'm very interested in journalism and want to attend some of their sessions. Maybe they'll give me a degree." At St. Louis, we boarded the Missouri Pacific, stowed our belongings, and Flynn set up headquarters in the dining car, downing scrambled eggs with several shots of brandy. At the last stop, I called the Daniel Boone Hotel.

Below: Peggy Satterlee stands in schoolgirl attire behind Flynn and his counsel at the trial and (right) takes the stand to display photographs taken on the "Sirocco."

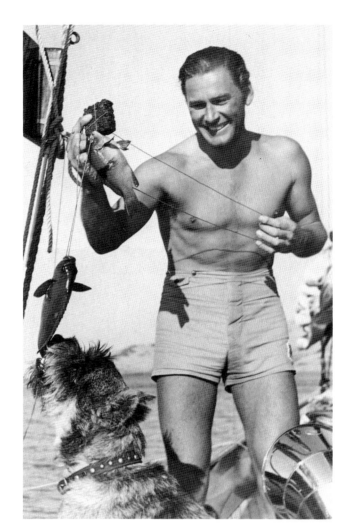

"Could you reserve a room for a guest of mine?" I asked nervously. The receptionist said the hotel was full. "Well, could you put an extra bed or cot in my room?" I asked.

"I think we can," she said. "What's your guest's name?"

"Errol Flynn," I answered, "E-R-R . . ." I could hear her laughing.

At the hotel in Columbia, Errol ordered some whiskey and mix and proceeded to start shaving, while I tried to reach Hicks and warn him without luck. The deluge began—

Facing page, top:
Flynn shows off his catch.

Above: Flynn enjoys a chaise on a neighboring boat, specifically designed to ease the drinking man's kidneys, and has dinner and drinks with Stackpole and hostesses at the Chi-Chi Club on Catalina Island, July, 1941 (right).

Photographer Unknown

gentle taps on the door, mingled with giggles. The elevator operator delivered coeds to our door, charging ten cents a head. First student journalists called, then the local paper, then out-of-town papers, then the news services from all over the country. I was to be the volunteer public-relations man for Flynn. It was true, I told them all: Mr. Flynn was vitally interested in journalism.

The next knock brought in the reporter from New York I was to work with. Flynn was still busy shaving by the hall mirror, stripped to the waist. "Errol," I said, "I'd like you to meet Miss LeMonnier from 'LIFE.'" She stood with her mouth open and lips trembling; all I could think to do was offer her a drink, and reassure her that I was ready for work. She'd arranged the first picture-taking session at a sorority house. Flynn suggested he play our chauffeur and assistant, saying that he liked college girls. "Yes, I know," I said.

At the sorority a dozen coeds gracefully posed on the staircase while my aide carried in all the equipment and helped me set up the lights. Just as I was about to shoot the first picture, he turned to me. "Boss, I haven't had a bite to eat all day. I can't even afford a cup of coffee on the wages you give me." Then he removed his hat and glasses and stomped out the door. One of the girls screamed, "It's Errol Flynn!" and they stampeded down the stairs toward the cab.

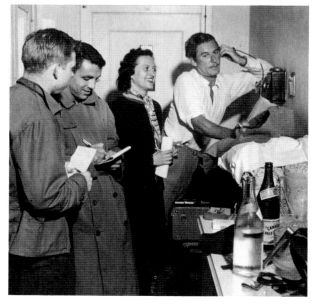

Hicks had heard about everything, and at dinner I searched his face for signs of disapproval. But as my guest described our past twenty-four hours, I could see Hicks's stern demeanor cracking. Flynn bought some kegs of beer for Hicks's old fraternity, and it was smooth sailing.

That night kids came to the room in droves; Flynn told a few stories, kissed a few coeds good night, and by two a.m. everyone went away happy. "Why in hell do I do these crazy things?" he asked. "Why do I want to captivate every beautiful young girl I see?" This was the real Flynn, reaching for things that vanished as fast as he found them, and never holding on to things that should have meant the most to him. The next morning his PR man and wife Nora tracked him down, and I heard Flynn promise to catch the next plane "as soon as they give me my honorary degree." I was actually sorry to see him go, and felt both envy and pity for him: this most handsome man lived too fast but played his part well, and gave what he could of himself. —PS

Errol Flynn signs a bottle of Daniel Boone in the hotel room (above), and takes an anxious call from the studio while student reporters snicker.

Facing page: Stackpole's cover shot of Jimmy Stewart on his return home to Indiana, Pennsylvania, in 1945.

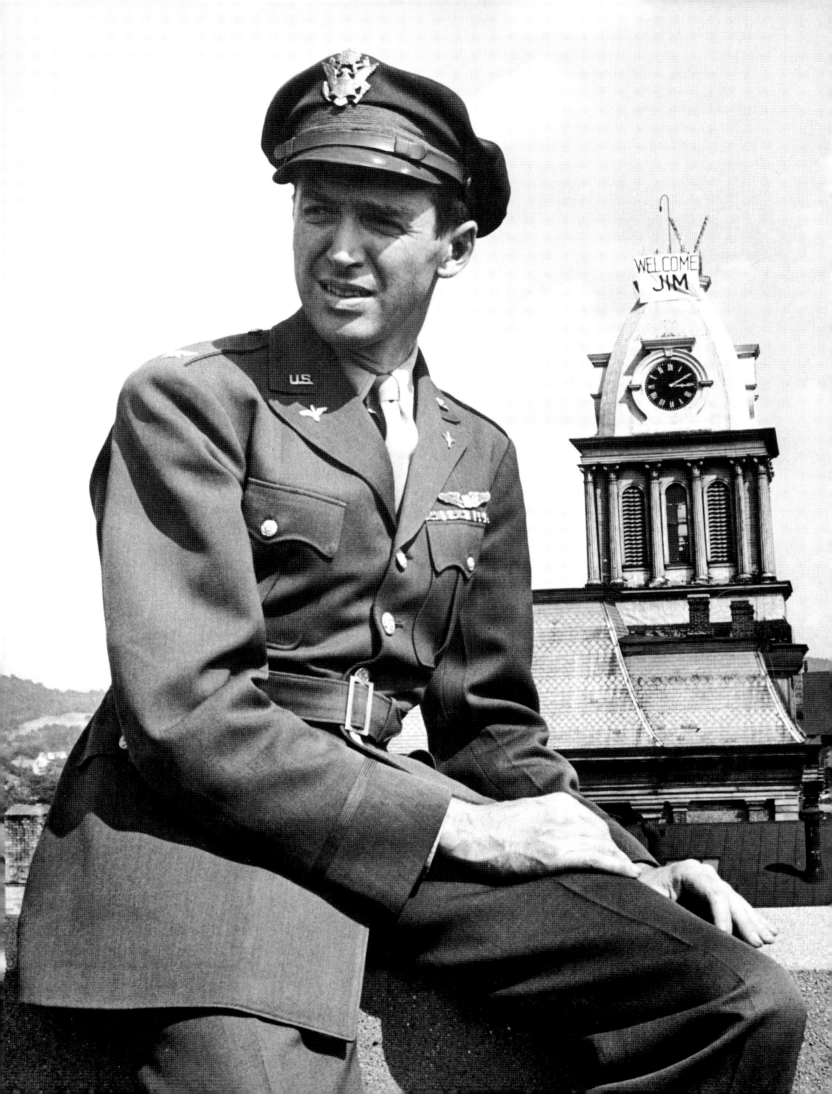

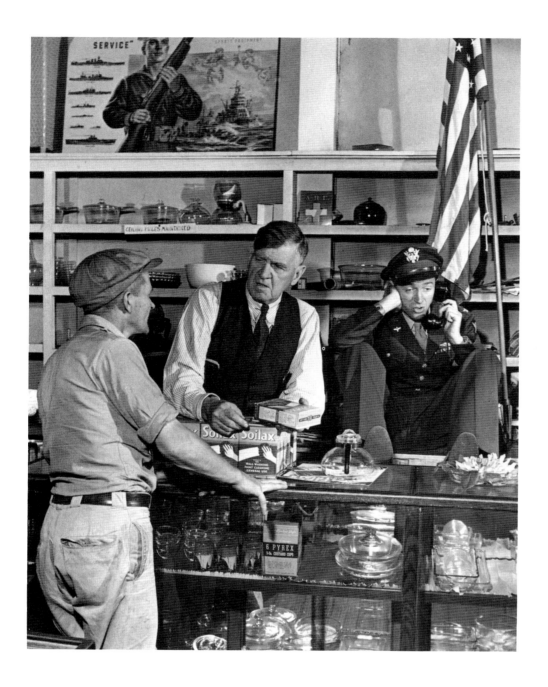

When Jimmy Stewart returned from World War II after twenty combat missions, a Croix de Guerre and the Flying Cross, "LIFE" sent me to record a visit to his hometown of Indiana, Pennsylvania. Stewart gave kids autographs on the street under a city hall banner that read "Welcome Jim." At home he dined with his parents and sisters, helped clear the table and relaxed with old friends. Pictures and family mementos were everywhere, and his father's hardware store was a classic small-town business.

The next day Stewart and his old friend Woodie Woodward went bass fishing on a nearby lake. Ten minutes into the session Stewart's hook caught me in the middle of the right eyebrow, and efforts to remove it proved futile. They took me to a country doctor, with Stewart stuttering a bit while he watched the hook being removed.

It was the kind of happy small-town story the editors of "LIFE" loved, and work started on the layout right away in New York.

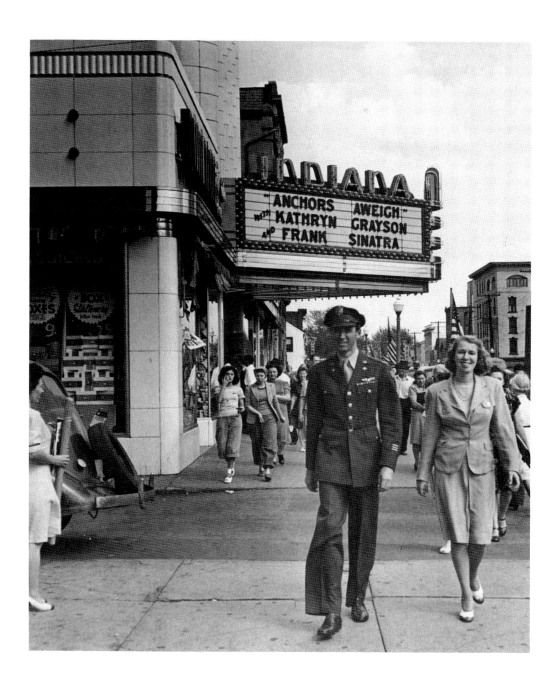

When I arrived early to view the cover candidates, I didn't see Stewart in the thirty images on the wall. I rushed down to the darkroom, made a quick enlargement of a shot of Stewart with the "Welcome Jim" banner behind his head, dashed back upstairs and slid the print under a transparent cover. It made the cover; before it reached the stands a telegram arrived from Stewart: "The Hooker wants to know how the Hooked is feeling." —PS

Facing page: In the family hardware store, Jimmy Stewart makes a fishing date on the telephone while his father waits on a customer (top), and chats with George Little, the store's oldest employee (bottom).

Above and right: Stewart strolls down Indiana's main street with his sister Mary and is promptly deluged with autograph seekers.

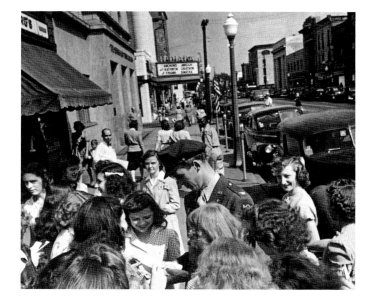

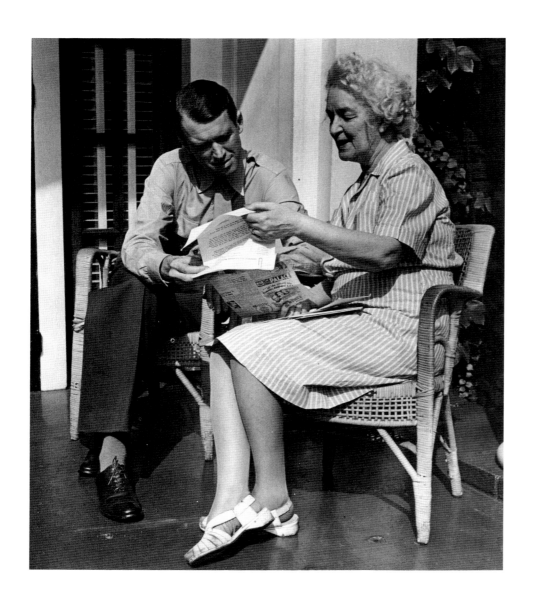

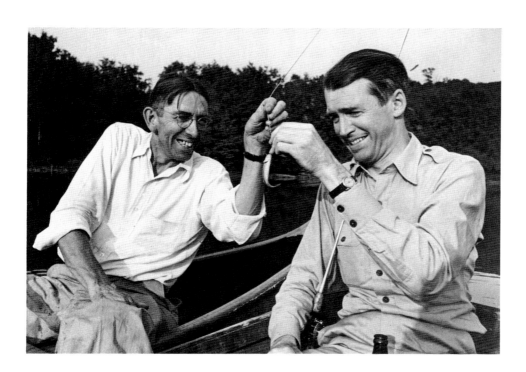

*Stewart with his mother (above)
and on the fishing trip with
childhood friend Clyde
"Woodie" Woodward.*

In the summer of 1936 I received an unexpected assignment from ''Fortune'' magazine to photograph William Randolph Hearst at his Wyntoon, California, summer estate, on the McCloud River near Mount Shasta. Two editors gave me a lot of background and saw me off at the station, but what I was to shoot was up to me.

At Wyntoon I was shepherded around by Joe Willicombe, an affable, heavyset, old-time newspaperman, who introduced me to the actors Dick Powell and Henry Wilcoxon, the syndicated columnist Harry Crocker, a lot of pretty young things, and Marion Davies, who forbade me to photograph any of the young girls inside the main buildings if they were in shorts.

I decided it might be best if I refrained from any picture-taking until morning. That night at dinner Hearst arrived wearing a Tyrolean hat, and Davies came in pink slacks. Willicombe introduced me to the Chief, who said, in a little, high voice, that he hoped I'd get some good pictures. Later we saw a new film starring Henry Wilcoxon in the downstairs theater; Hearst had new films flown up to the ranch every week.

Above: William Randolph Hearst, Wyntoon, 1936.

Right: The main house on the Wyntoon estate near Mount Shasta.

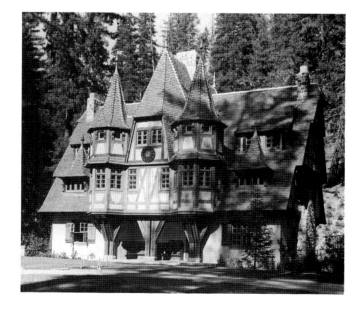

The next morning I photographed everything in sight, including the German auto-club emblems plastered on the front bumper of Hearst's large Buick. Hearst's valet took me upstairs and showed me Hearst's vast wardrobe. I spread a dozen feathered Tyrolean hats on his bed for a photograph and I had taken about three shots when Hearst came in. My heart was pounding. "This makes a good picture, don't you think, Mr. Hearst?" I said, weakly.

"Oh, yes, very good," he said in that same high voice. And then he left.

Late that afternoon, I found him on the tennis courts whacking the ball to Harry Crocker, and Marion Davies suggested that I get a shot "of old elephant pants playing tennis." Nearby, at the pool, one young lady pouted when she was told that Hearst wouldn't approve of her and the others visiting a roadhouse that night. "Darn Mr. Hearst," she said. "I wish he wasn't here." —PS

Top: Hearst and Marion Davies, Wyntoon, 1930.

Bottom: The members of the Wyntoon house party. Henry Wilcoxon, an actor in Cecil B. DeMille's "Cleopatra" and "The Crusades," is second from left; Marion Davies is at center, in sunglasses.

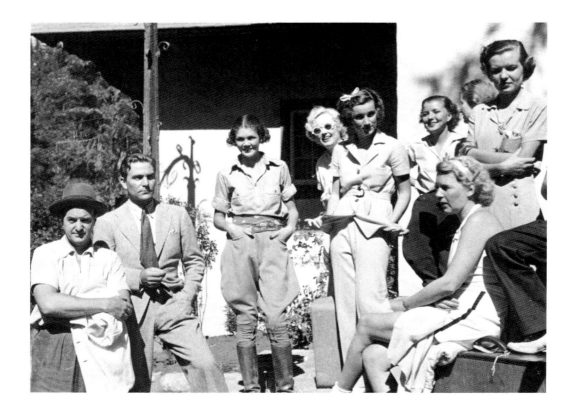

Facing page: Martha Raye was part of an impromptu floor show at a party given by Edgar Bergen for Charlie McCarthy at the Beverly Hills Hotel in 1939.

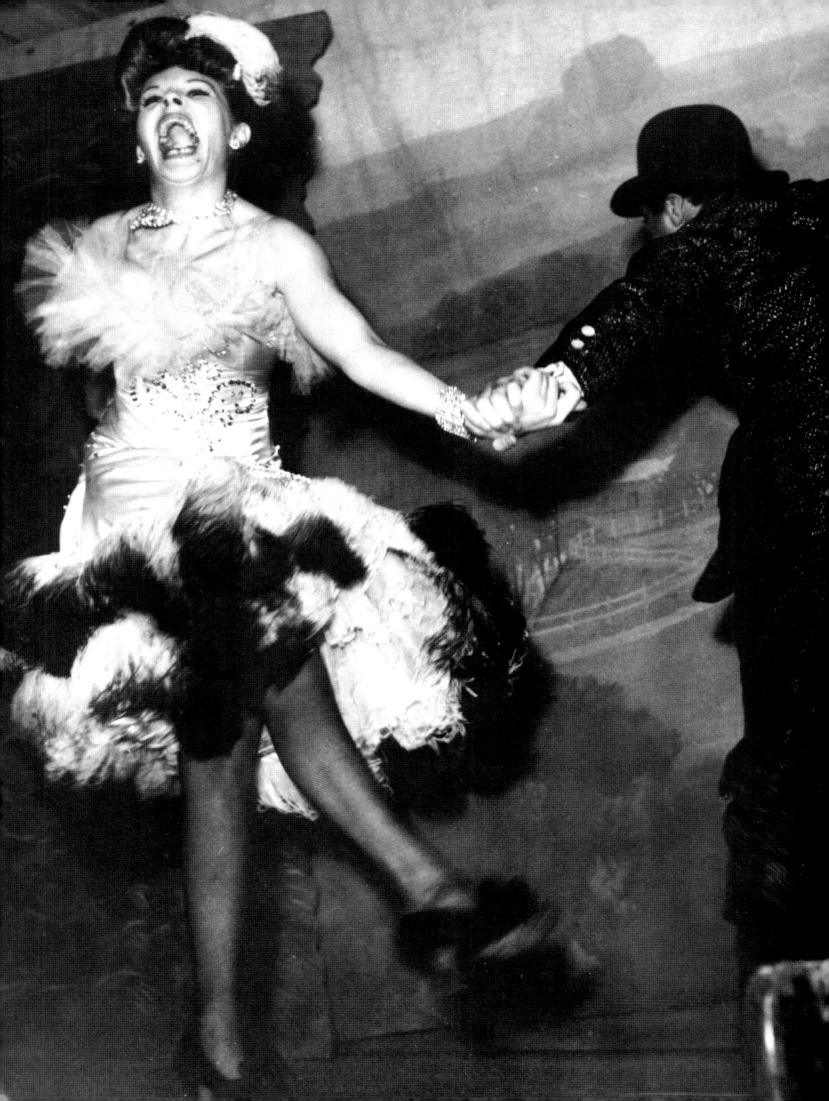

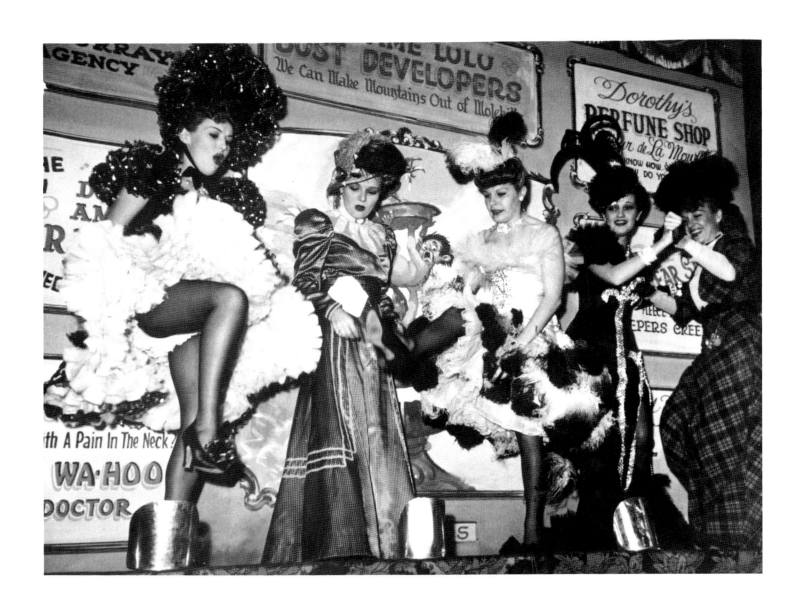

Above: The can-can line at Edgar Bergen's party included Betty Grable, Princess Baboa of Sarawak, Martha Raye, Dorothy Lamour, and Shirley Ross.

Facing page, top: Celeste Holm proves her nerve at a circus party in 1948.

Bottom: At a 1943 magic show for G.I.s, Orson Welles shows how to saw Rita Hayworth in two.

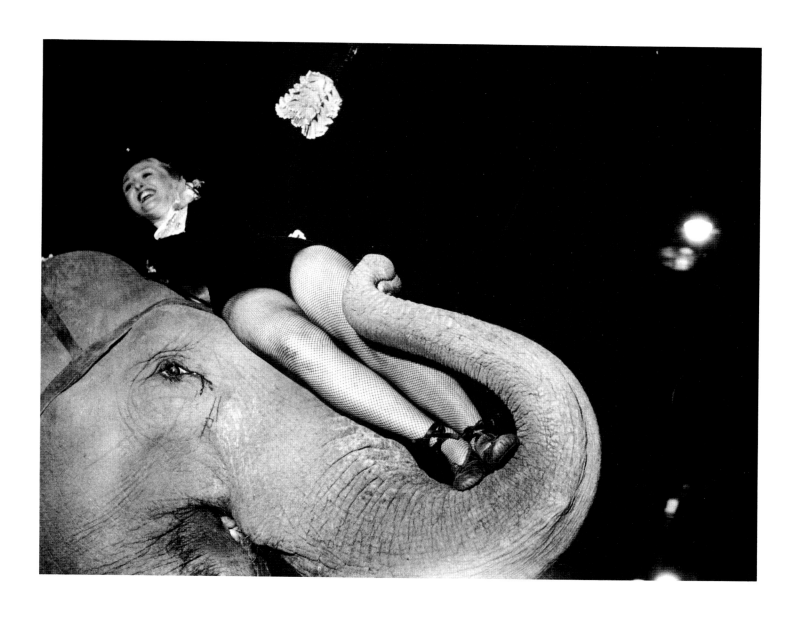

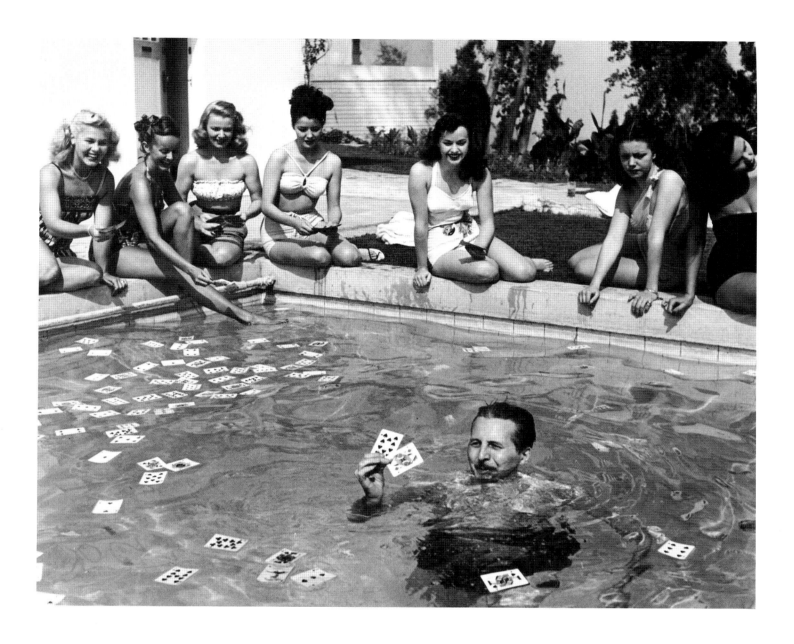

Facing page: a "hose party" at the Beverly Hills Hotel in 1940 featured (bottom, from left) John Hubbard, Ann Rutherford (who appeared in the Andy Hardy films and "Pride and Prejudice," and played Carreen in "Gone with the Wind"), Arleen Whelan ("Kidnapped" and "Young Mr. Lincoln") and Whelan's husband, Alex D'Arcy (who specialized in gigolo roles and appeared in "The Prisoner of Zenda" and "The Awful Truth"). Rand Brooks (Charles in "Gone with the Wind") carries Ann Rutherford in the photo at upper right.

Above: Magician Dai Vernon demonstrates card tricks.

Above: Corinne Calvet, a French
actress whose American films
included ''Rope of Sand,'' frolics
with husband John Bromfield (who
eventually played the lead in ''U.S.
Marshal'') in Palm Springs,
1949.

Facing page: Duke Ellington plays
an all-night party in the forties.

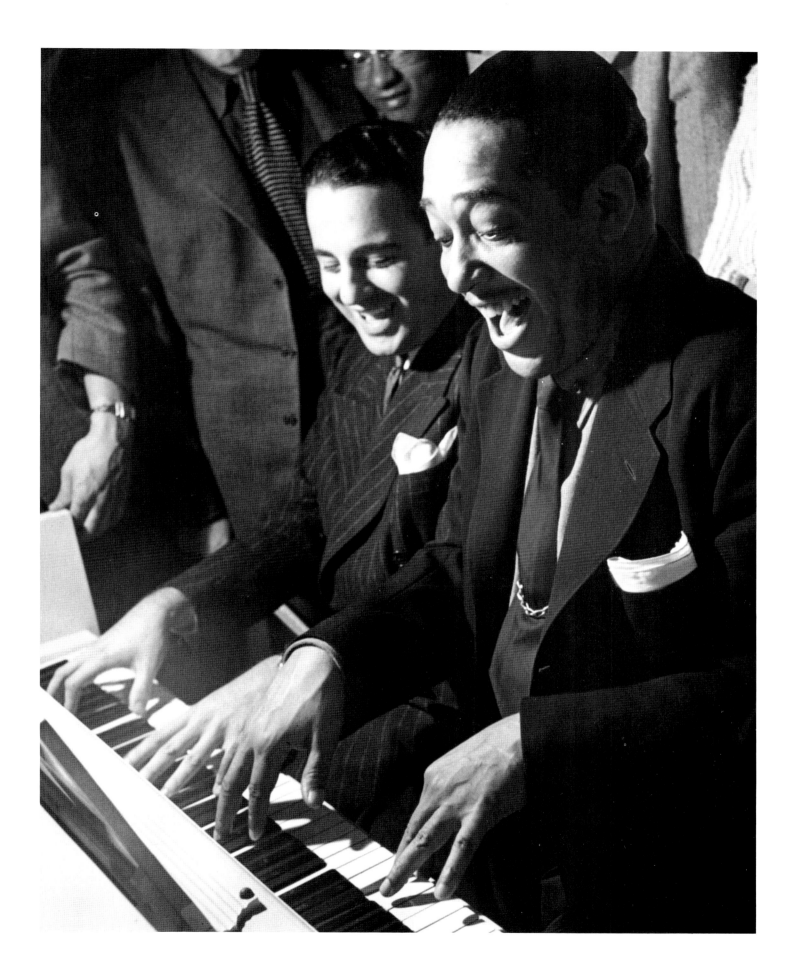

Slim Gaylord (left) and his bassist (lower left), played regularly at Hollywood nightclubs; the unidentified woman below was photographed at one such party.

Facing page: An unidentified couple dance in the mid-forties.

Above and facing page, top: Merle Oberon and husband Alexander Korda at home. They were married from 1930–1945; during their relationship, Korda, the major force in British cinema in the thirties and forties, directed Oberon in "The Private Life of Henry VIII," "The Scarlet Pimpernel," and "The Divorce of Lady X." Oberon's most famous role was Cathy in "Wuthering Heights"; Korda's later productions included many of Carol Reed's movies, including "The Fallen Idol" and "The Third Man."

Facing page, bottom: Merle Oberon with Lady Sylvia Ashley, wife of Douglas Fairbanks, Sr., 1938.

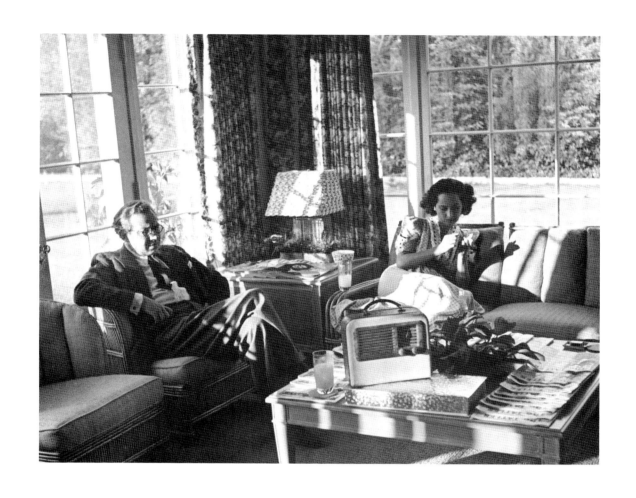

Stackpole took these photos of Rita Hayworth and Orson Welles at home in 1945, around the time Hayworth was filming "Gilda"; their marriage broke up two years later while Welles directed her in "The Lady from Shanghai." The child is Welles' daughter from his first marriage, Christopher; the bullfighter was a house guest.

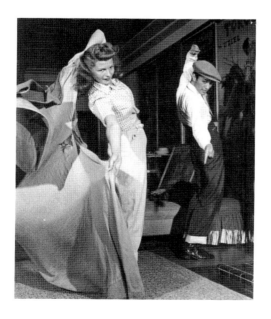

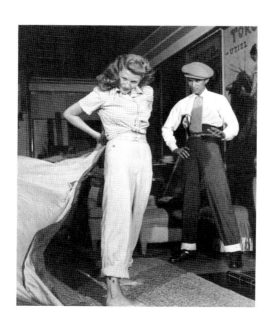

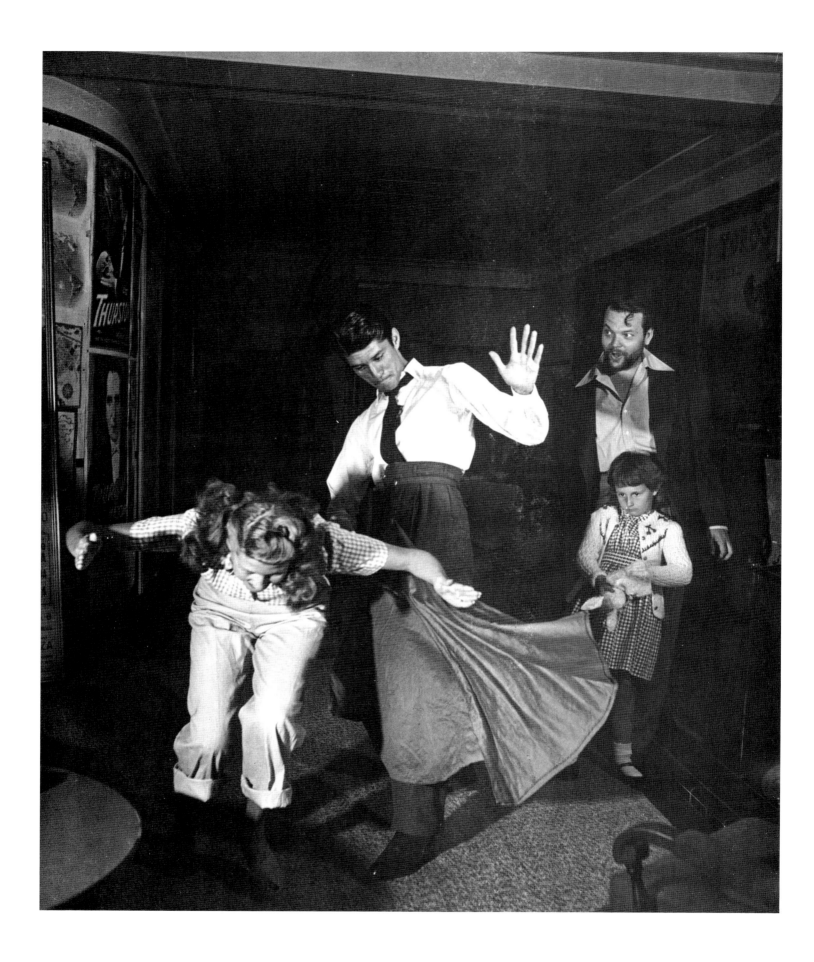

Facing page: Rita Hayworth,
an unidentified bullfighter,
Orson Welles, and
Christopher Welles, 1945.

Above: Joan Crawford with
husband Philip Terry and children
Christopher and Christina, on
vacation in Carmel, 1945.

Right: Joan Crawford and
Philip Terry, 1945.

Above and left: Joan Crawford and daughter Christina, 1945.

Facing page: Gary Cooper on skis above Aspen, Colorado, 1949.

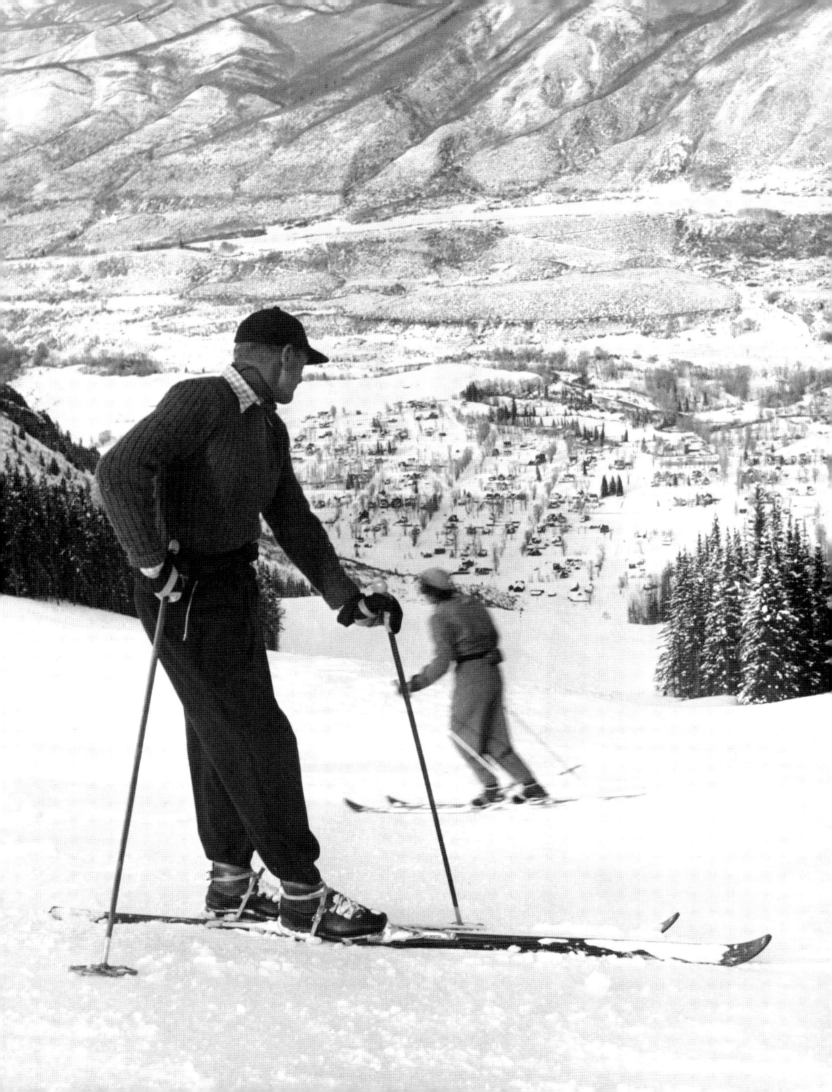

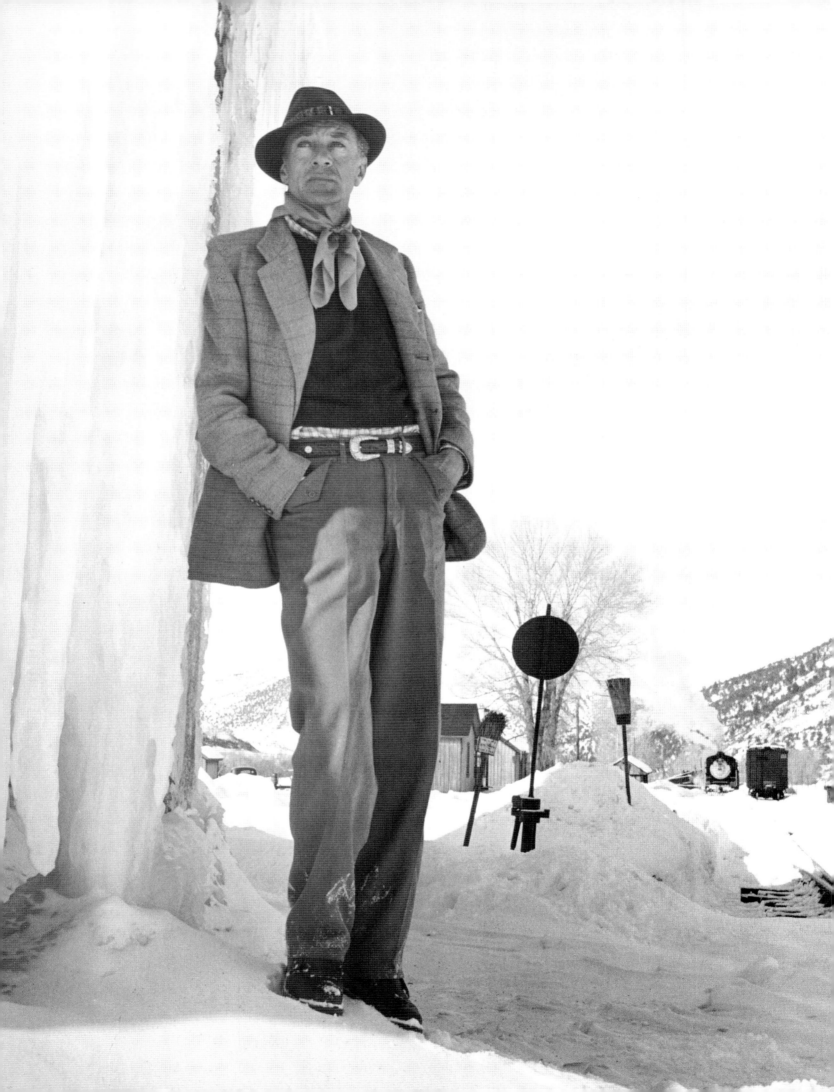

Gary Cooper was the most delightful, easygoing and unaffected of all the male movie people I encountered. I covered him on location for "Beau Geste" and "The Westerner" and in 1949 was assigned to photograph his family's ski vacation in Aspen. At the time the town was still undeveloped, and the Coopers were building a lodge. The point was to follow Coop around, letting him think up the kind of thing he wanted to do most; this included "plunking" (blasting at buzzards on treetops with a rifle) and talking about the weather with old-timers in a country store, none of whom recognized him. Another stop was the railroad yard just below town, where Coop tested his balance. At lunch at the Jerome, he showed me a trademark stunt: he'd wet the filter end of a cigarette and give it an underhand toss to the ceiling, where it joined many similar stalagtites. Restaurants usually waited to clean up the evidence until the Coopers left town. —PS

Facing page: Gary Cooper at the Aspen railroad yard; tying shoes in the Jerome Hotel (right); dancing with daughter Maria (below right); and posing with his family in an abandoned house.

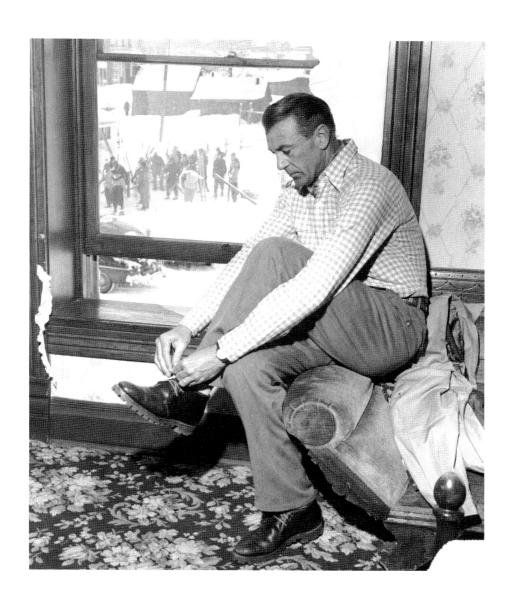

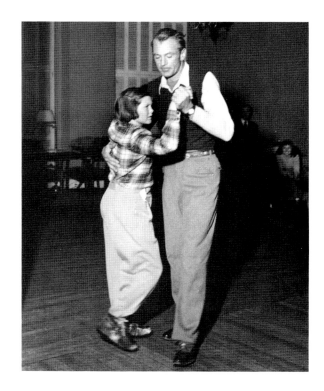

Above: Cary Grant and Sam Jaffe
ride an elephant on the
"Gunga Din" set, 1938.

Facing page:
Douglas Fairbanks, Jr.,
on the set of
"Gunga Din," 1938.

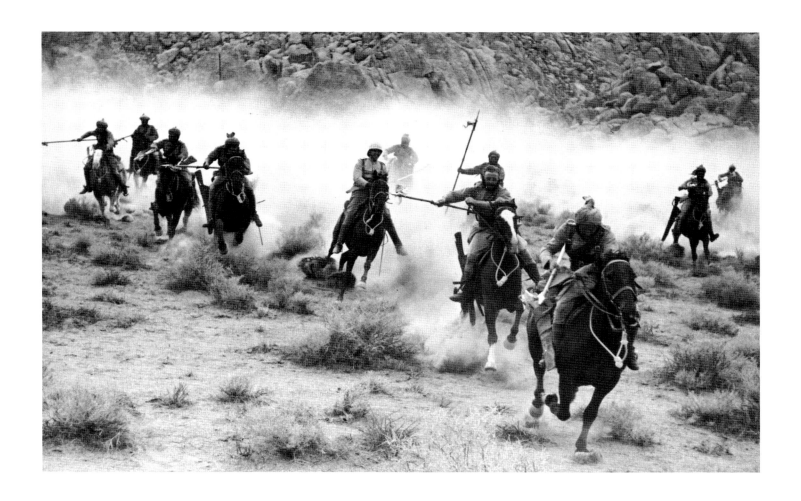

A studio limo drove me four hours to the base of Mount Whitney for my first big location shoot, "Gunga Din," an epic which featured dozens of elephants and horses, hundreds of soldier and tribesmen extras, and a cast and crew that had taken over the town of Lone Pine. Joan Fontaine looked lovely riding side-saddle in a scene with Cary Grant and Douglas Fairbanks, Jr. The next afternoon when I was photographing the long lunch line a young woman wearing blue jeans approached me and said, "Hello, Mr. Stackpole." I looked puzzled. "Don't you remember me? I'm Joan Fontaine," she said. I went red, and all I could think to say was, "Oh, I'm sorry, Miss Fontaine, I didn't recognize you with your pants on." —PS

On the set of "Gunga Din," 1938: Joan Fontaine relaxes between takes (facing page); a battle scene (above); a remarkably lightweight boulder lands on Robert Coote (right).

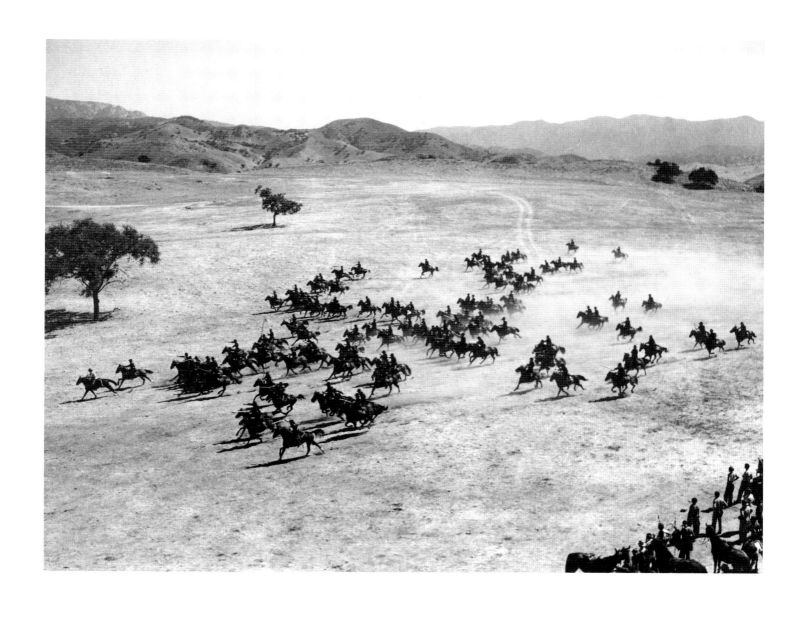

*Above: A cavalry charge from
"They Died with Their
Boots On," 1942.*

*Right and facing page: Extras on
the set of "The Hunchback of
Notre Dame," 1939.*

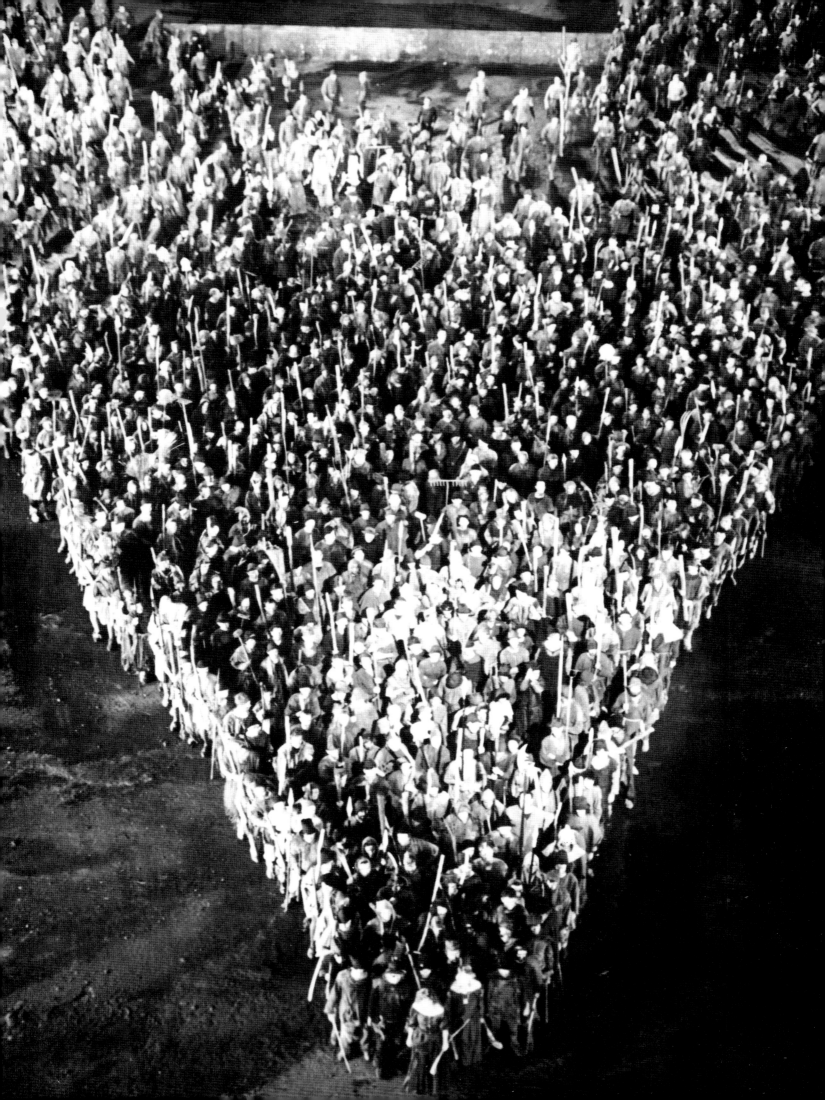

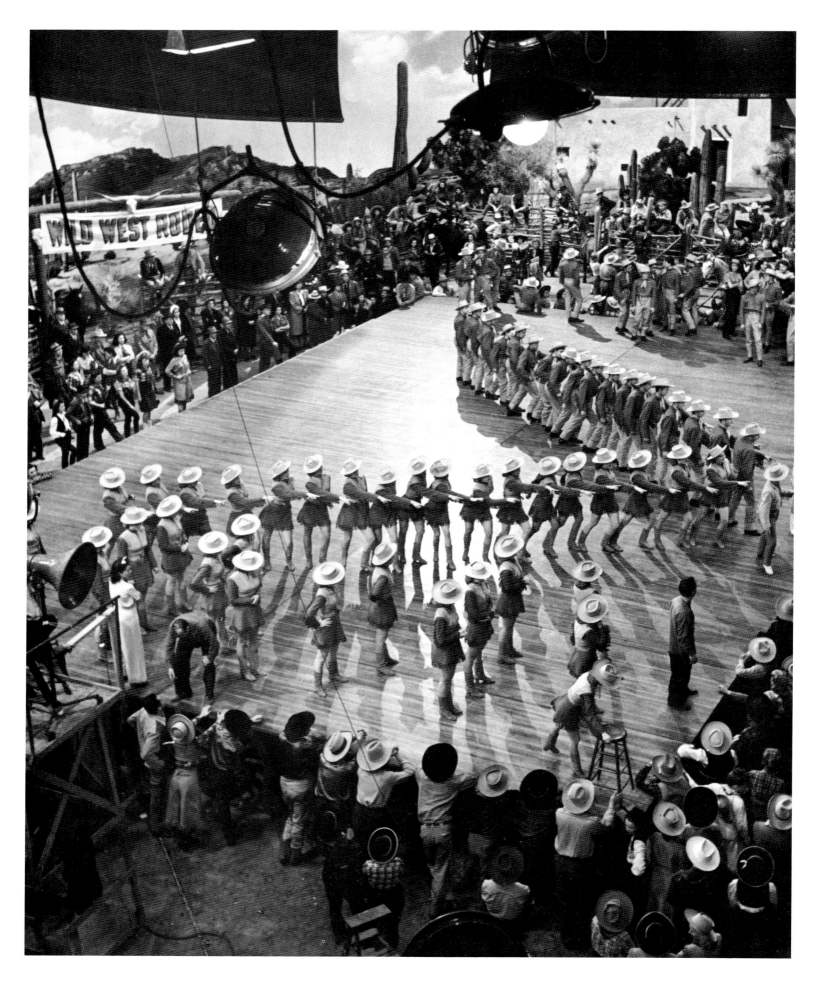

*Facing page: Showgirls on the
soundstage of a big budget musical
in the early forties.*

*Above: An animal trainer readies
ravens for a short titled
"Bill and Coo."*

*Left: A makeup woman prepares
Linda Darnell for a scene.*

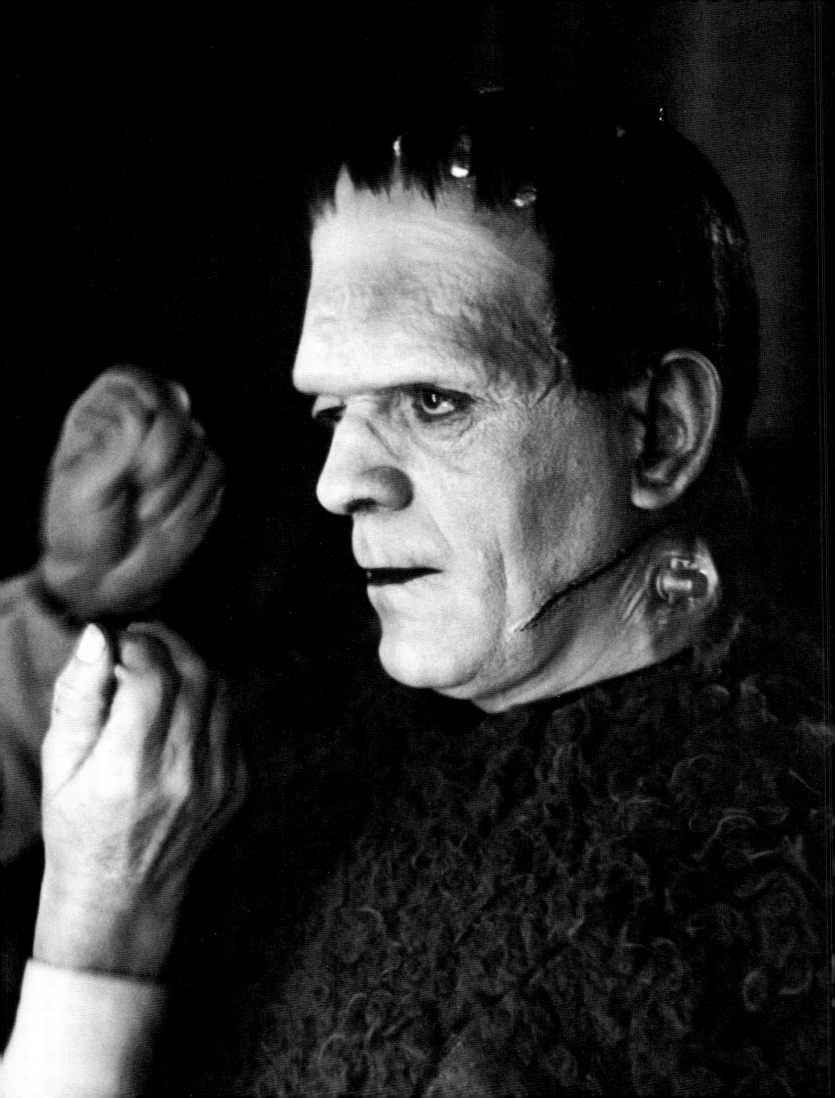

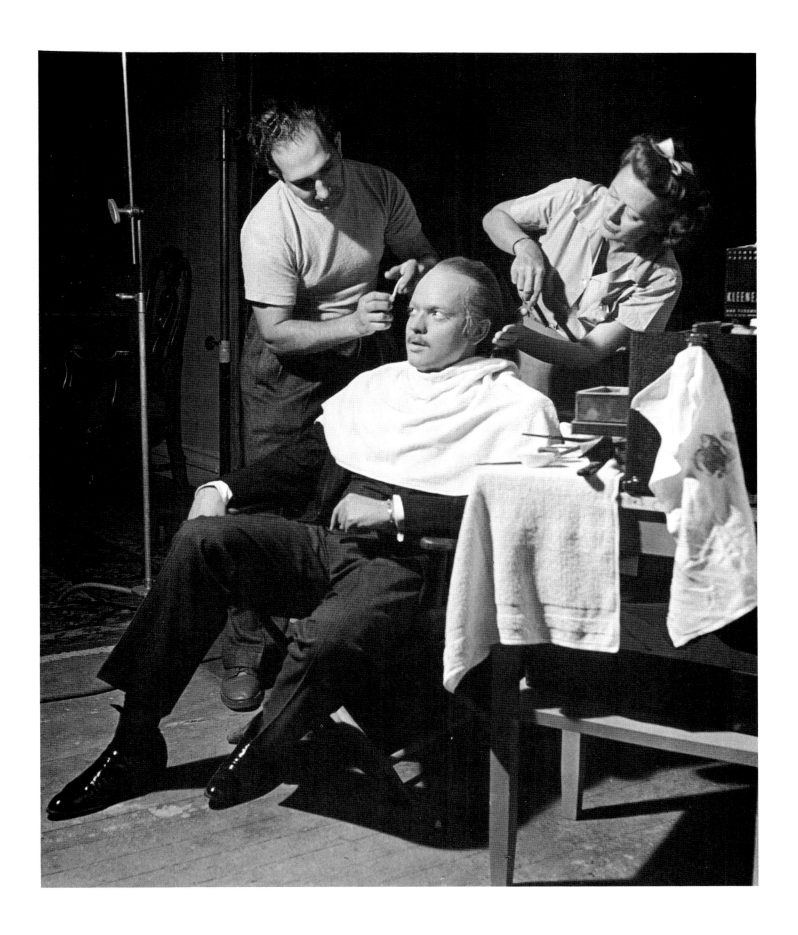

Facing page: Boris Karloff as the
"Son of Frankenstein," 1937.

Orson Welles in makeup for
"Citizen Kane," 1940.

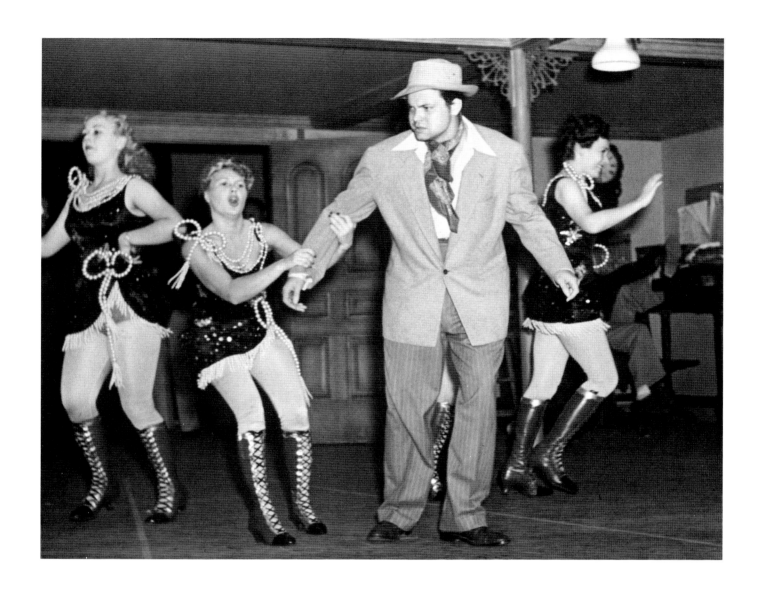

Above: Orson Welles in a rehearsal for "Citizen Kane," 1940.

Left: Billy Wilder tests a Charles Eames chair, designed for the television viewer, 1951.

Right: Danny Kaye drives home in costume as Walter Mitty (1940) and gauges his maid's response (above).

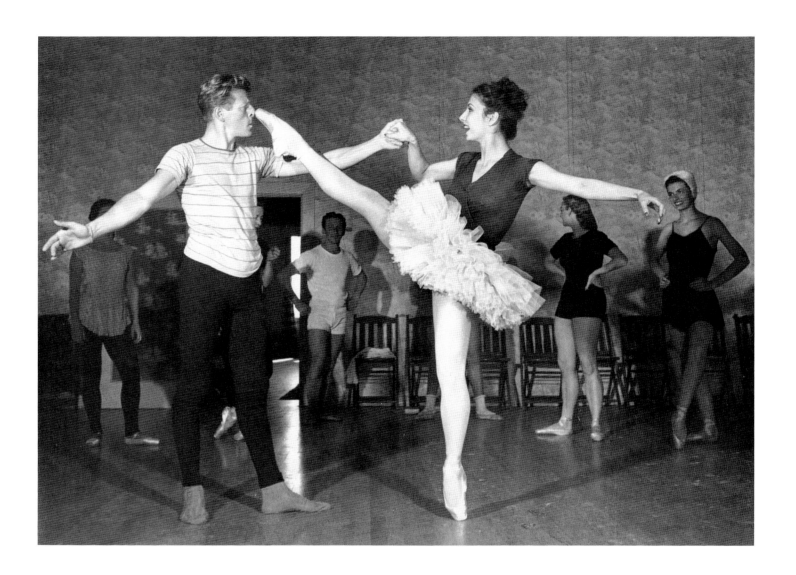

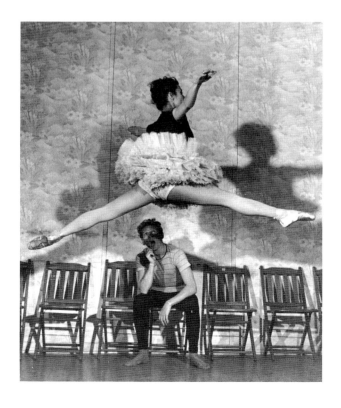

Above and left: Danny Kaye with
a ballerina at a Goldwyn Studios
rehearsal, 1940. Stackpole used
some new strobe equipment for
lighting, which resulted in the
double shadow in the photo at left.

Facing page: Danny Kaye sings
with Dinah Shore in "Up in
Arms," 1943.

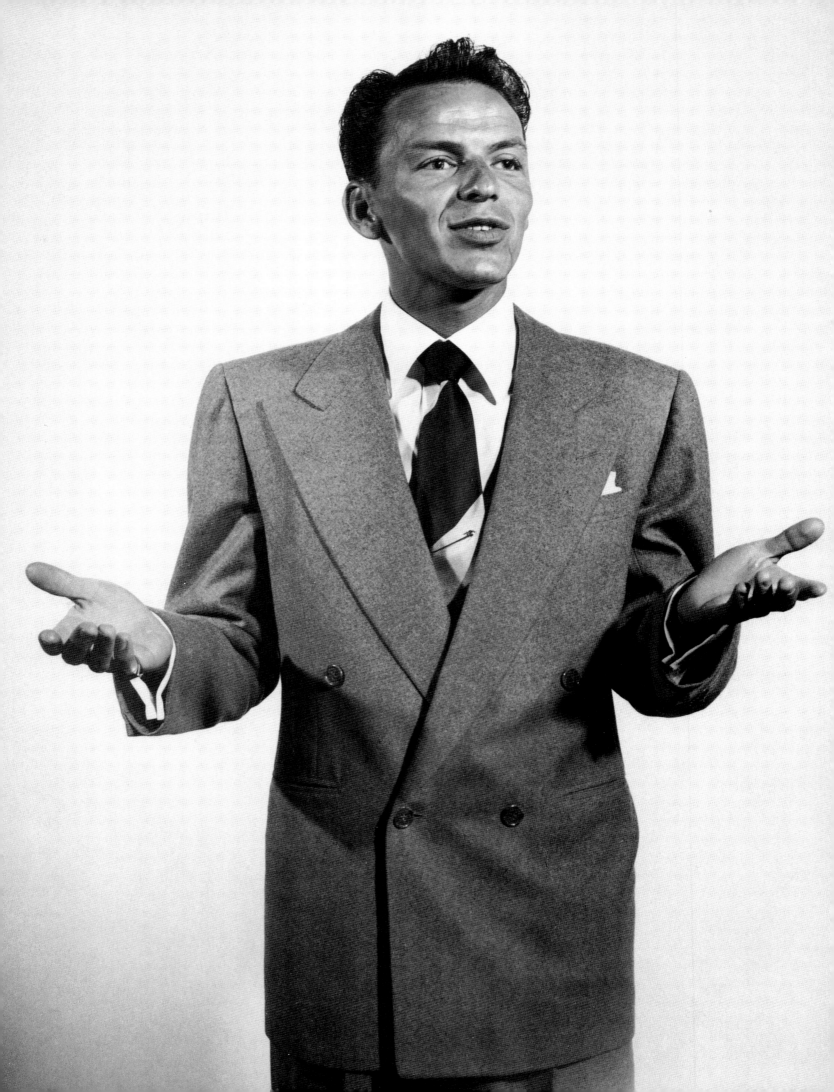

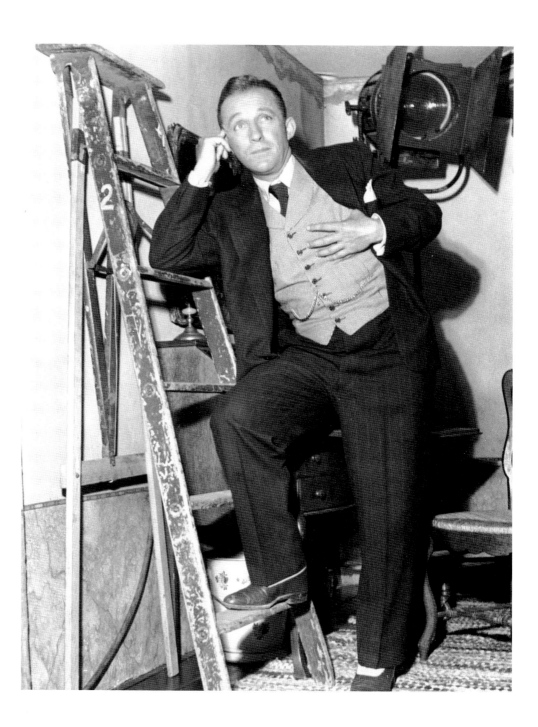

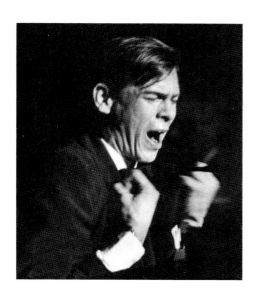

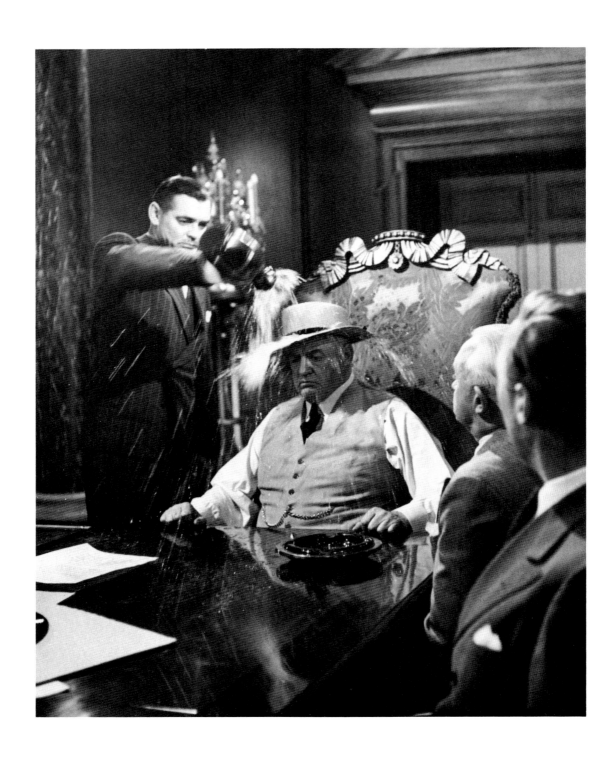

Above: Clark Gable douses Sidney
Greenstreet on the set of
"The Hucksters," 1946.

Facing page: Gable at
Santa Anita, 1945.

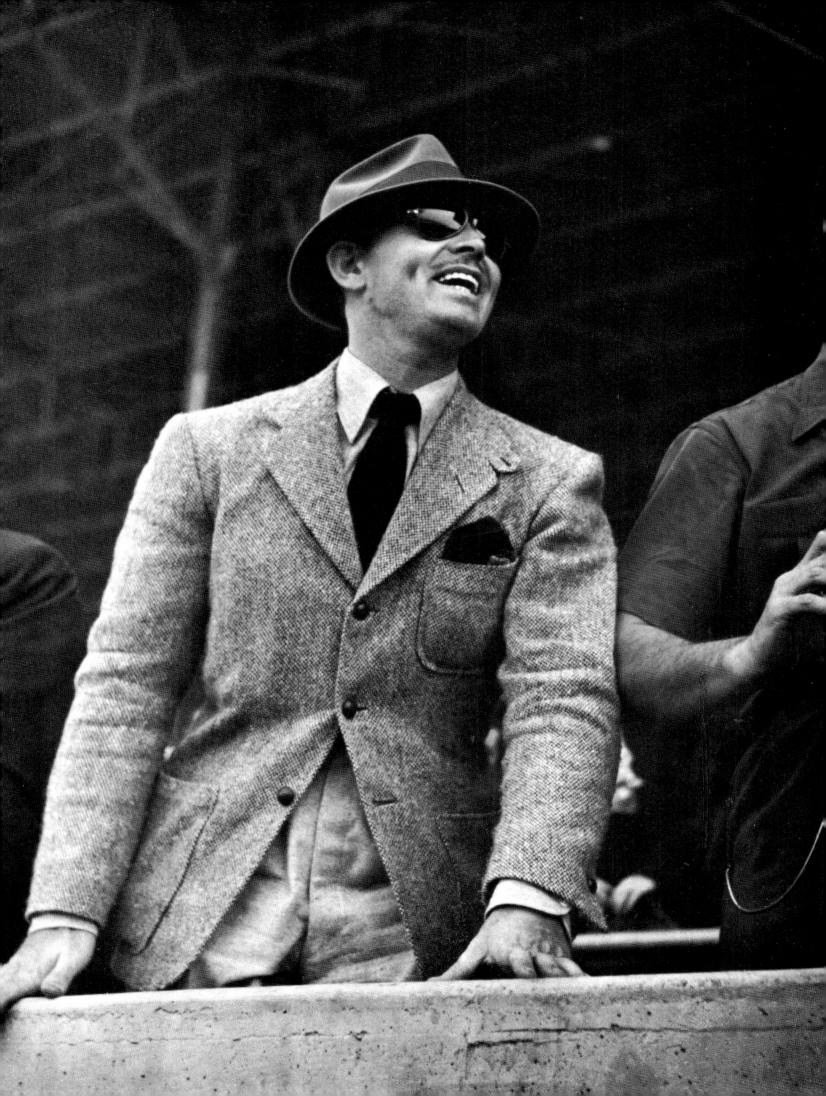

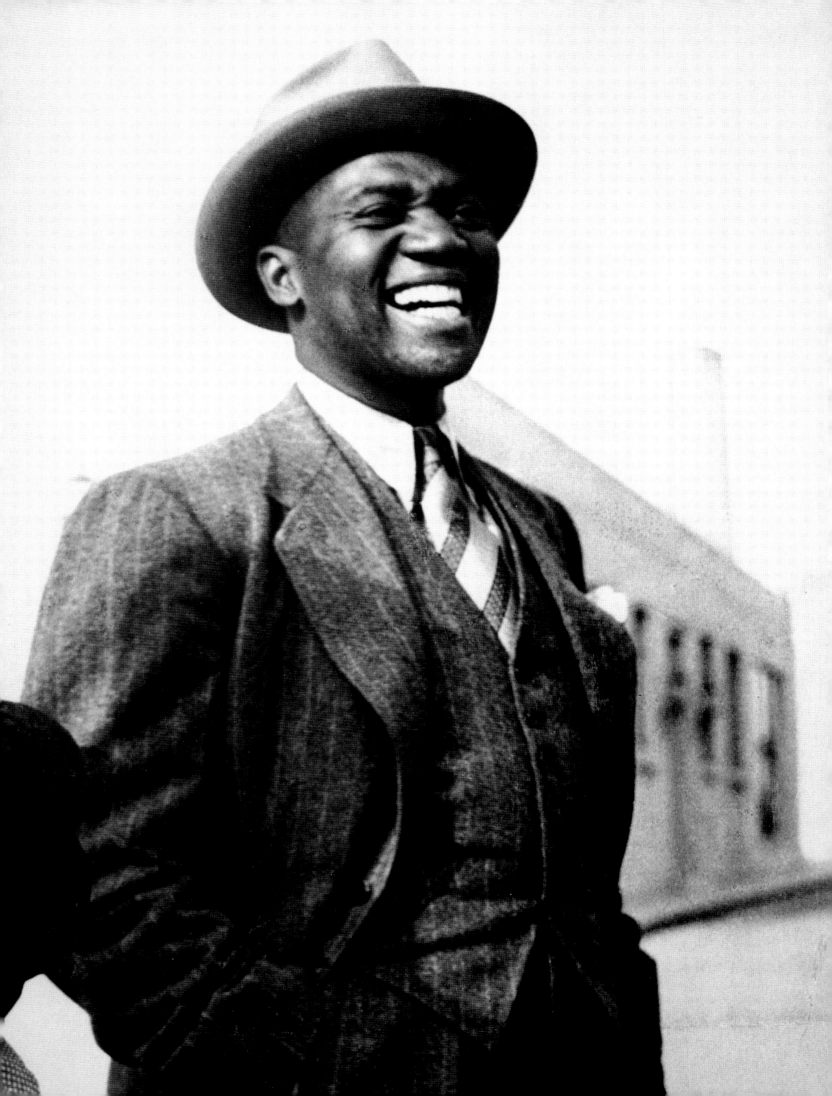

Facing page: Bill "Bojangles" Robinson, star of "Stormy Weather," also coached and costarred with Shirley Temple in numerous movies.

Above: Walter Huston ("The Virginian," "The Light that Failed," "Treasure of the Sierra Madre") as the Devil in "All That Money Can Buy," 1941.

Right: New matinee idol Van Johnson ("The Caine Mutiny," "Brigadoon") reads a letter from home, 1944.

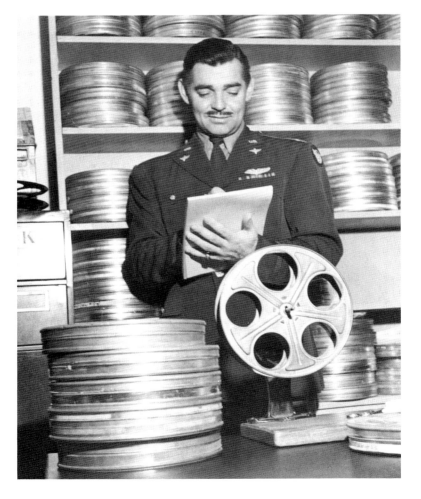

Above: William S. Hart, 1945. Hart was the first film cowboy hero, and went on to direct some of the first Westerns, including "The Silent Man" and "The Narrow Trail," both filmed in 1917.

Left: Clark Gable, in uniform, takes notes amid MGM film reels, 1943.

Facing page: Gary Cooper between takes as Beau Geste in Yuma, Arizona, 1938.

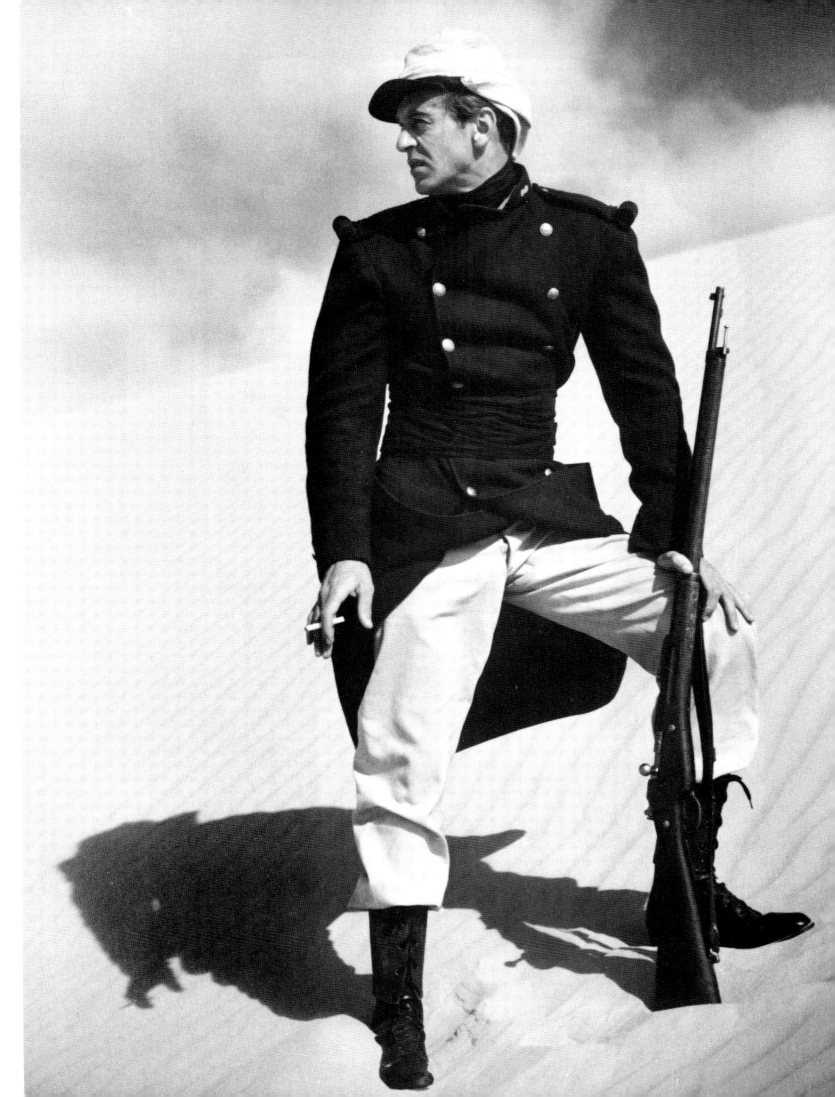

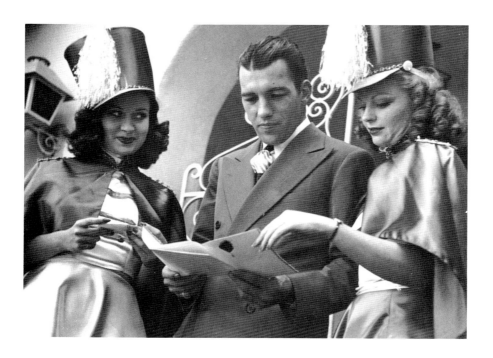

Top: Charles Boyer
("Love Affair," "All This and
Heaven Too," "Gaslight")
and Ronald Colman ("Raffles,"
"The Prisoner of Zenda,"
"A Double Life"), 1938.

Bottom: Messenger girls on
motorscooters deliver a party
invitation to Ed Sullivan.

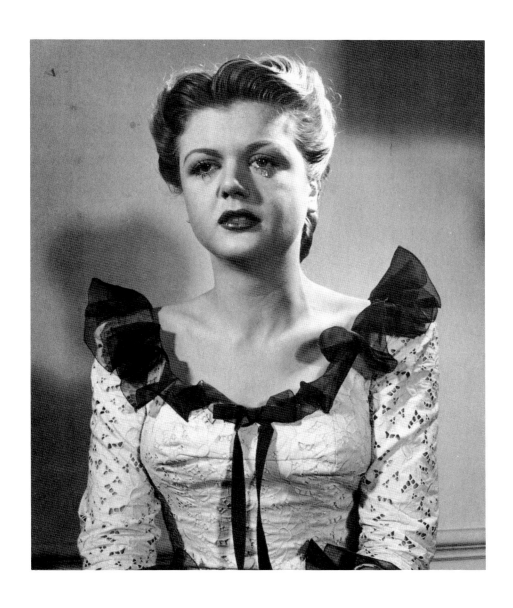

Top: Angela Lansbury's early reputation was partly based on an ability to cry at will for a role. This photo was taken in 1946, after "Gaslight" and "Dorian Gray" and before "State of the Union."

Right: Mary Martin, whose Broadway shows included "South Pacific" and "Peter Pan," films a strip scene for "Kiss the Boys Good-Bye," 1941.

Following pages: Greer Garson as Mrs. Parkington in 1944 (left); Vivien Leigh as Scarlett O'Hara during the filming of "Gone with the Wind," 1939.

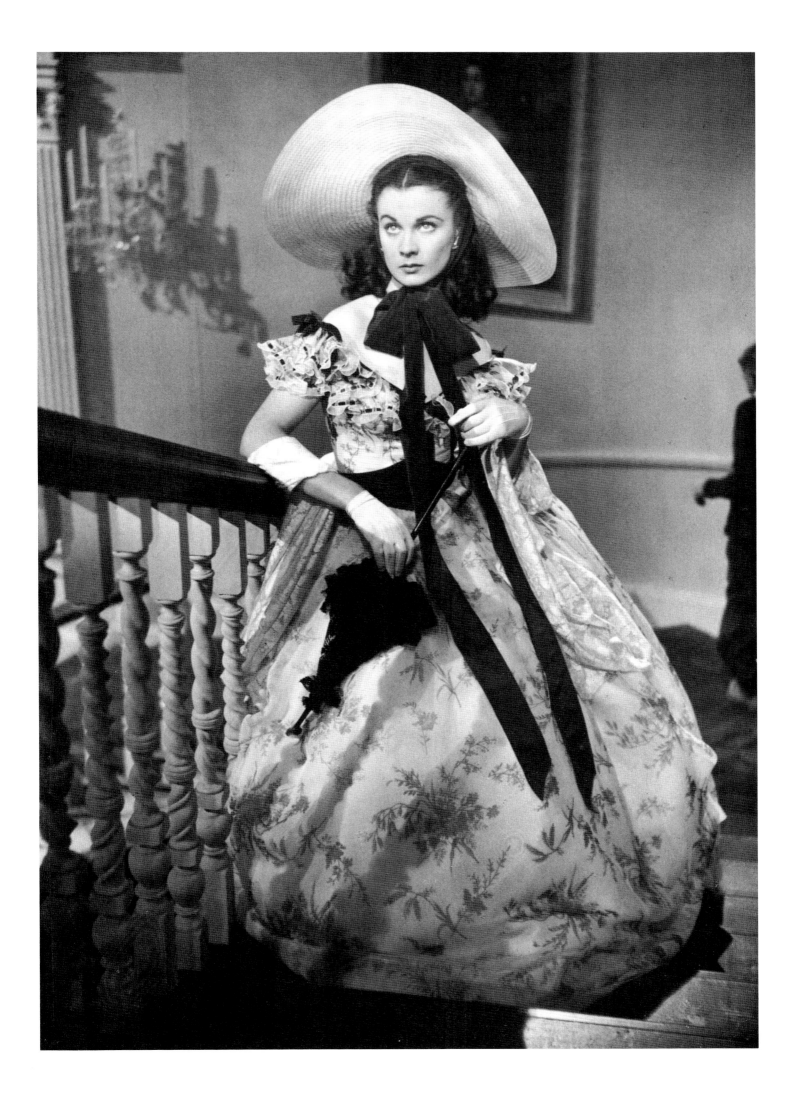

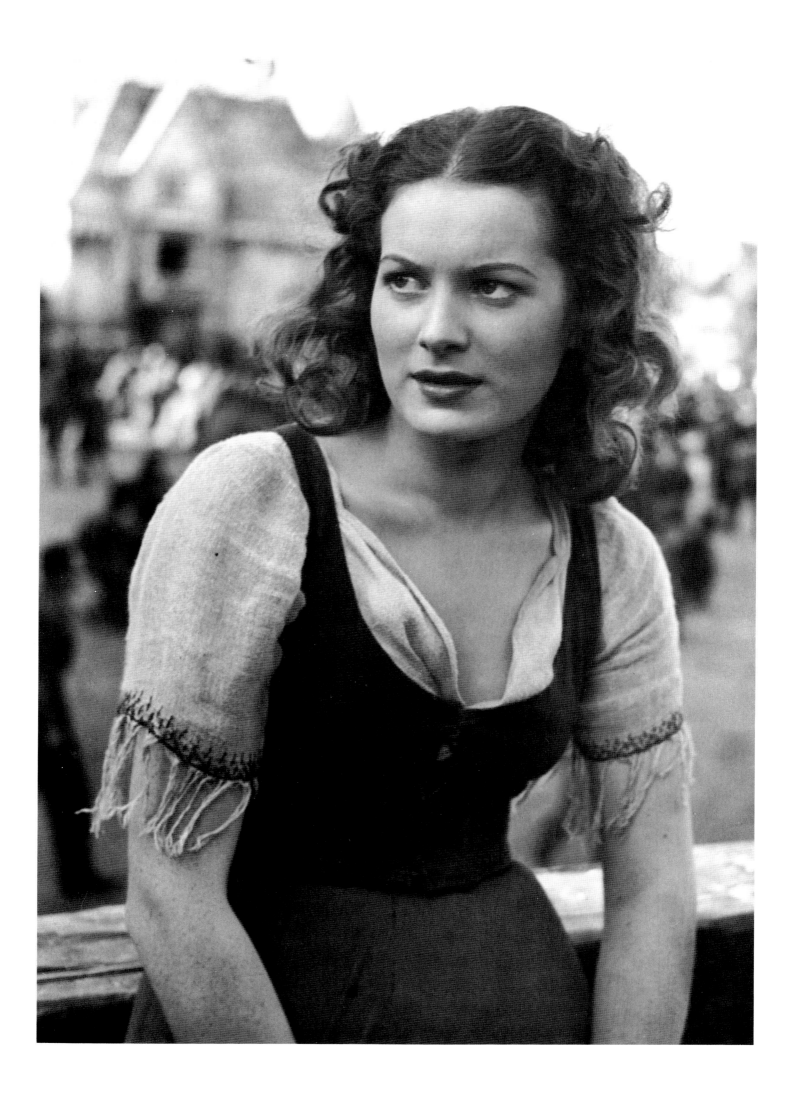

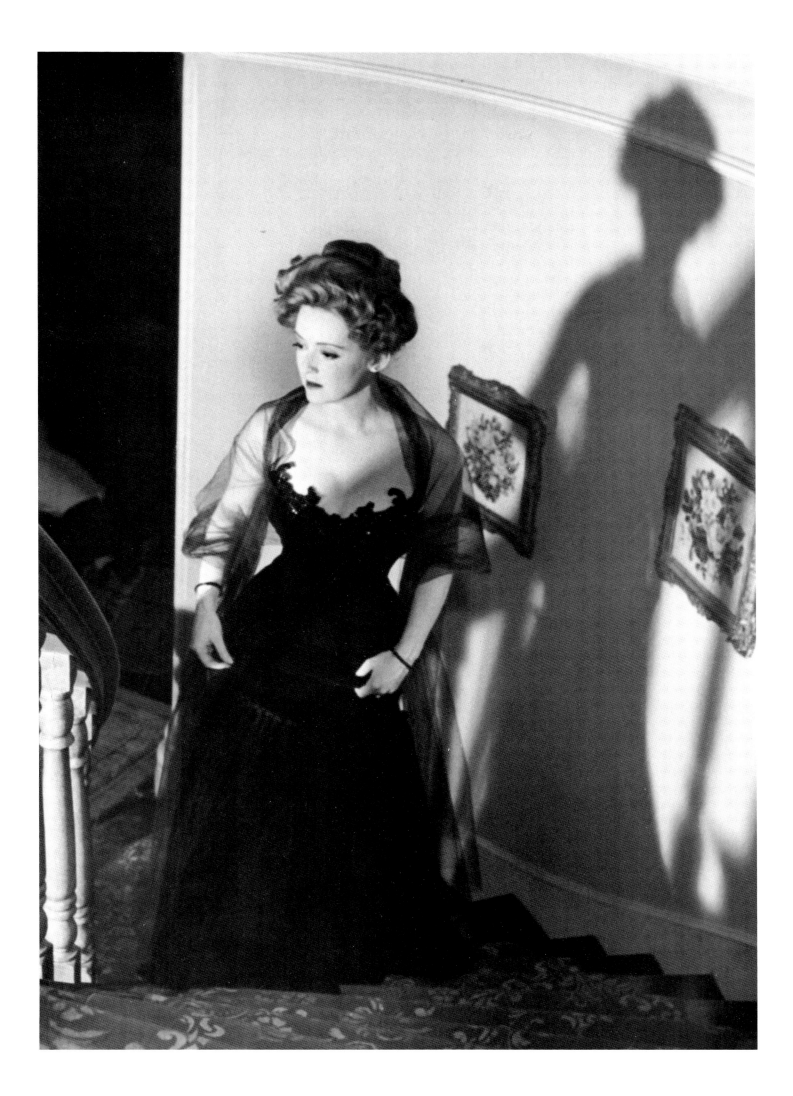

Preceding pages: Maureen O'Hara in costume as Esmeralda in "The Hunchback of Notre Dame," 1030 (left); Bette Davis in "The Little Foxes," 1941.

Above: Maureen O'Sullivan ("Tarzan the Ape Man," "Pride and Prejudice"), 1948.

Left: Barbara Bel Geddes ("The Long Night," "Vertigo"), 1046.

Facing page: Ingrid Bergman in 1041, during the filming of "Dr. Jekyll and Mr. Hyde."

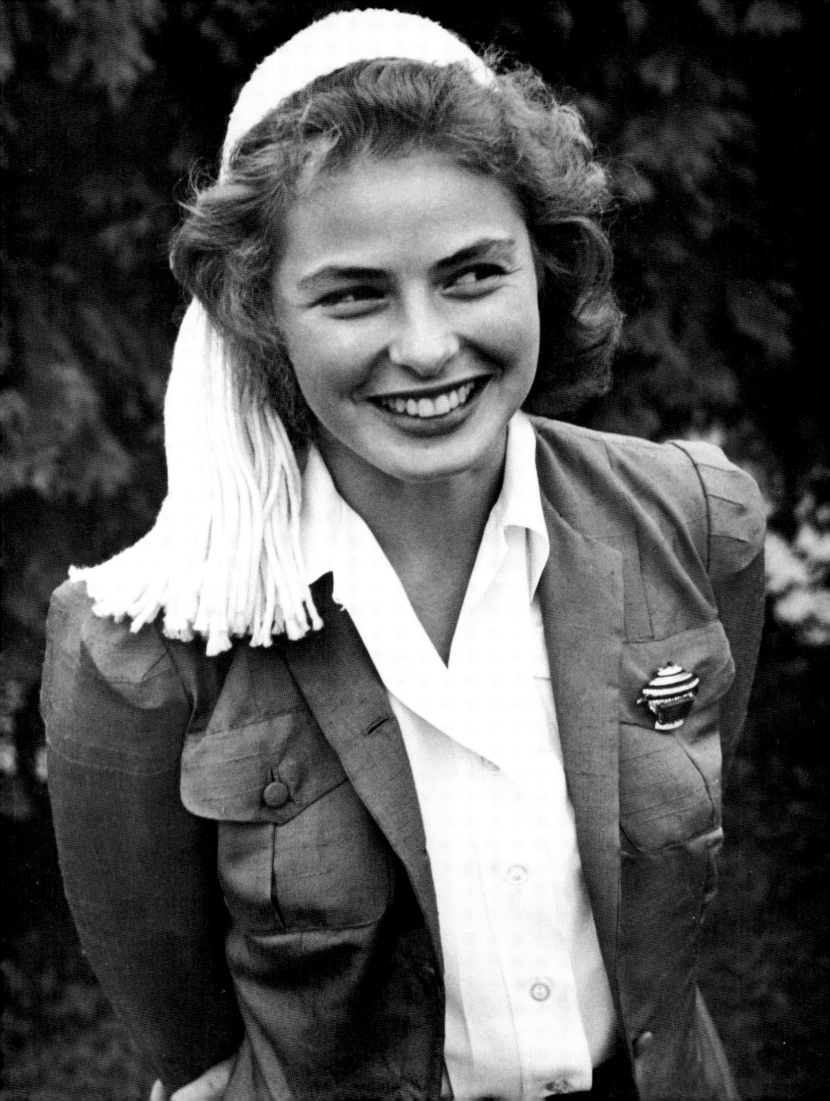

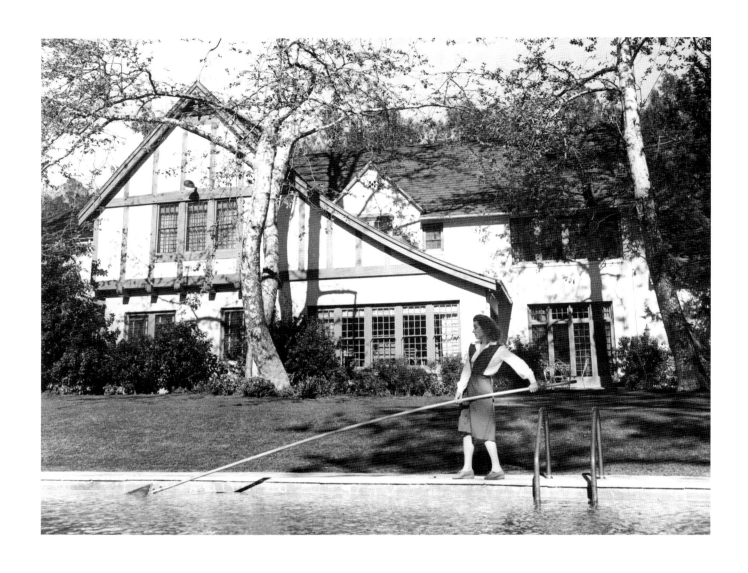

Greer Garson would arrive home from the studio for a shoot at least an hour late, followed by an entourage of three black studio cars containing a publicity man, hairdresser, makeup man and their chauffeurs. She had wit and charm, and rare beauty. She always asked what she should wear, had her butler bring drinks and made sure everyone was comfortable. After one shoot, when she found out I'd become a father, a car arrived the next day with a beautifully wrapped package of sculpture tools, brushes, paints and a toy camera. —PS

Above: Greer Garson, whose films included "Blossoms in the Dust," "Mrs. Miniver," and "Madame Curie," cleans her pool in Bel Air (1940) and tests the water from her diving board (facing page).

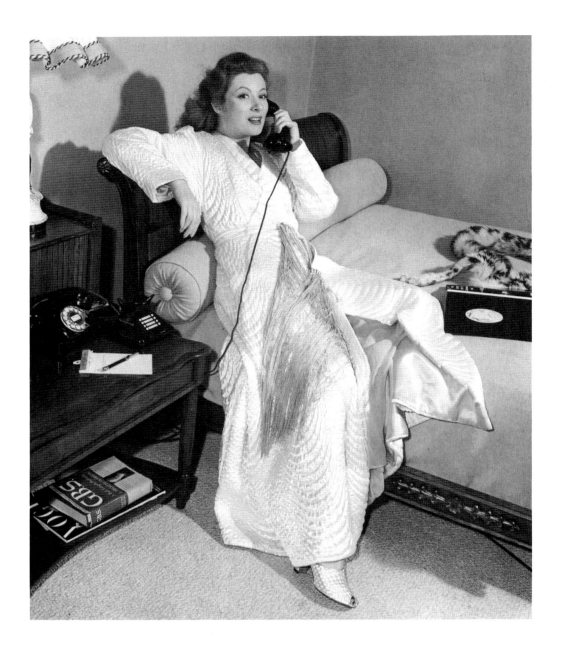

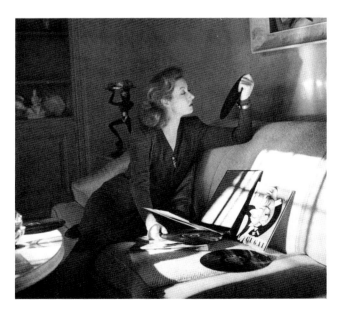

The first time I photographed her, I used a 4×5 camera to pick up her delicate coloring, and the slightly pink hair she'd set off with a light green dress. I dropped the film off at the office and the next day was shocked to find all the images of her were pale ovals surrounded by light-struck borders; an office secretary who was a Greer Garson fan had opened the box and ruined the film. Garson agreed to another visit but insisted on seeing the faint images. She loved the pale color, which made me nervous about duplicating the effect; the new images were correctly exposed, but the pale effect she liked so much was gone. —PS

Top and left: Greer Garson on the phone and sorting her record collection, 1940. "LIFE's" caption mentioned the fact that Garson actually read books, like the George Bernard Shaw biography on display on her bedside table.

Facing page: Stackpole photographed Anne Baxter (Frank Lloyd Wright's granddaughter, whose roles included parts in "The Razor's Edge" and "All About Eve") in 1942, and writes that "she knew I was happy with what I saw in the camera, and she relished the situation." Nigel Bruce arrived for Ping-Pong and brunch and broke the tension.

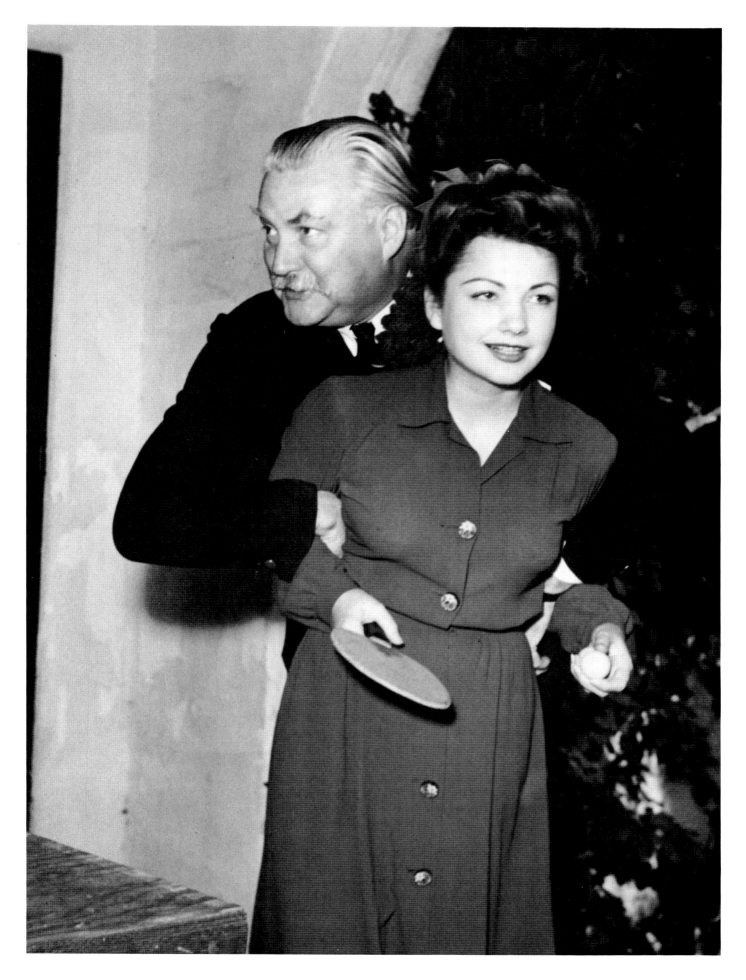

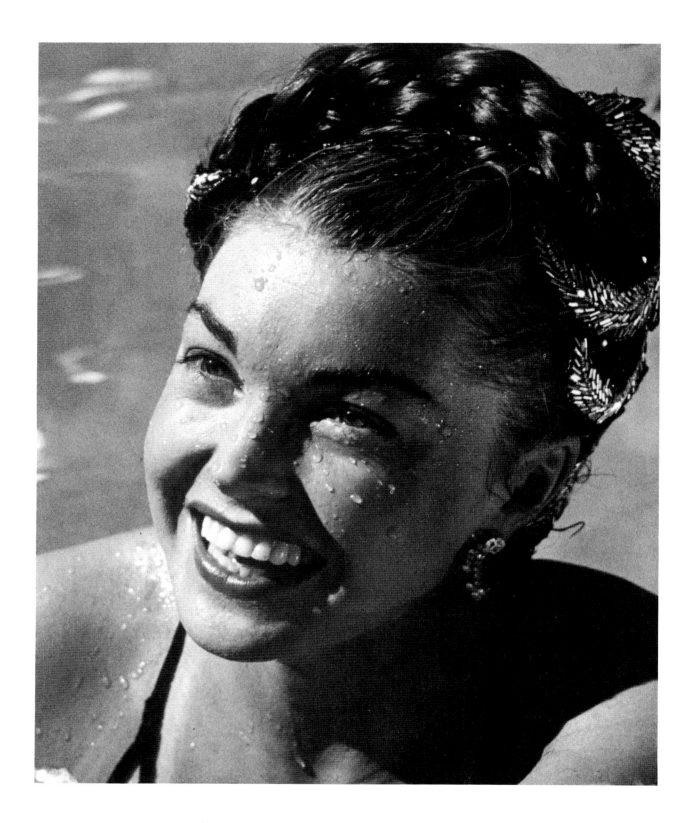

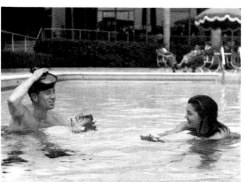

Above: Esther Williams ("A Guy
Named Joe," "Ziegfeld Follies") in
a cover photo from 1951
and with Stackpole
during the shoot (left).

Facing page: Esther Williams
sips a soda, 1943.

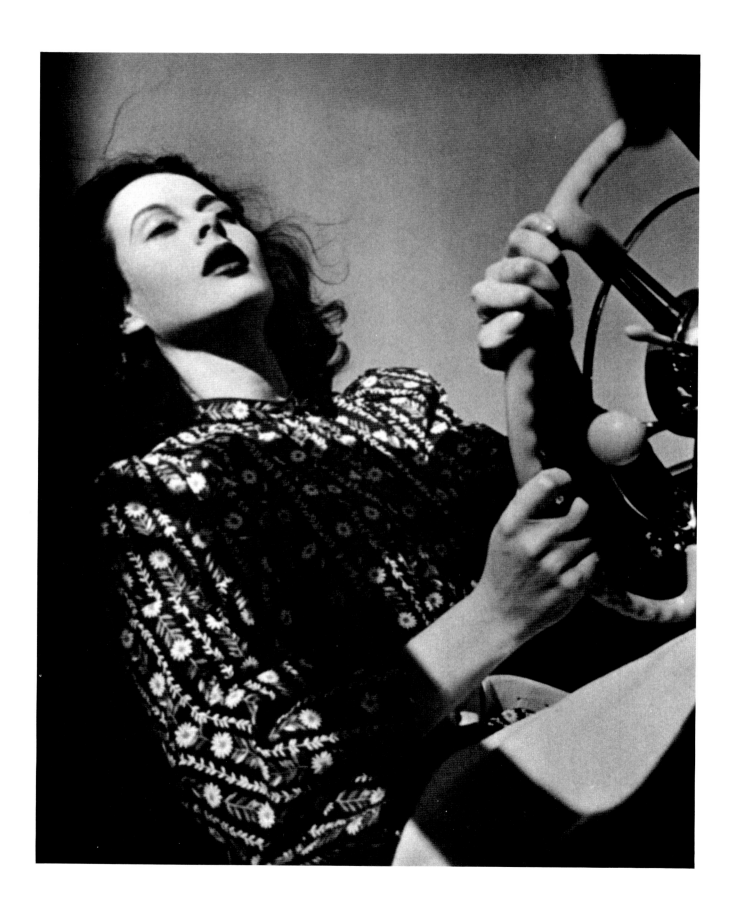

As a high school kid I'd sheepishly
paid my way into a fleatrap movie
house on Market Street in San
Francisco to see "Hedy Kiesler" in
the Czech film "Ecstasy." It was
featured as an art film, too strong
for the major houses, and
photographing her became one of
my ambitions. When I finally
photographed Hedy Lamarr at her
house below Mulholland I was
clearly nervous, and she knew it
and was impatient, but after a few
reluctant poses I think she realized
I wasn't a gag photographer. It
was clear she wanted to remain well
dressed rather than exploiting the
figure I remembered so well, but I
was glad she was wearing a lot of
pearls—anyone who has seen
"Ecstasy" remembers her broken
necklace falling to the floor.

I suggested a short drive in my new
Buick. Her hair blew wildly as she
sped along the road, and I lay on
the floor, my legs up the back of
the seat, to frame her face and the
steering wheel against the sky. We
were tearing around curves, tires
squealing, when suddenly Hedy
screamed with laughter: a lady in
her garden had dropped everything
at the sight of a movie star racing
by with someone's legs in the air
next to her. —PS

Facing page: Hedy Lamarr takes
Stackpole for a ride in the
Hollywood Hills and (right)
pores over a screen
magazine in her home.

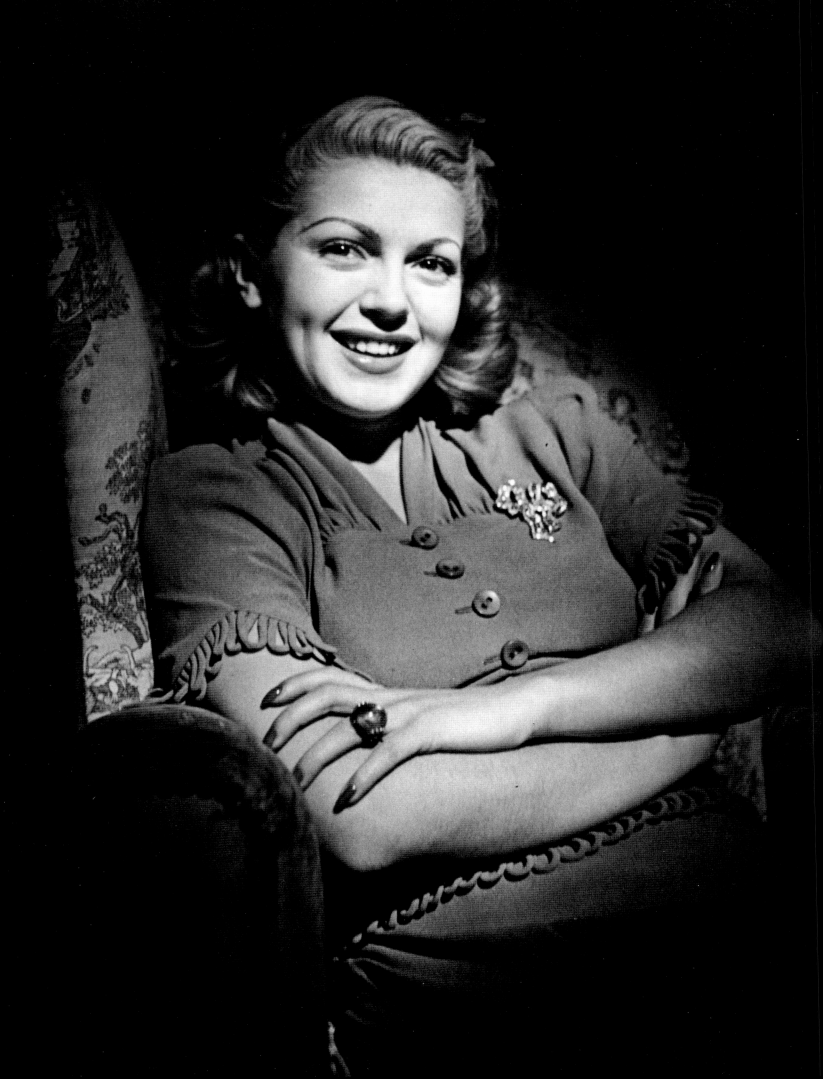

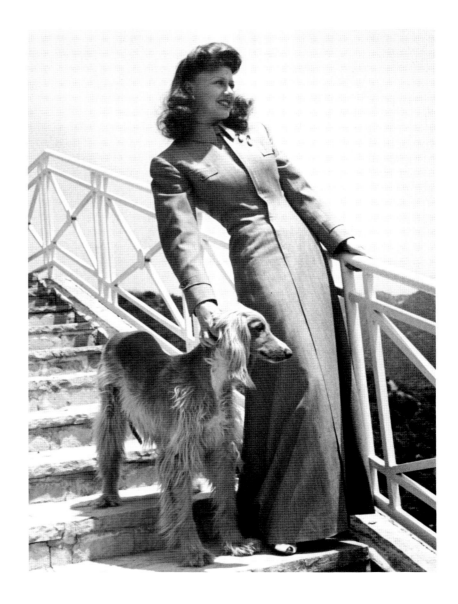

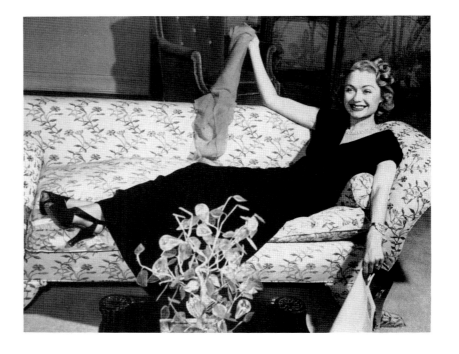

Facing page: Lana Turner ("The Postman Always Rings Twice," "Imitation of Life"), in 1941.

Above: Ginger Rogers ("Flying Down to Rio," "Top Hat," "Stage Door") with her Afghan in the early forties.

Right: Constance Bennett ("Topper," "Two-Faced Woman") displays her usual sense of humor.

Following pages: Loretta Young ("Eternally Yours," "The Farmer's Wife") waters her garden in 1940 (left); Joan Bennett (Constance's younger sister, and the star of "Woman in the Window" and "The Reckless Moment") claimed in 1940 that she picked fresh flowers daily for her house and third husband, Walter Wanger (producer of such varied efforts as "Stagecoach" and "Cleopatra"). This domestic bliss came into question when Wanger shot Bennett's agent, Jennings Lang, in 1952; Wanger and Bennett stayed together until the mid-sixties.

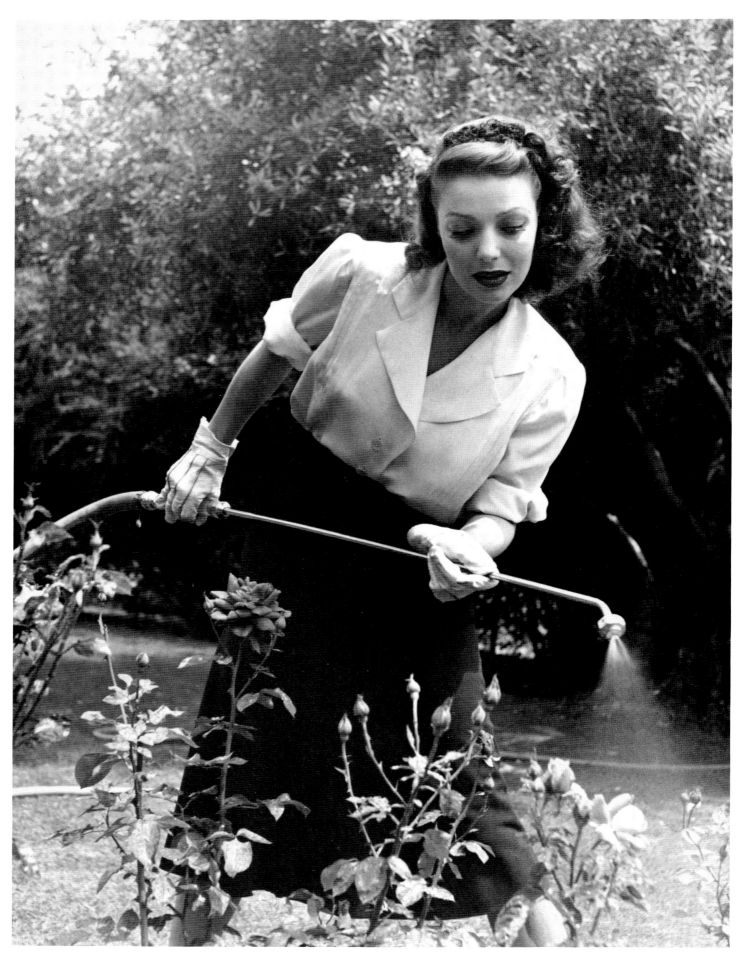

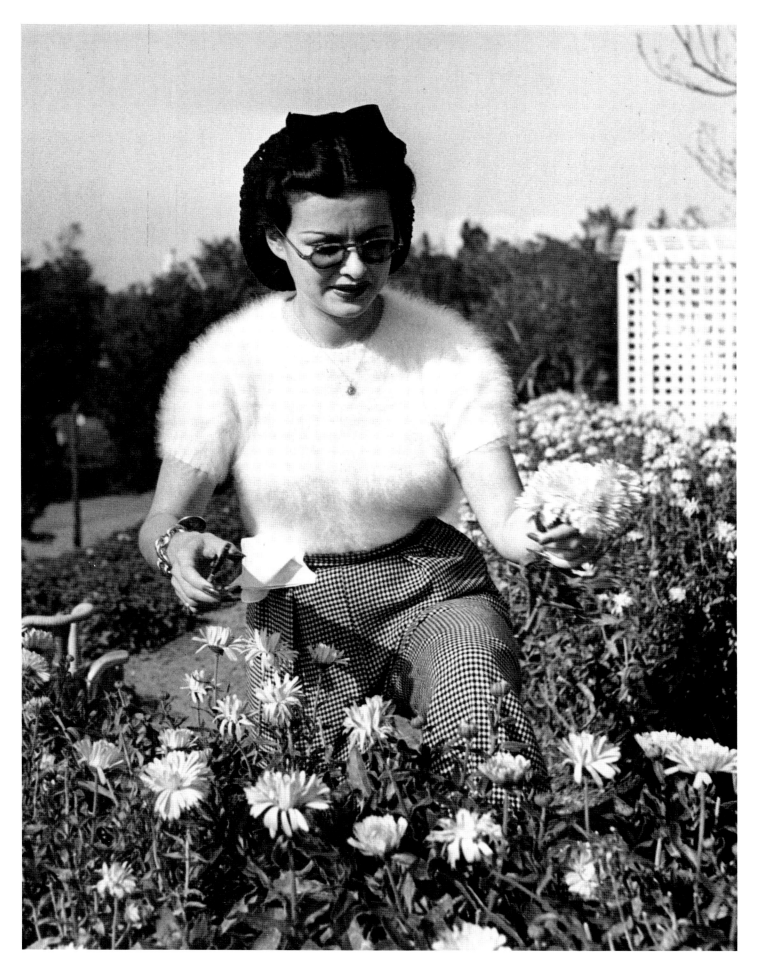

Facing page: Ann Miller ("On the Town," "Kiss Me Kate"), 1941.

Above and right: Mary Pickford watches a kabuki dancer and arranges flowers at Pickfair in the early forties, a decade after her retirement from acting.

Preceding pages: Joan Bennett tests a new bacon-cooking device in 1940 (left); Maureen O'Hara ("How Green Was My Valley," "Rio Grande") collects vegetables, 1940.

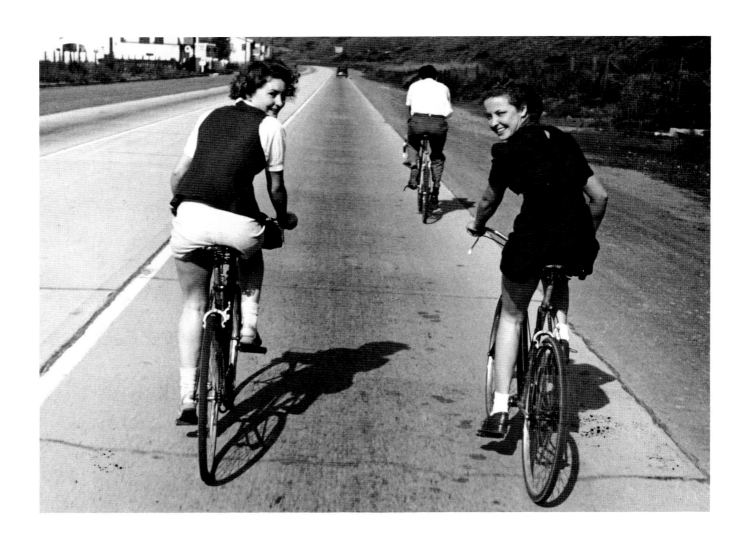

Above: Laraine Day (right) and a friend ride bikes up the coast highway; Day on the MGM lot (facing page).

One morning at RKO I caught some scenes from "Foreign Correspondent," and between takes I found myself chatting with Laraine Day, the female lead, a strict Mormon. I liked her style and intelligence, and it turned out that she loved bicycling. Months later, when she was working at MGM, several of us set off for Malibu on Highway 101, a jaunt that would be impossible in today's traffic. We kept the bikes in close formation, Laraine getting the exercise she thought she needed. There was a premium on flat stomachs in those days, and I remember seeing a torturous strip of tight rubber underpants as she cycled. —PS

Laraine Day with her dance
instructor. Her most notable role
was as the fiancée in the
"Dr. Kildare" series, but after
she married Leo Durocher in 1947
she became known as
"the first lady of baseball."

Robert Walker and June Allyson in
"Her Highness and the Bellboy,"
1945.

Facing page: Ginger Rogers in a dance marathon scene from "Bachelor Mother," 1939.

Above and right: Ray Bolger ("The Great Ziegfeld," "Babes in Toyland"), 1939.

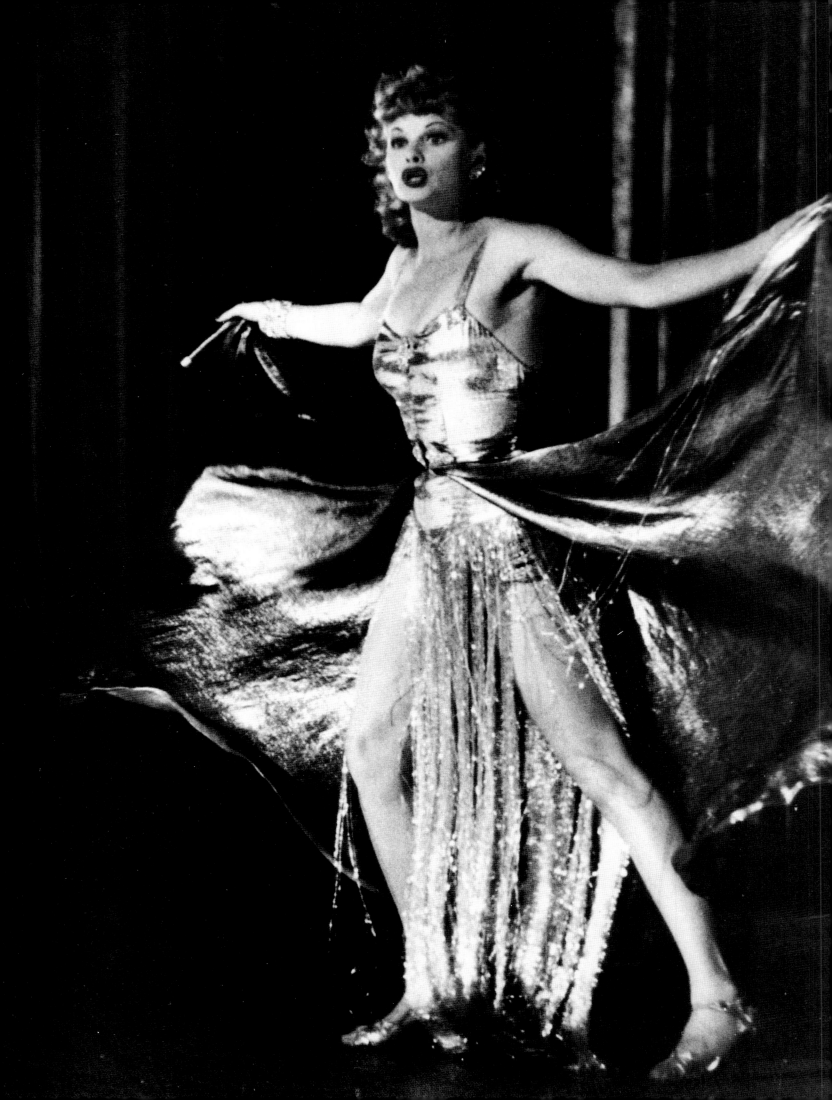

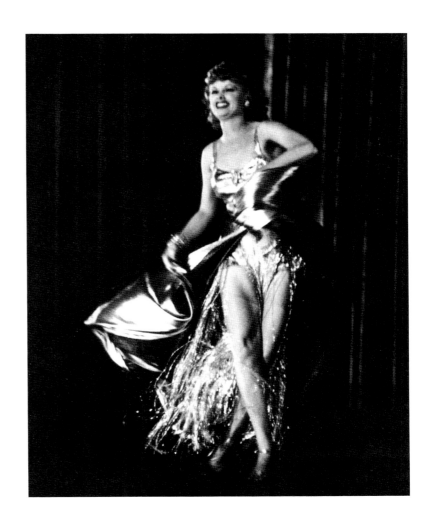

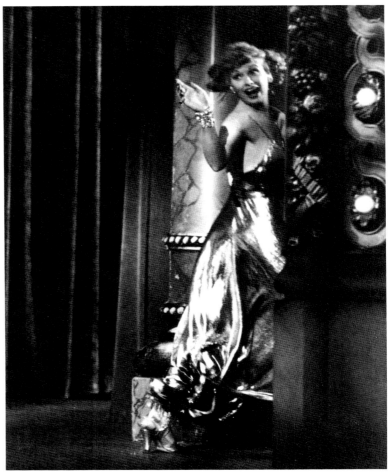

Lucille Ball's striptease in "Dance Girl, Dance" (1940) was performed in a cellophane skirt so flammable that a fire marshal stood on hand while the scene was filmed.

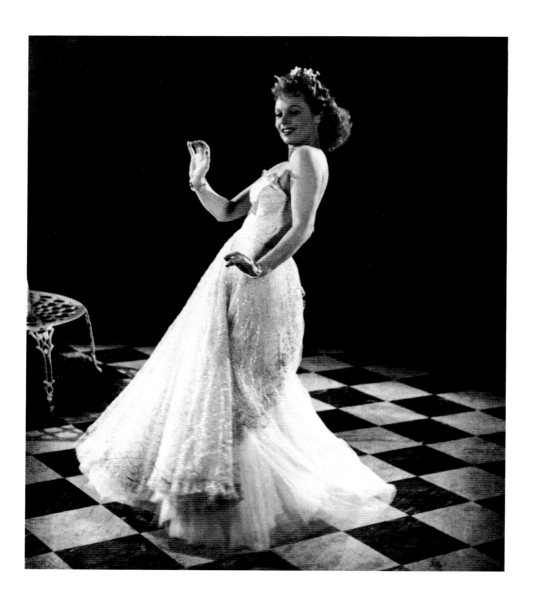

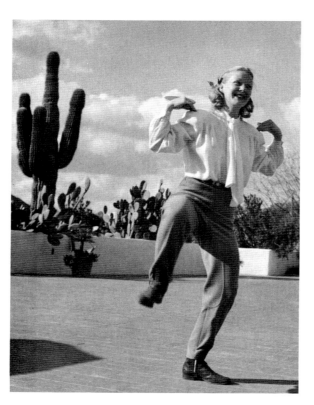

Above: Anna Neagle
in "Irene," 1940.

Left: Betty Hutton does a
cactus dance on a dude ranch
in Arizona in 1945.

Facing page: Ginger Rogers has a
soda with her mother Lela at home
after winning the Oscar for
"Kitty Foyle," 1941.

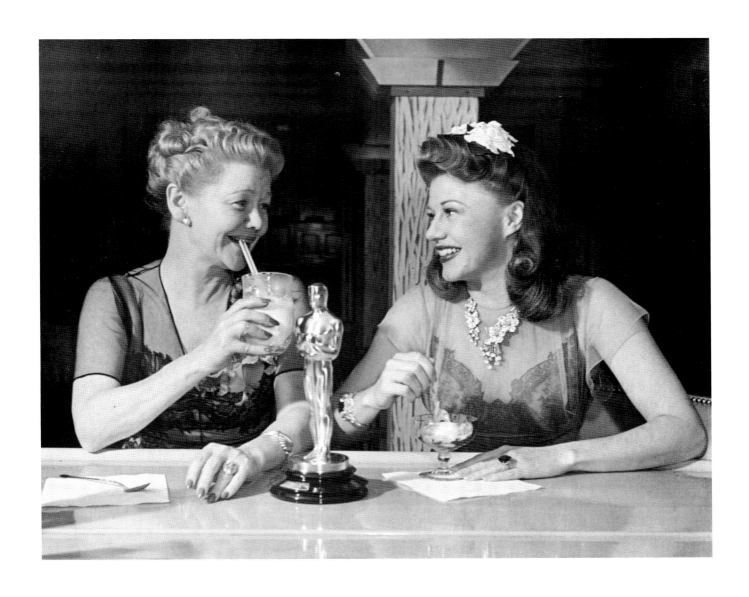

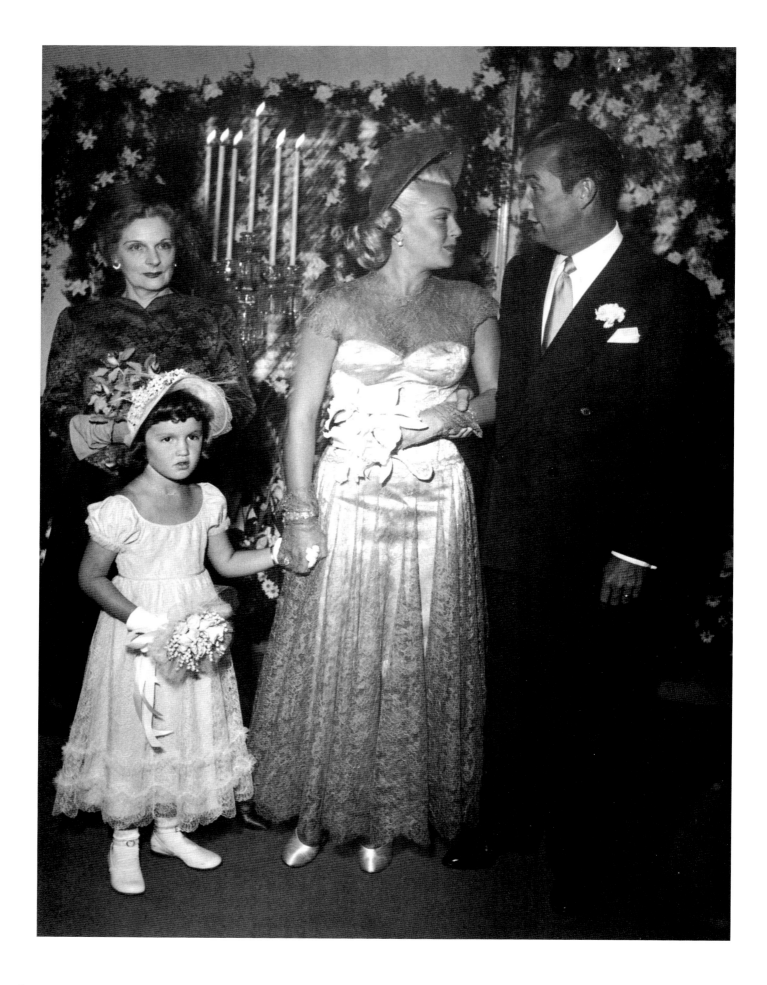

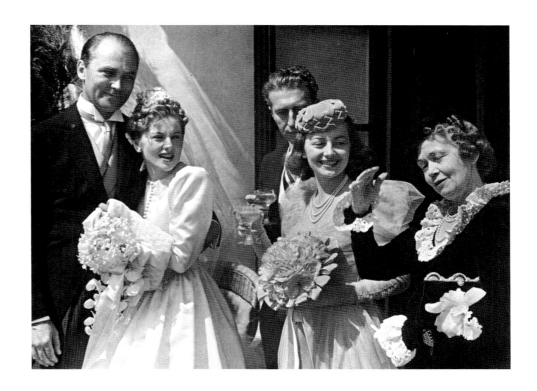

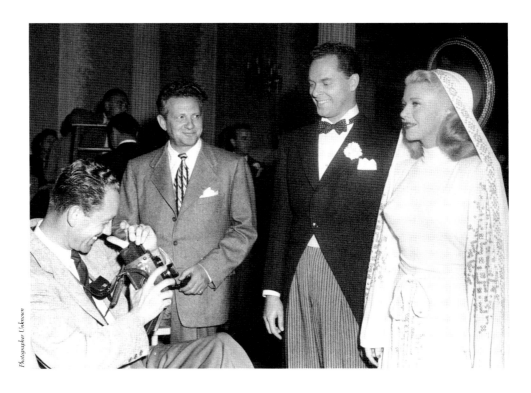

Photographer Unknown

Facing page: Lana Turner and Bob Topping (the former owner of the New York Yankees) at their wedding with her daughter Cheryl, 1948.

Top: Joan Fontaine and Brian Aherne (left) pose after their August, 1939, wedding with Fontaine's sister Olivia de Havilland and their mother Lillian de Havilland.

Right: Peter Stackpole photographs Ginger Rogers in a wedding scene.

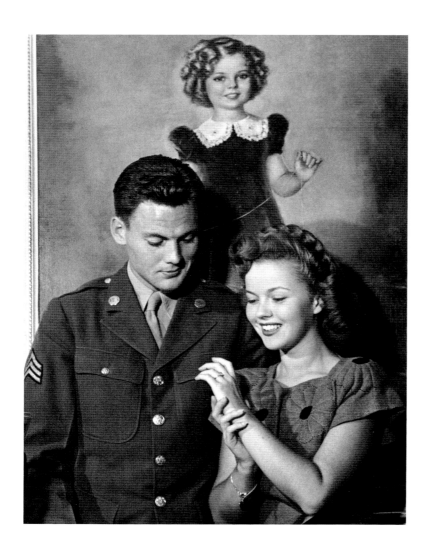

Top: Seventeen-year-old Shirley Temple shows off her engagement ring with fiancé Sergeant John Agar, 1945.

Left: Deanna Durbin at her wedding to Von Paul, 1941.

Facing page, top: Betty Grable and husband Harry James help daughter Victoria celebrate her first birthday in 1945.

Right: Sandra Lee "Baby Sandy" Henville, the youngest male impersonator on record, and "his" fan mail, 1939.

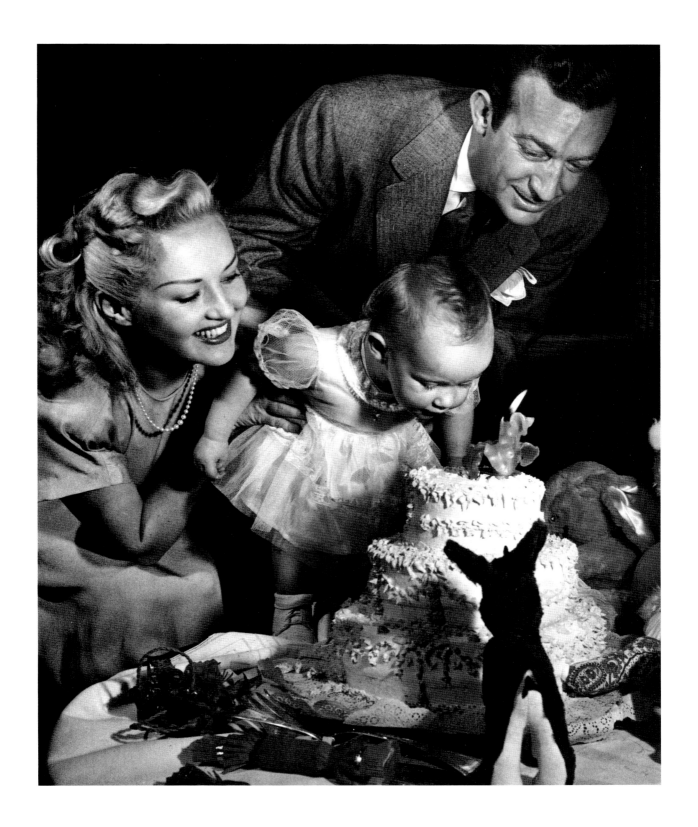

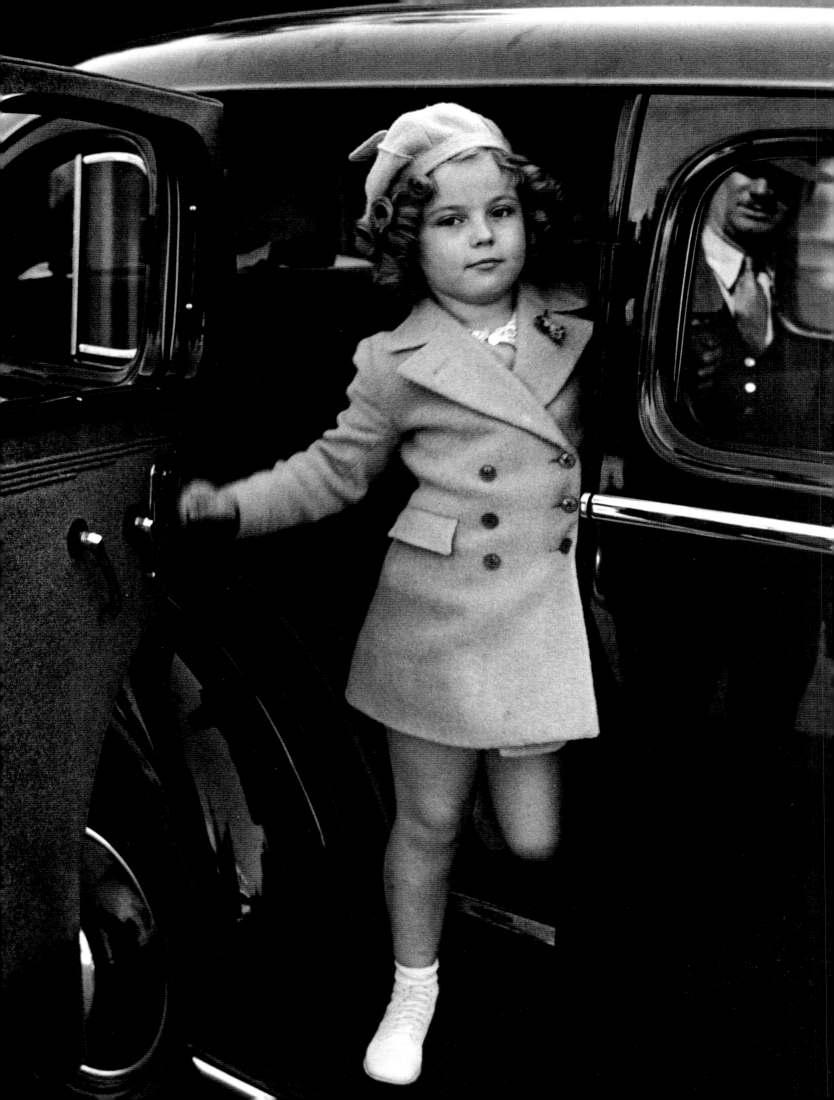

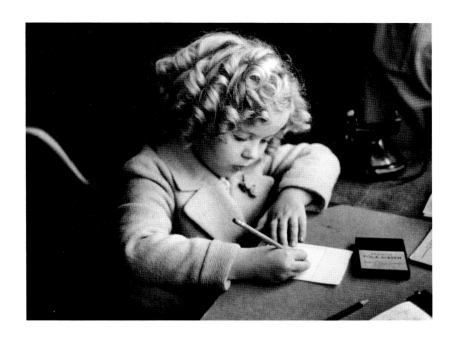

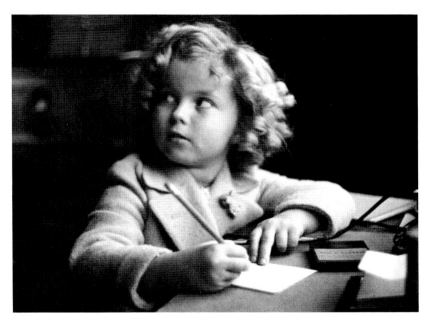

Stackpole photographed Shirley
Temple at various points in her
career, but these photos were taken
on his first trip to Hollywood in
1930. On the facing page, her
chauffeur/bodyguard is reflected in
the car window. Shirley Temple
was Hollywood's top box-office star
from 1935 to 1938; she retired
from films for good in 1949.

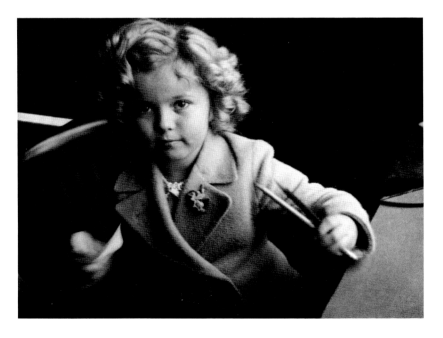

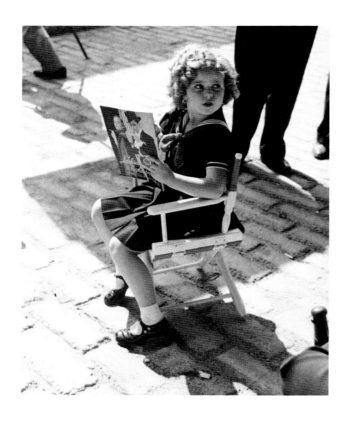

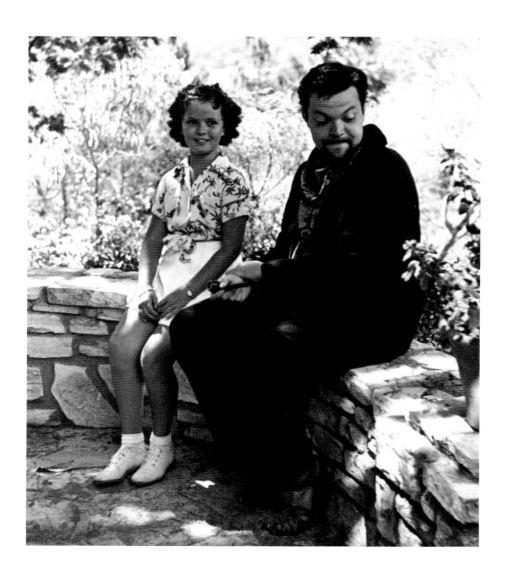

Shirley Temple in her director's chair, between takes on the set (above); with Orson Welles, who lived across Buckingham Drive from the Temples before marrying Rita Hayworth (left); and practicing the piano in her early teens.

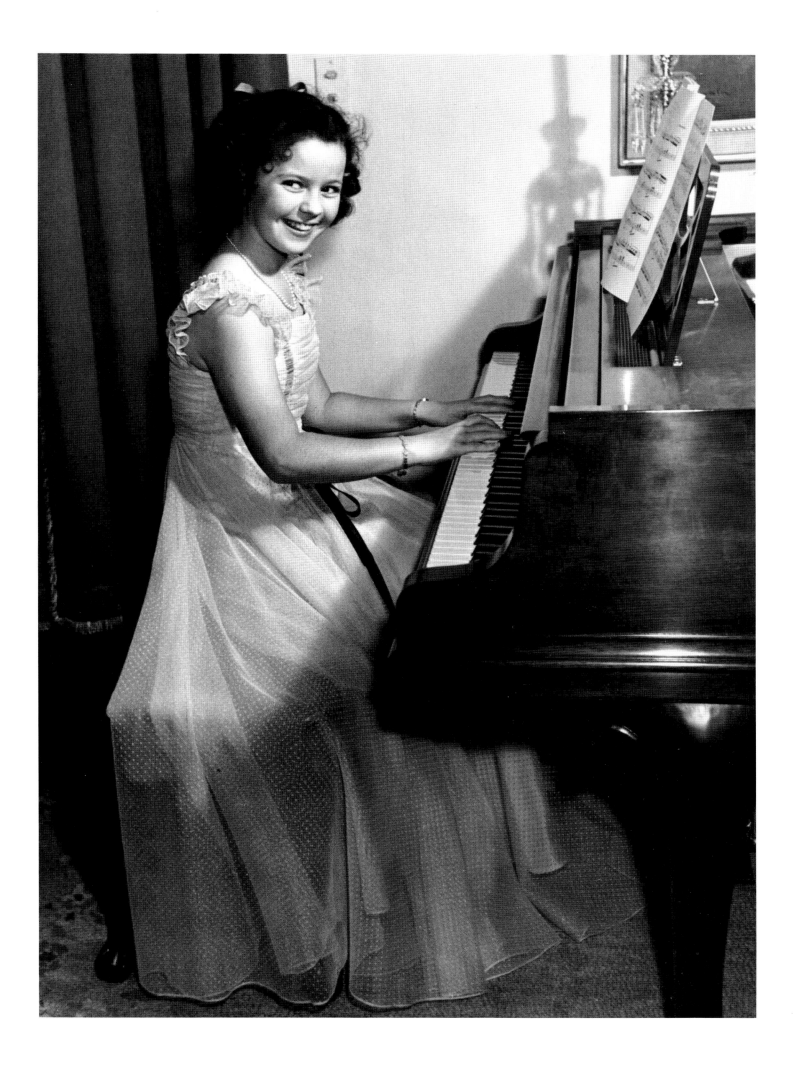

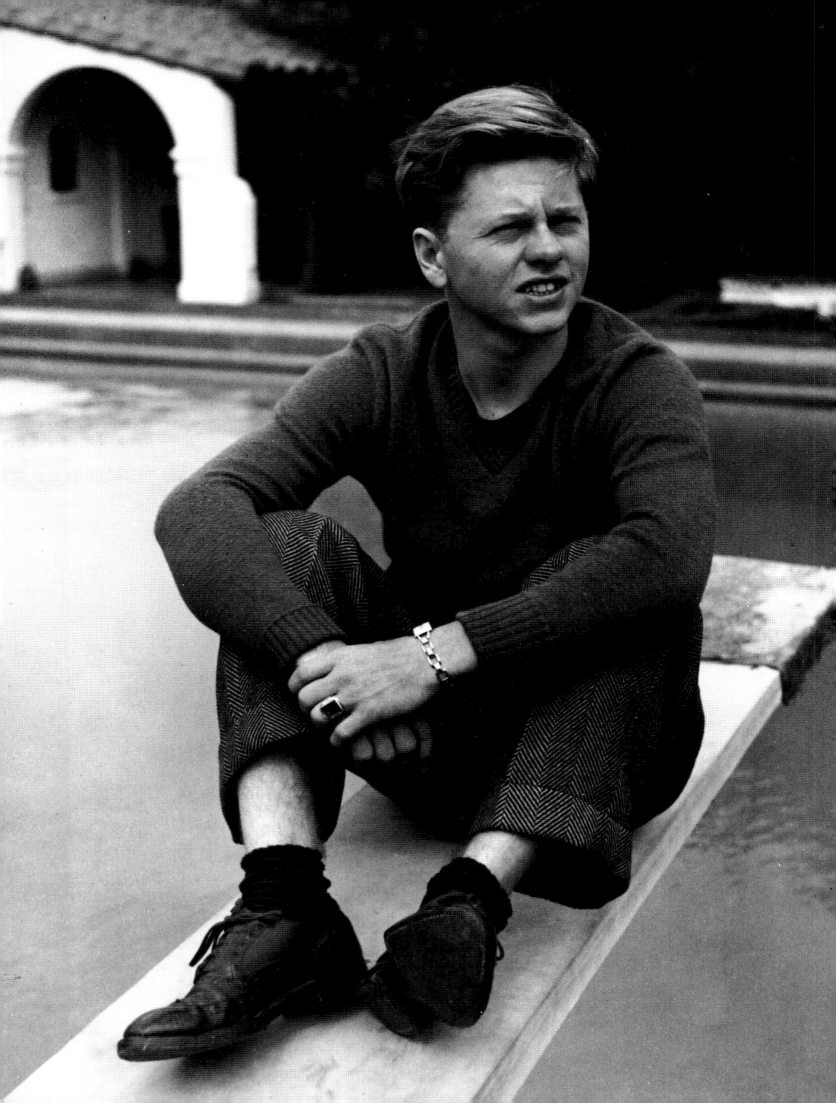

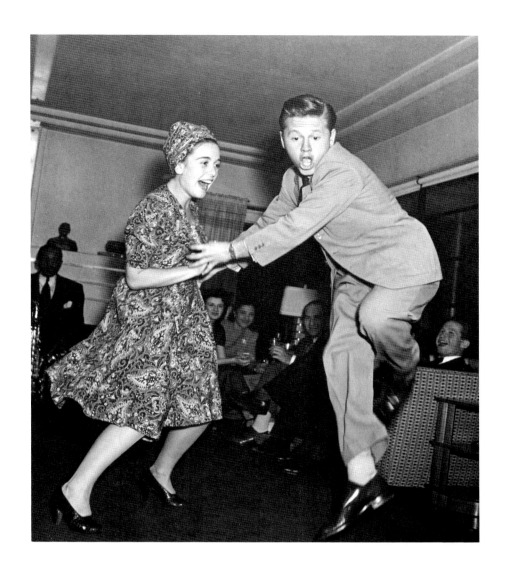

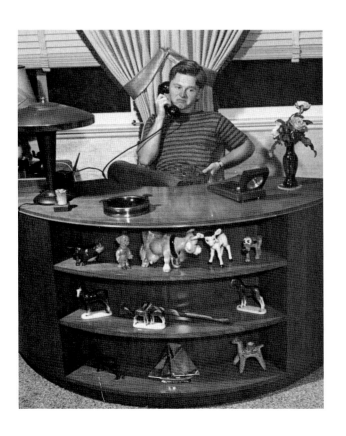

Mickey Rooney started working in Hollywood at age seven, and by the time of the first Andy Hardy movie ("A Family Affair," 1937), he'd appeared in two dozen films. Stackpole photographed him playing mogul behind his desk in 1939 (left) and dancing with an unidentified date in 1942.

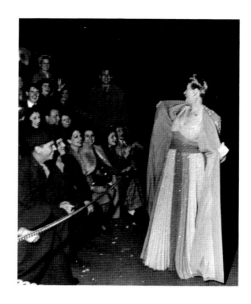

Hedda Hopper, shown recording her broadcast in 1950 (left) and displaying her dress to fans at a 1945 premiere (above), and Louella Parsons (photographed with David Hearst at a testimonial given by Hearst Newspapers in 1948, left) were Hollywood's gossip grand dames, and their rivalry was notorious.

Facing page: Art openings were an infrequent Hollywood habit. Artist Thomas Hart Benton and Edward G. Robinson discuss aesthetics at one exhibition (right); Robinson actually had an extensive collection of Impressionist oils. Portraitist John Decker and John Barrymore, shown at an opening for Decker in 1941 (far right), were drinking buddies.

Near right: Artist Raphael Soyer paints three barmaids for "The Long Voyage Home," 1939.

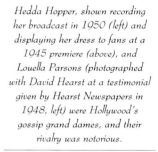

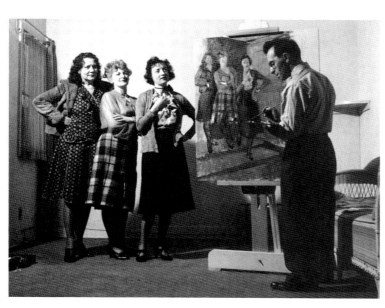

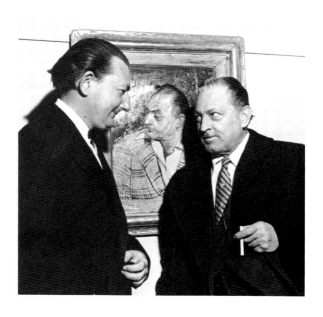

Diego Rivera uses turkey bones to
imitate Greta Garbo at a San
Francisco restaurant.

Facing page: John Carradine
mimes a critic at John Decker's
art opening, 1941.

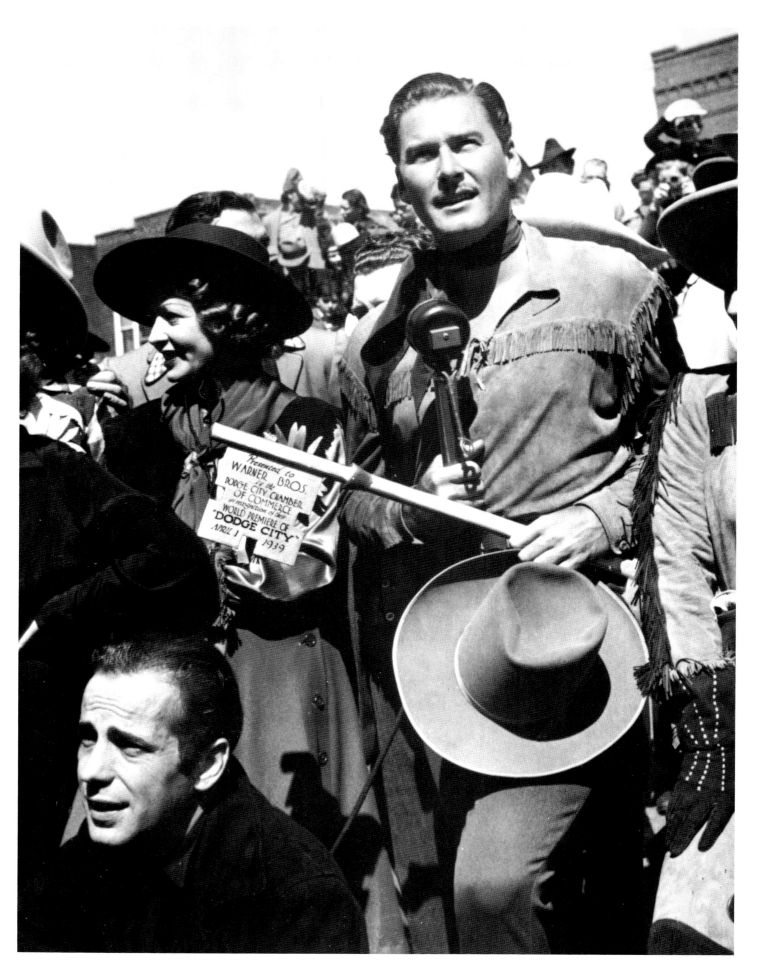

By far the most extravagant movie promotion junkets ever were for three Warner Bros. films—"Virginia City," "Dodge City" and "Santa Fe Trail." They ran on the Atchison, Topeka & Santa Fe Railroad, complete with boxcars decorated in Wild West motifs.

Hollywood columnists, photographers, stars, publicity people, New York press, Western Union reps, some starlets and a few girls who just looked like starlets all joined in on the train treks, eager to see what effect the glitter of Hollywood would have on rural America. Enroute to Dodge City, Kansas, whole towns seemed to turn out, and crowds swarmed over the tracks to get a glimpse of Errol Flynn, Humphrey Bogart, Alan Hale and other stars, who took turns plugging movies at the rear platform.

But the trips were too long for all those egos to be captive on one train. Near Dodge City, Big Boy Williams got in a fight with another cowboy and had to be taken off. Actors drank heavily, making good copy for the columnists. A day out of Los Angeles on the "Dodge City" trek, Bogart had one of his predictable fights with wife Mayo Methot. He thought she was losing too much money at cards, chased her from the bar and ran after her through several cars. He caught up with her just as she reached their bedroom compartment and she slammed the door behind her, catching him across the eyes and giving him two shiners. Bogart got off the train in Los Angeles wearing the darkest glasses he could find. —PS

Facing page: Errol Flynn with the key to Dodge City, flanked by Humphrey Bogart (bottom left) and Jean Parker, 1942. Neither Bogart nor Parker was in the movie; Warner Bros. simply sent them along for the ride.

Errol Flynn dances with Jean Parker on the Dodge City train (above), and Humphrey Bogart leads a toast in the bar car.

Above: The Hollywood press corps packs the bar car on the Dodge City trek. The three women are Lola Lane, Priscilla Lane (two of the three Lane sisters), and Jean Parker (from left); Stackpole stands third from right; Humphrey Bogart frames a photo at far right.

Left: Stackpole sets up a photograph during Warner's "Virginia City" junket.

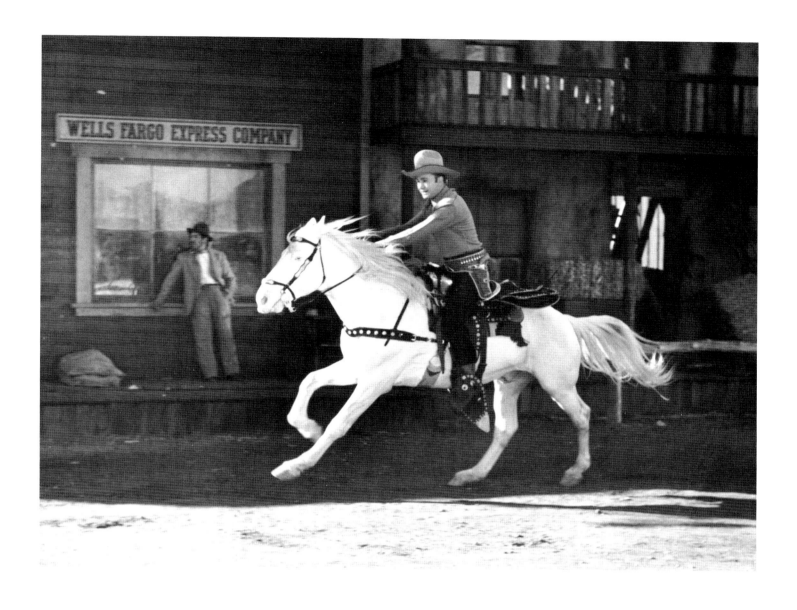

*Above: A good guy on a
Western set, 1940.*

*Right: Whip Wilson with
his weapon of choice.*

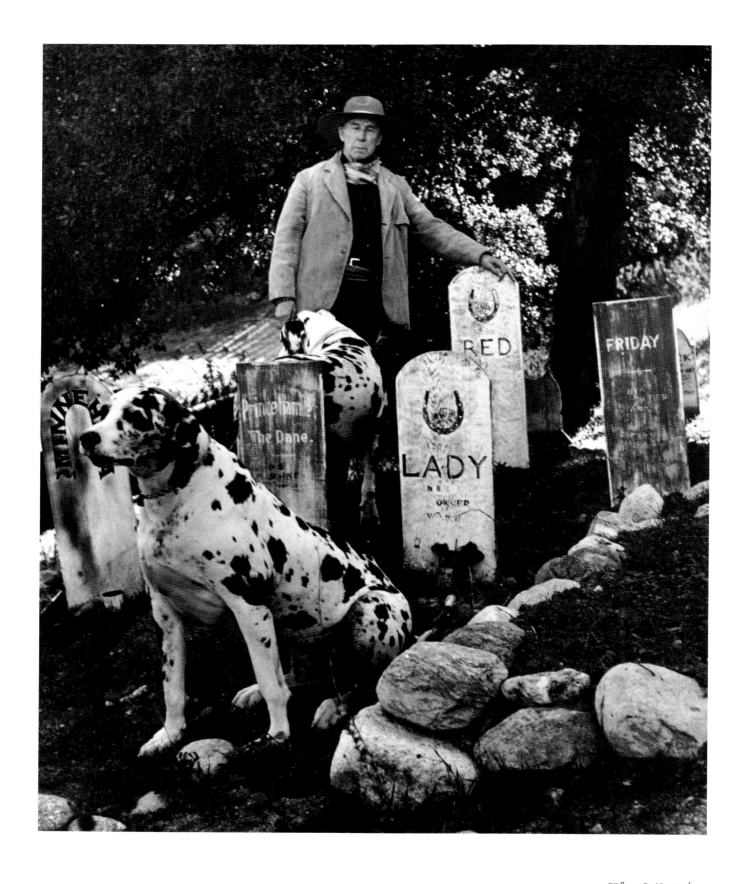

William S. Hart in his
pet cemetery, 1945.

Bert Lahr and a showgirl, 1951.

All of the Marx Brothers—Harpo,
Chico, Gummo, Zeppo, and
Groucho—in 1938 (right);
Chico, Harpo, and Groucho
up a tree (below).

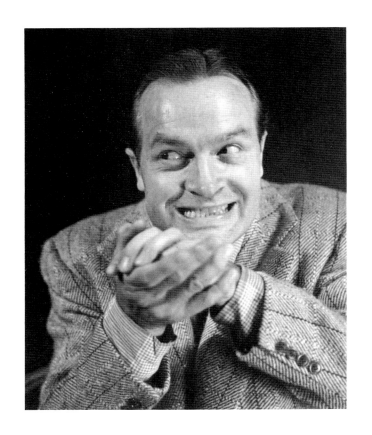

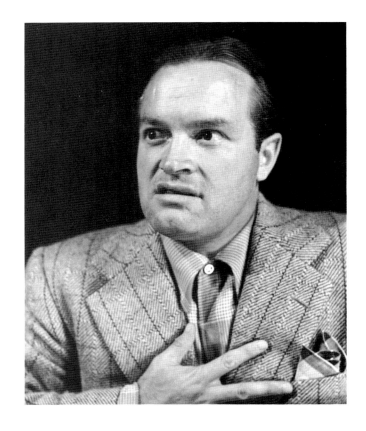

Bob Hope shows off a quick-
change range of emotion left over
from vaudeville days, including
greed, shock, misery, guilt,
satisfaction, nausea, and hatred.

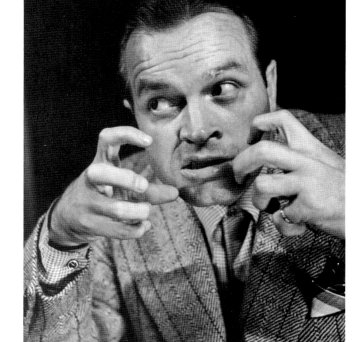

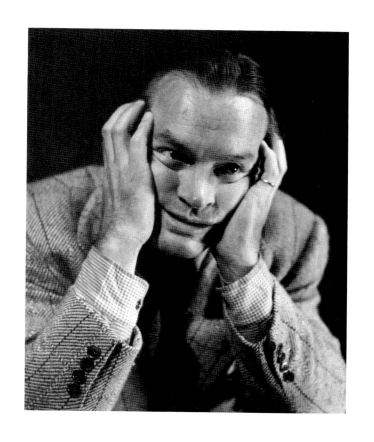

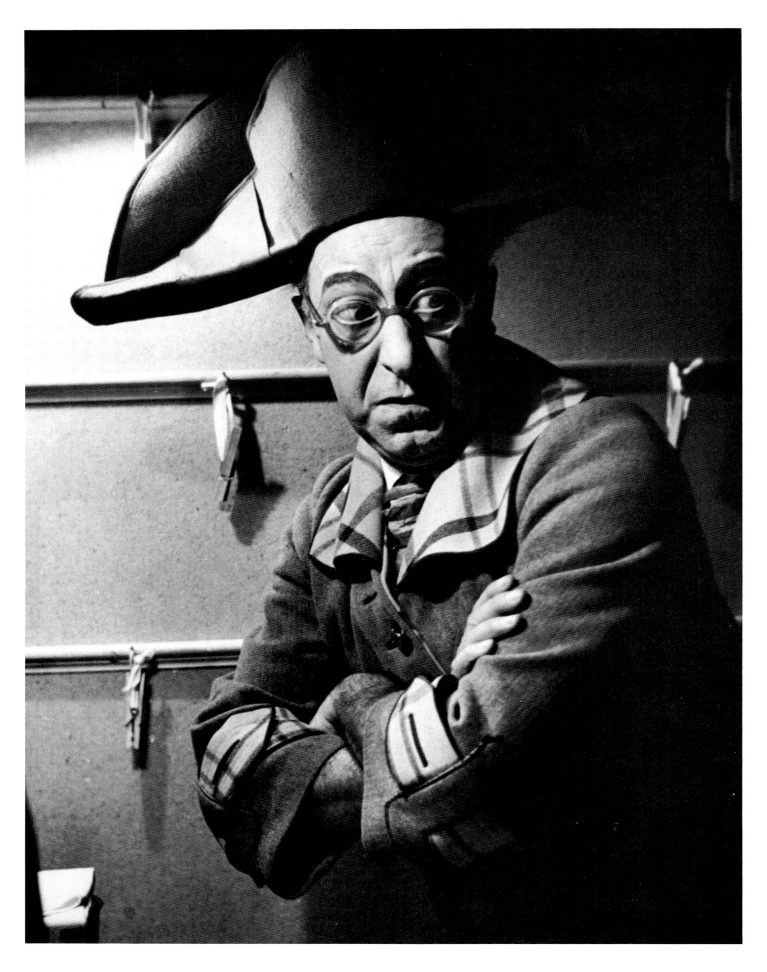

Facing page: Ed Wynn in
"Hooray for What!," 1948.

Above: Jerry Lewis and friend,
1951. Lewis's partner,
Dean Martin, asked, "Which is
my partner?"

*Eleanor Counts (second from left)
and other contestants in Goldwyn's
1939 legs contest.*

Marlene Dietrich gives "LIFE"
layout man Matt Green tips on
airbrushing her legs
in a 1952 photo.

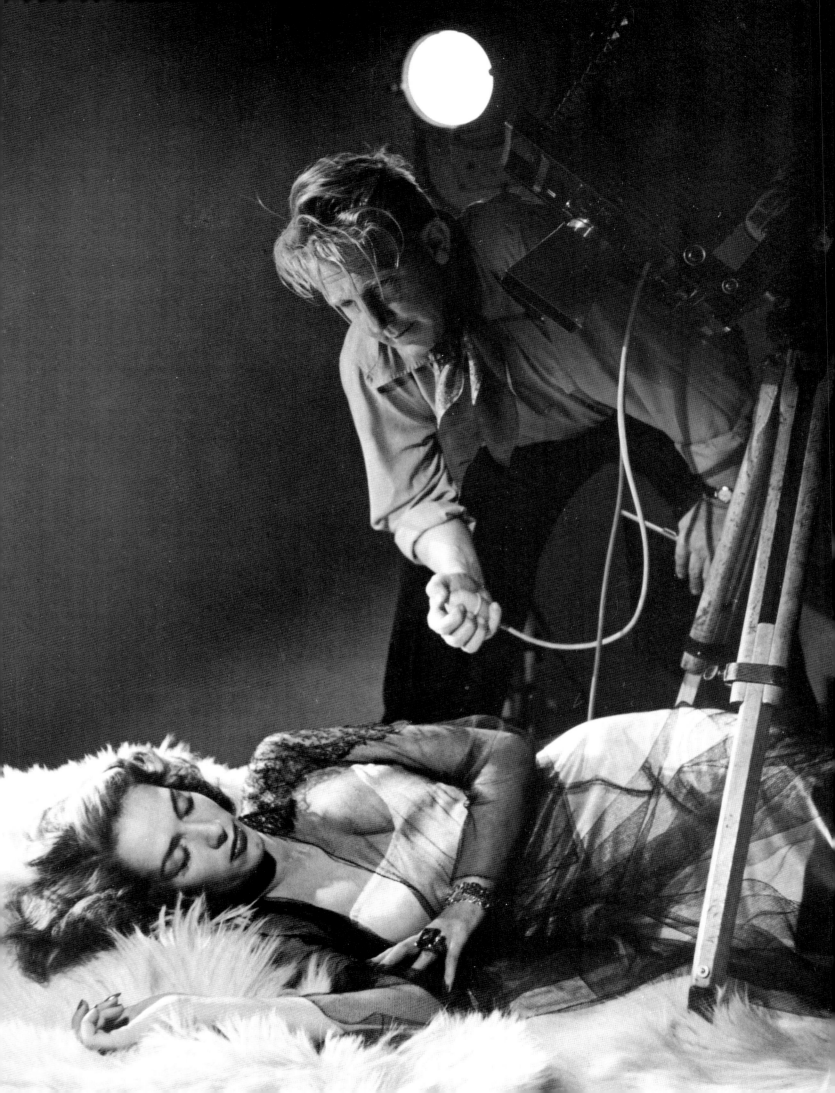

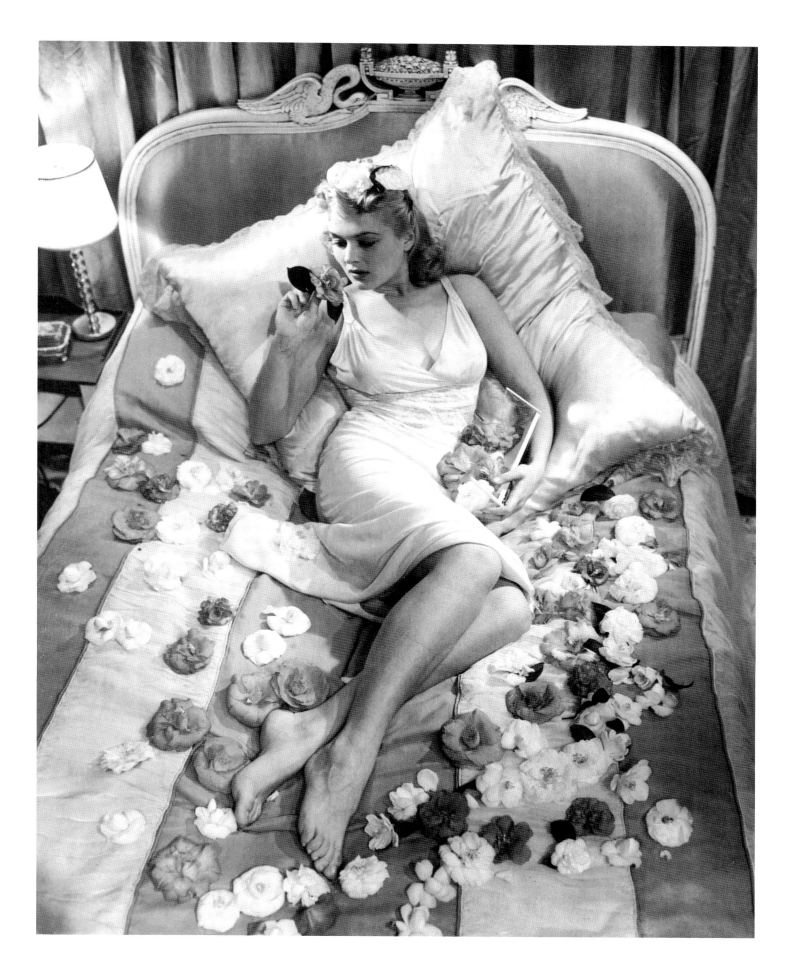

Facing page: Whitey Schaffer
gives starlet Jinx Falkenberg
the glamour treatment for a
Paramount movie, 1941.

Above: Beth Drake,
Warner's "Camellia Girl."

223

Above: An unidentified starlet.

Facing page: Veronica Lake in the Paramount wardrobe department, in costume for husband Andre de Toth's "Ramrod," 1946.

Facing page: Jeanne Crain's bath bubbles were a publicity stunt for ''Margie,'' 1940.

Above: Hazel Brooks as a Varga girl on the set of ''DuBarry Was a Lady,'' 1942; she later married Cedric Gibbons, designer of the Oscar.

Right: Margaret O'Brien in 1945, the year after she received a special Academy Award as ''Outstanding Child Actress.''

Above: Cadet Larry Landry
assists Veronica Lake into the
cockpit of a BT14 in 1941;
regulations prevented her
from actually flying.

Facing page: Dona Drake
("Louisiana Purchase," "Another
Part of the Forest"), 1941.

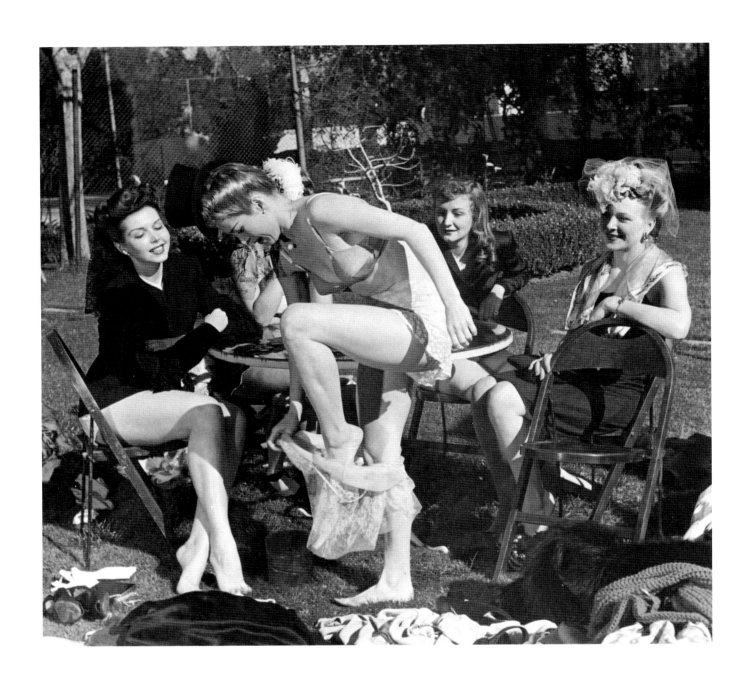

Press agent Russell Birdwell (the man behind the search for Scarlett O'Hara) staged this strip poker game at his home in 1945, using starlets Ann Miller, Toni Seven, Nina Foch, Evelyn Ankers and Renee de Marco (from left, facing page). Each woman donated five pounds of clothes to the United Nations Clothing Collection for wartorn Europe; Mr. Birdwell called the stunt a "great humanitarian spectacle."

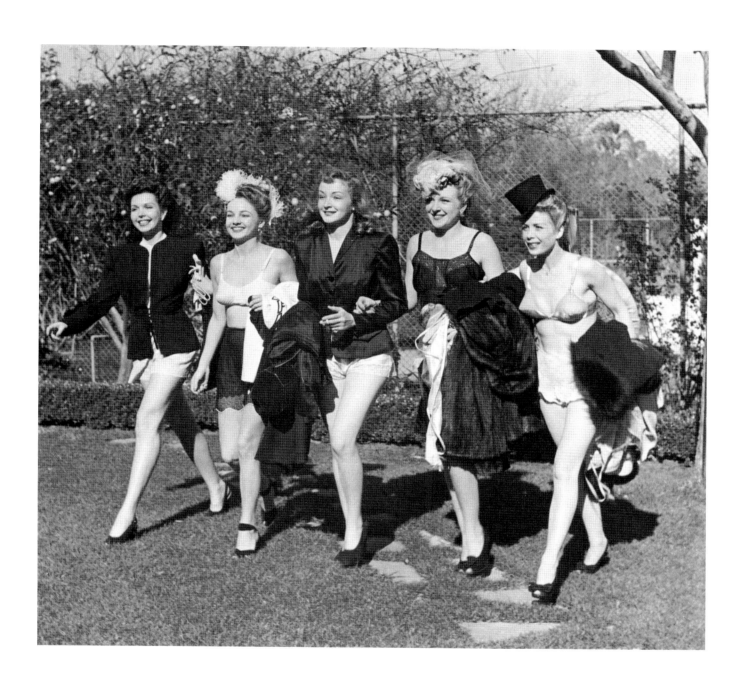

*Facing page: Pin-up girl Chilly
Williams braves the surf in 1944.*

*Top and bottom: In 1945
"LIFE" named Linda Christian
"Miss Anatomical Bomb"; she
was married to Tyrone Power and
had parts in "Tarzan and the
Mermaids" and "The House
of the Seven Hawks."*

Esther Williams, 1950.

*Cyd Charisse on Santa Monica
Beach, 1946.*

235

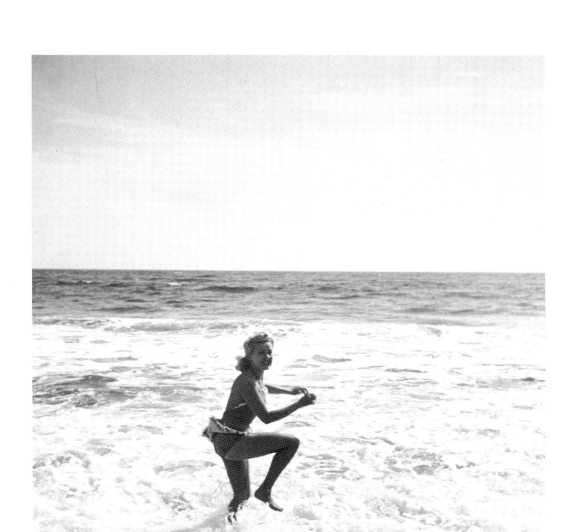

Facing page: Rita Cansino, soon to be Rita Hayworth, models tennis fashions in 1939.

Above and right: Betty Grable on the beach in Malibu, 1940.

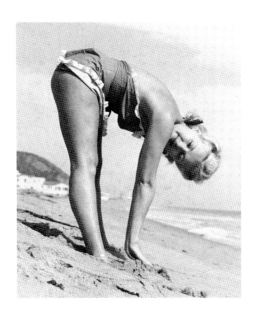

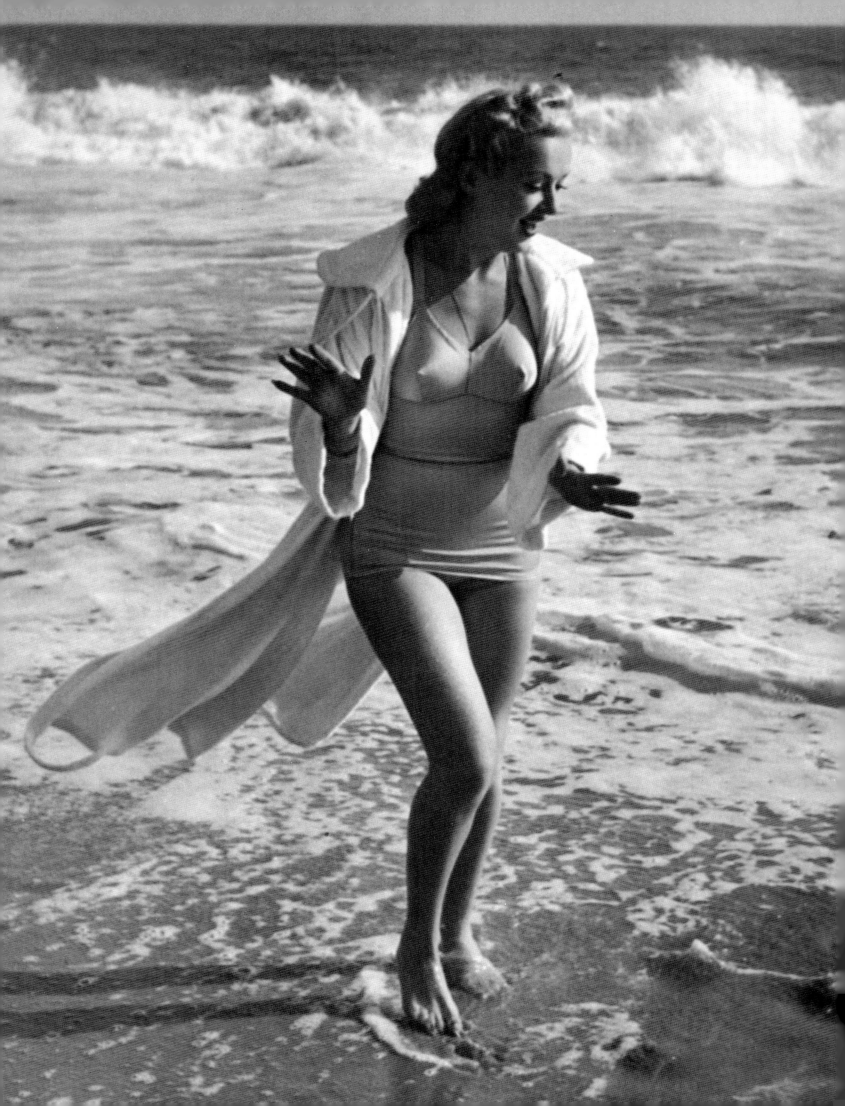

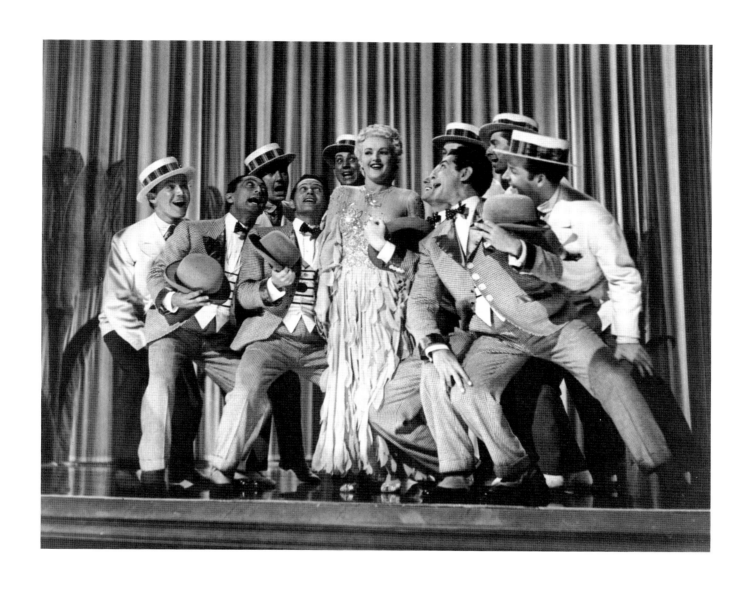

Betty Grable in Malibu, 1940
(facing page), and filming a
number in the early forties.

One day the call came to shoot someone new in town, a girl from the Dominican Republic named Maria Montez. Her reddish hair didn't go particularly well with her Latin features, but she wore a black cross and said she was a friend of the Luces. She wore a sweater without a bra underneath, so I brought her to the Garden of Allah and placed her by the pool. That was all we needed to make a full-page photo; it was quite a provocative picture in its day. Later, on a photo shoot with Maria and W. C. Fields, I asked her how much fan mail the sweater picture had brought in. "I got about three hundred letters, and most of them wanted to know my bust measurement," she said. "Yeah," said Fields, "I suppose a lot of people haven't been weaned yet." —PS

Facing page: Maria Montez at the Garden of Allah, 1941.

Left: Joan Crawford crosses a creek near Carmel, 1945.

Below: Marie "The Body" McDonald ("Lucky Jordan," "Living in a Big Way"), 1945.

Facing page: Jane Russell, 1944.
"Why I was assigned to
photograph her back I'll never
know," says Stackpole.

Above: Gene Tierney ("Laura,"
"Leave Her to Heaven"), 1942.

Above: Yvonne de Carlo showers in a cheap motel during the filming of "Salome, Where She Danced" (which "LIFE" called "one of the silliest pictures to come out of Hollywood in a long time") across the street at Universal, 1944.

Facing page: This 1940 stunt with actress and acrobat June Preisser was a rehearsal for a scene that never made it into "Strike Up the Band," with Judy Garland and Mickey Rooney. The milk came from Hollywood's Arden Dairy.

INDEX

Academy Awards, 78, 86, 96–102, 192, *193*, 227
Adams, Ansel, 11
Agar, Sergeant John, *196*
Aherne, Brian, *105*
All That Money Can Buy, 157
Allen, Fred, *85*
Allyson, June, *187*
Anderson, Eddie "Rochester," 82
Andy Hardy, 203
Ankers, Evelyn, *230*, *231*
Ashley, Lady Sylvia, 128, *129*

Babes in Arms, 48
Bachelor Mother, *188*, 189
Baer, Max, *2*
Baker, Graham, 82, *83*, *84*, 85
Ball, Lucille, *190*, *191*
Bankhead, Tallulah, *95*
Barrymore, John, 204, *205*
Baxter, Anne, 170, *171*
Beau Geste, 137, 158, *159*
Bel Geddes, Barbara, *166*
Bennett, Constance, *177*
Bennett, Joan, *82*, 177, *179*, *180*, 183
Benny, Jack, *82*
Benton, Thomas Hart, 204, *205*
Bergen, Edgar, 118, 120
Bergman, Ingrid, *86*, 166, *167*
Beverly Hills Citizen, 30
Beverly Hills Hotel, 109, 118, 123
Bill and Coo, 145
Billings, Shaw, *23*, 27
Birdwell, Russell, 230
Bogart, Humphrey, 110, *209*, *210*
Bolger, Ray, *48*, *189*
Bourke-White, Margaret, *12*
Boyer, Charles, *160*
Brackett, Charles, *75*
Brand, Harry, 90, *91*, 92
Brett, Lady, *30*
Bromfield, John, *124*
Brooks, Hazel, *227*
Brooks, Rand, *122*, 123
Brown, Alan, 30
Bruce, Nigel, 170, *171*

Calvet, Corinne, *124*
Cansino, Rita. *See* Hayworth
Capa, Robert, 19
Capra, Frank, *74*, 82, *83*
Carradine, John, 206, *207*
Carroll, Earl, 25, 58–59, 65

Cartier-Bresson, Henri, 19
Chandler, Hope, 30, *31*
Chaplin, Charles, 107
Charisse, Cyd, *235*
Christian, Linda, *233*
Citizen Kane, 77, 147, 148
Cohn, Harry, 82, *83*
Colman, Ronald, *160*
Columbia Steel, 2, *3*, 11
Columbia Studios, 82
Cooper, Gary, *14*, 134, *135*, *136*, *137*, 158, *159*, *250*
Cooper, Maria, *137*
Coote, Robert, *141*
Corio, Ann, 29
Counts, Eleanor, 70, *71*, *220*
Craft, Roy, *39*
Crain, Jeanne, *226*, 227
Crawford, Christina, *133*, 134
Crawford, Christopher, *133*
Crawford, Joan, *133*, *134*, *240*
Crocker, Harry, 117, 118
Crosby, Bing, *153*
Crowninshield, Frank, 11
Cukor, George, 82, *83*
Cunningham, Imogen, 11
Curtiz, Mike, *79*
Cushingham, Eleanor, *240*

Dance Girl, Dance, 191
D'Arcy, Alex, *122*, 123
Darnell, Linda, 71, *145*
Davenport, Russell, *11*
Davies, Marion, 104, 117, *118*
Davis, Bette, *165*, 166
Day, Dennis, *82*
Day, Laraine, *184*, *185*, *186*
Decker, John, 204, *205*, 206
de Carlo, Yvonne, *244*
de Havilland, Lillian, *195*
de Havilland, Olivia, *101*, *195*
de Marco, Renee, *230*, *231*
De Mille, Cecil B., 118
de Toth, Andre, 224
Dietrich, Marlene, 20, *54*, *55*, 71, *221*
Disney, Walt, *77*, *102*
Dodge City Train Trek, 104, 209, 210
Drake, Beth, *223*
Drake, Dona, 228, *229*
Du Barry Was a Lady, 227
Durbin, Deanna, *196*
Durocher, Leo, 186

8 x 10 camera, 30
Ecstasy, 175

Eddington, Nora, 112
Eisenstaedt, Alfred, *12*
Ellington, Duke, 124, *125*
Enright, Florence, 60, *61*

4 x 5 camera, 1, *12*, 25, 170
Fairbanks, Douglas Jr., 138, *130*, 141
Fairbanks, Douglas Sr., 128
Falkenberg, Jinx, *222*, 223
Fields, W. C., 48, *49–53*, 240
Filan, Frankie, 25
Fink, Hymie, 39
Flynn, Errol, 104, *105–112*, *208*, *209*
Foch, Nina, *230*, *231*
Fontaine, Joan, *96–98*, 99, *140*, 141, *195*
Ford, John, *77*
A Foreign Affair, 54
Foreign Correspondent, 184
Fortune, 4, 11, 23, 117
Freund, Karl, *78*

Gable, Clark, *154*, *155*, *158*
Garbo, Greta, 206
Garden of Allah, 54
Garland, Judy, *48*, *89*, 244
Garson, Greer, 20, *99*, 161, *162*, *168–170*, *249*
Gaslight, 86, 160, 161
Gaylord, Slim, 126
Geisler, Jerry, 110
Giannini, Lawrence, *8*
Gibbons, Cedric, 227
Gilmore, Virginia, 70, *71*
Goldwyn Girls, *71*, *87*
Goldwyn, Sam, 65, *87*
Goldwyn Studios, 71, 102, 150, 220
Gone with the Wind, 101, 123, 161, *163*
The Good Earth, 78
Gordon, Ruth, 80
Grable, Betty, 72, *120*, 196, *197*, *237*, *238*, *239*
Grant, Cary, *138*, 141
Graphlexes, 1
Green, Matt, *221*
Greenstreet, Sidney, *154*
Griffith, D. W., 92
Group F/64, 11
Gunga Din, *79*, *138–141*

Hale, Alan, 209
Hardy, Rex Jr., 30
Harrison, Joan, *78*

Harrison, Rex, 72
Hart, William S., *158*, *212*
Hayworth, Rita, *15*, 30, 37, 120, *121*, *130–133*, *200*, *236*, 237
Hearst, David, 30, *204*
Hearst, William Randolph, 1, 4, 5, 11, *117*, *118*
Hemstead, David, *99*
Henville, Sandra Lee "Baby Sandy," 196, *197*
Her Highness and the Bellboy, 187
Hicks, Wilson, 12, 25, 110, 111
Hitchcock, Alfred, 20, 78, 92, *93–97*
Hitchcock, Alma, *96*
Hitchcock, Patricia, *96*
H. M. Pulham Esq., *87*, 88
Holm, Celeste, 120, *121*
Hoover, Herbert, 1
Hope, Bob, *216*, *217*
Hopper, Hedda, *204*
Howard, Bob, 50, *53*
Howard, Leslie, 23, *24*, 25
Hubbard, John, *122*, 123
The Hucksters, 154
Hughes, Howard, 10, 110
The Hunchback of Notre Dame, *142*, *143*, *104*, 166
Huston, Walter, *157*
Hutton, Betty, *192*

If You Knew Susie, 66
Irene, 192

Jaffe, Sam, *138*
James, Claire, *65*
James, Harry, 196, *197*
James, Victoria, 196, *197*
Janie, *79*
Johnson, Nunnally, *90*
Johnson, Van, *157*

Kanin, Garson, *80*, *81*, 82
Karloff, Boris, *140*, 147
Kaye, Danny, *149*, *150*, *151*
Keaton, Buster, 92
Kismet, 54, 55
Kiss the Boys Good-bye, 161
Kitty Foyle, 96, 99, 192
Knowland, William, 1
Korda, Alexander, *128*, *129*
Korda, Zoltán, 78

Lahr, Bert, *48*, *213*
Lake, Veronica, 72, 224, *225*, *228*

Lamarr, Hedy, 12, *13*, *87*, *88*, *89*, *174*, *175*
Lamour, Dorothy, *120*
Landis, Carole, *72*, *73*
Landry, Bob, 30
Landry, Cadet Larry, *228*
Lane, Lola, *210*
Lane, Priscilla, *210*
Lang, Jennings, 177
Lange, Dorothea, 11
Lansbury, Angela, *161*
Larson, Roy, 23
La Rue, Peggy. *See* Satterlee
Laughton, Charles, *81*
Lawrence, Freda, *30*
Lawrence, Gertrude, 27
Leica, model A, 1, 2, 12, 19, 23
Leigh, Vivian, *100*, *101*, 161, *103*
Le Monnier, Jean, 112
Le Roy, Mervyn, 74, *75*
Lewis, Jerry, *219*
LIFE, 1, 11, 12, 16, 19, 20, 23, 25, 27, 30, 39, 65, 72, 75, 79, 112, 114, 170, 221, 233, 244
Lifeboat, *95*
The Little Foxes, *105*, 166
Little, George, *114*, 115
Livingstone, Mary, *82*
Loewy, Raymond, 246
Lombard, Carole, *79*, *81*
The Long Voyage Home, 204, 205
Longwell, Dan, 23, 25
Loren, Sophia, *19*
Los Angeles Herald, 30
Luce, Henry, *11*, 23

Magic Town, *38*, 39
Margie, 227
Marglen, Juliette, *37*
Martin, John, 23, 25
Martin, Mary, *161*
Marx Brothers, *214*, *215*
Mayer, Louis B., *99*
McAvoy, Thomas D., 11, *12*
McCarthy, Charlie, 118
McDonald, Marie, *240*
McKenna, Peggy, *72*, *73*
Merthot, Mayo, 209
MGM, 23, 25, 47, 54, 68, 69, 158, 184
Miles, Johnny, *71*
Miller, Ann, 72, *182*, 183, *230*, *231*
Minnelli, Vincente, *89*
Minsky's Burlesque, 27, *28*, *29*
Monroe, Marilyn, 39, 90

Montez, Maria, 50, *51–53*, 240, *241*
Morgan, Helen, 30
Mrs. Parkington, *162*
Mydans, Carl, 12, *39*

National Velvet, 45
Neagle, Anna, *192*

Oakland Museum, 20
Oakland Post-Enquirer, 1, 2
Oakland Tribune, 1
Oatman, Fred, *70*
Oberon, Merle, *102*, *128*, *129*
O'Brien, Margaret, *227*
O'Curran, Charlie, 66, *67*, *68*
O'Hara, Maureen, *104*, 166, *181*, 183
Olivier, Laurence, *100*, 101
O'Sullivan, Maureen, *166*

Paramount, 68, 69, 223, 224
Parker, Jean, *208*, *209*, *210*
Parsons, Louella, *204*
Paul, Von, *196*
Photoplay, 39
Pickford, Mary, *183*
Pollard, Dick, 30, 50
Powell, Dick, 117
Power, Tyrone, 233
Preisser, June, 244, *245*

Ramrod, 224
Ramsden, Frances, *86*
Ratoff, Gregory, *77*
Ray, Johnny, *153*
Raye, Martha, 118, *119*, *120*
Reed, Carol, 128
Reville, Alma, *78*
Richmond, Howard, *23*
Rivera, Diego, 1, 8, *9*, 20, *206*
RKO, 66
Robinson, Bill "Bojangles," *156*, 157
Robinson, Edward G., 204, *205*
Rogers, Ginger, 96, *99*, *177*, *188*, 189, 192, *193*, *105*
Rogers, Lela, 192, *193*
Rogers, Will, 30
Romeo and Juliet, 23, 25, *26*, 82
Rooney, Mickey, *48*, *202*, *203*, 244
Roosevelt, James, *102*
Ross, Shirley, *120*
Russell, Jane, 30, *242*, 243
Rutherford, Ann, *122*, 123

16 mm camera, 11
Salome, Where She Danced, 244

San Francisco Bay Bridge, *4*, 11, 20
San Francisco Museum of Modern Art, 11
Santa Fe Trail, 209
Sarawak, Princess Raboa of, *120*
Satterlee, Peggy, 107, 109, *110*
Schaffer, Whitey, *222*, 223
Schenck, Joseph M., *92*
Schwab's Pharmacy, *33*
Selznick, David O., *86*, 96, *97*
Selznick, Irene Mayer, *101*
Seven, Toni, *230*, *231*
Severn, Clifford Brill, *02*
Shearer, Norma, 23
Sheridan, Ann, 71
Shore, Dinah, 150, *151*
Silver, Sam, *92*
Sinatra, Frank, *152*, 153
Siodmak, Robert, *89*
Sirocco, 104, *105–107*, 110
Skolsky, Sidney, 33
Slade, Shirley, 16, *17*
Smith, Eugene, 12
Snow White, 77, 102
Son of Frankenstein, *146*, 147
Soyer, Raphael, 204, *205*
Spruce Goose, 10, *11*
Stackpole, Hebe, *20*, 30, 33
Stackpole, Peter, *vi*, 1–*12*, 12–*21*, *22–37*, *38–39*, 62, *73*, *79*, 95, 109, *111*, 150, 170, *172*, 175, *195*, *210*, 243
Stackpole, Ralph, 1, 2, *8*, 9, 20
Stagecoach, 77, 177
Stevens, George, 74
Stewart, Jimmy, 39, *112–110*
Stewart, Mary, *115*
Sturges, Preston, *86*
Sullivan, Ed, *160*
Suspicion, 96, 99

35 mm camera, 2, 12, 25, 30
Taylor, Elizabeth, 40, *41–47*
Temple, Shirley, *10*, 20, 23, 90, *91*, *102*, 157, *196*, *198–201*
Terry, Philip, *133*
They Died with Their Boots On, *142*
They Knew What They Wanted, 81
Thief of Baghdad, 78
Thorndyke, Joseph, *23*, 90
Tierney, Gene, *243*
Time, 1, 11, 23
Time, Inc., 1, 11
Topping, Bob, *194*, 195
Towne, Gene, 82, *83*
Turner, Cheryl, *194*, 195

Turner, Lana, *32*, 33, 72, *170*, 177, *104*, 195
Twentieth Century Fox, *22*, 23, 39, *56–57*, 60, 61, *00*, 68, 69, 90, 92

Universal Studios, 244
University of California at Berkeley, 1
University of Missouri, 110
Up in Arms, 150, *151*

Vandivert, William, 12
Van Dyke, Willard, 11, *30*
Vanity Fair, 11
Vernon, Dai, *123*
Vidor, King, *87*, *88*, 89
Virginia City, 209, 210

Walker, Robert, *187*
Walter Mitty, 149
Wanger, Walter, 177
Warner Bros., 82, 110, 209, 210, 223
Welles, Christopher, *132*, 133
Welles, Orson, 20, *76*, 77, 120, 121, *130*, *131*, *132*, 133, *147*, *148*, *200*
Wellman, William, *39*
The Westerner, 12, *14*, 137
Weston, Brett, 33
Weston, Edward, 11, 33
Whelan, Arleen, *122*, 123
Whitney, John Hay, *100*, 101
Wilcoxon, Henry, 117, *118*
Wilder, Billy, 54, *75*, *148*
Wiles, Buster, *107*
Williams, Big Boy, 209
Williams, Chilly, *232*, 233
Williams, Esther, *172*, *173*, *234*
Willicombe, Joe, 117
Wilson, Whip, *211*
Winchell, Walter, 30
Withers, Jane, 39
The Wizard of Oz, 48, 68, 69
Wood, Sam, 74
Woodward, Clyde "Woodie," 114, *116*
World War II, 12, 19, 20, 25, 33, 35, 80, 120
Wright, Frank Lloyd, 170
Wuthering Heights, 101, 128
Wynn, Ed, *218*, 219
Wyntoon, *4*, *5*, 117, 118

Young, Loretta, 177, *178*

Zanuck, Darryl, 23, 66, *92*

COLOPHON

Jacket and book design by Anne Garner.
Composed in Bernhard Modern by Wilsted & Taylor, Oakland.
Printed and bound by Ringier America.

Gary Cooper walking a snow-covered rail
in Aspen, Colorado, 1949.